LÁZQUEZ•HOGARTH•TITIAN RUBENS•VELÁZQUEZ•HOGARTH

MATT'S **OLD MASTERS**
TITIAN · **RUBENS** · VELÁZQUEZ · HOGARTH
MATTHEW COLLINGS

WEIDENFELD & NICOLSON

Also by Matthew Collings

THIS IS MODERN ART

First published in Great Britain in 2003
by Weidenfeld & Nicolson

A CIP catalogue record for this book
is available from the British Library.

ISBN 0 297 64671 0

Designed by Harry Green

Printed in Italy by Printers Trento srl

Weidenfeld & Nicolson
The Orion Publishing Group Ltd
Orion House
5 Upper Saint Martin's Lane
London, WC2H 9EA

Contents

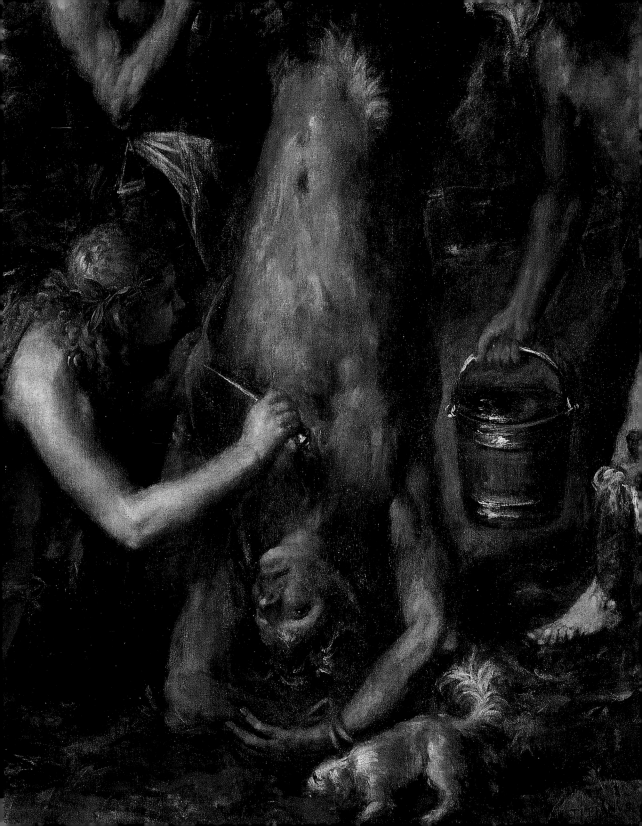

Titian
FLESH

Dressed-up flesh

This is a book about three painters who stand for the highest that painting can go – Titian, Rubens and Velázquez – and then another one who didn't weigh in quite so heavy – William Hogarth. He's a bridge between their greatness and the place where art is at now. What links all four of them is paint, the idea that the handling of it has an expressive, rich, luxurious life of its own.

Anything can be art, of course, and it's great to know something about the minutiae of the differences between all the meanings of videos and installations, and all the other non-painting forms, but on the whole I don't care that much about them. I'm always surprised by the endlessness of painting, its depths, compared to the brittle, fast, amusing character of all that other stuff. The type of painting I find gripping is the type where you can say, 'Well, the paint is everything here,' regardless of what the subject matter is or what's known about what was going on in society at the time.

I think this inner life is still what defines painting today. But you've got to be aware that the past isn't the same as the present. People assume there's a continuous line between them, and that with enough education and help the public will finally see the connection between Titian and Sam Taylor-Wood. Or even Lucian Freud. In fact there's a break and not acknowledging it leads to misunderstandings about contemporary art as well as the old masters.

We don't have a system of beliefs and skills in place to be able to turn out the type of art that Titian did. I don't think that's such a horrifying thought. We're not connected enough to that art to be able to do it ourselves, but we're connected enough to be moved by it.

Titian's *Perseus and Andromeda* **1** appears weightless. The woman is chained to a circular emptiness. She seems to be all arms. The story is that Perseus rescues Andromeda from a sea monster. She's been sacrificed so her city can be saved. She's the focus but at the same time the non-flesh imagery is visually connected to the flesh imagery by painterly treatment. In a six-feet wide painting, the image of her parents who've given her up, only occupies a couple of square inches. The monster doesn't take up much room either. So it's not the mythological story that makes this painting what it is. And it's not the slightly strange nudity either: strange because of the way believable fleshiness inhabits a space

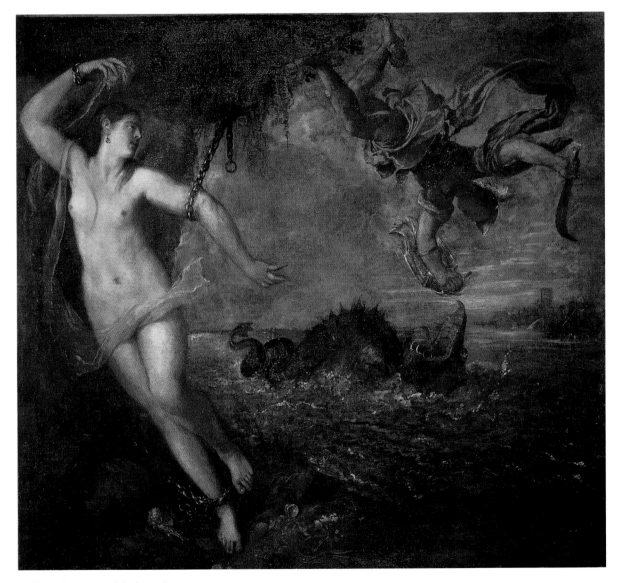

1 Titian, *Perseus and Andromeda*

that appears to have no depth at all. It's the hazy, swirling, merging treatment: the effect that comes from the touch of the brush and the play of the colour. If it were painted differently it wouldn't have that feeling.

It's Titian's originality to see that this broken surface could work as a look, where a lesser artist might only be concerned to get the highlights in the right place. So what you tend to find in a Bassano, say (one of Titian's contemporaries) is a lot of white patches creating an impression of rounded forms. This will be convincing in a naturalistic sense but the painting won't necessarily have anything visually distinctive about it. Titian is more like Picasso. He's bold. He sees that in order to make the whole thing have visual dynamism you can put the white anywhere you like. You can break any rule. You don't have to follow conventions.

Oil paint, as a material, wants to go in a certain direction: it's richer when it's loose, when the dried surface is broken rather than smooth, and the colour has a feel of being spread out and broad rather than crystalline or jewel-like. Oil painting as a technique and as a new bit of technology on the art scene arrived first in the Netherlands and then spread to different parts of Europe. But oil on canvas really gets going – its richness is first really drawn out – in Venice in the sixteenth century. This happened with Bellini and Giorgione, and then with Titian, who was taught by both of them.

The defining features of Venetian painting are like those of the city, especially its different types of light: reflected light in lagoons and canals, strong and bright, contrasted with soft dispersed light. What you can still see in the richly decorated architecture of Venice and the stuff that surrounds it, the water and the sky, is the blurring of the boundaries between the organic and the man-made: nature constantly changing, and the man-made deliberately designed to respond to those changes. For sixteenth-century Venetians the look of the place was all about glittering, shimmering decoration.

When Titian first arrived in Venice in the early 1500s oil painting had already existed in the city for about twenty-five years, and in Italy probably for fifty. It was used alongside other techniques like tempera and fresco. Painting was mostly done on wood, but painting on canvas also existed. One reason oil on canvas eventually became the most commonly used method was that the salty lagoon atmosphere was harmful to the surfaces of frescos on plaster and tempera paintings on wood. Another was the easy availability of canvas produced as sailing

cloth. The thing that distinguishes Titian from what came before him, however, isn't just the change of medium from water-based painting to oil-based, but what he does with the medium. He brings something new to art – a touch, a handling ability, where you feel these are now absolutely fore-grounded as content.

Tiziano Vecellio, known in English-speaking countries as Titian, was born in Cadore, a little way outside Venice, some time between the mid-1480s and 1490. By his mid teens he was in Venice, working as the pupil and assistant of Bellini, and by 1507 at the latest he was part of the Venice art world: he was working on commissions; he'd left Bellini's studio; he was knocking about with Giorgione, who was about ten years older than Titian.

Bellini's *Madonna of the Meadow* **2** is a traditional religious scene given a sort of humanised expression, but there's no false sweetness: the painting has its own toughness. The Madonna is a collection of blue triangles. The blue of the sky is a variation on the blue fabric, while the colouring of the child connects with the colour of the background landscape. That landscape has its own separate mood: part hazy and dreamy, part surprisingly ordinary. And its distinctive atmosphere affects and alters the emotion of the whole scene.

With Giorgione everything is concentrated down to sheer mood. *The Tempest* **3** is a small glinting scene, with the people and the landscape equally emphasised. The people are neither biblical nor mythological: they're not anyone and they don't symbolise anything. You probably assume the woman is the Virgin Mary. But she'd never be undressed. Art historians always describe the figures as 'a soldier and a gypsy' but nothing is actually recorded about Giorgione's intended meaning. Even the title is an afterthought, given by someone else: it highlights what must have seemed to be important about the painting at the time, which is light and feeling. As if the people are there to add a little recognisable humanity to something that is poetic and hard to define, rather than the other way round (the poignant vagueness of the landscape providing an emotional colouring for the people).

Titian absorbed this principle. Not that he ever painted non-thematic pictures, but he treated given subjects however he liked. The way in which objects were distributed around a space and the way they were fabricated by paint were crucial for him. The same stages of the process were more or less repeated from painting to painting: different types of grounds were followed by blocked-in shapes, which were followed by transparent colours done over the grounds and

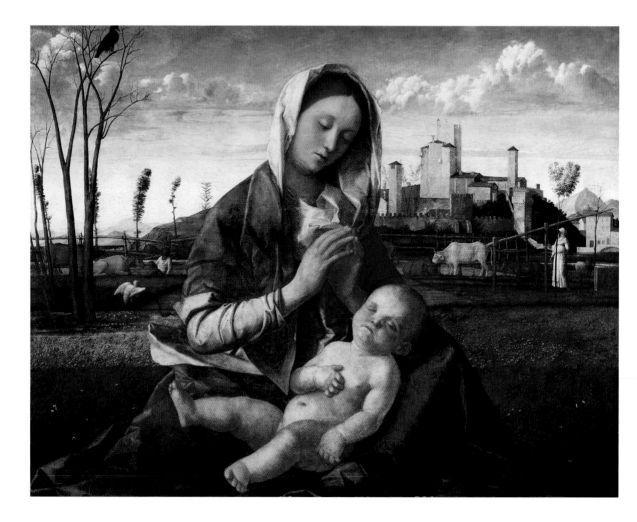

2 Giovanni Bellini, *Madonna of the Meadow*

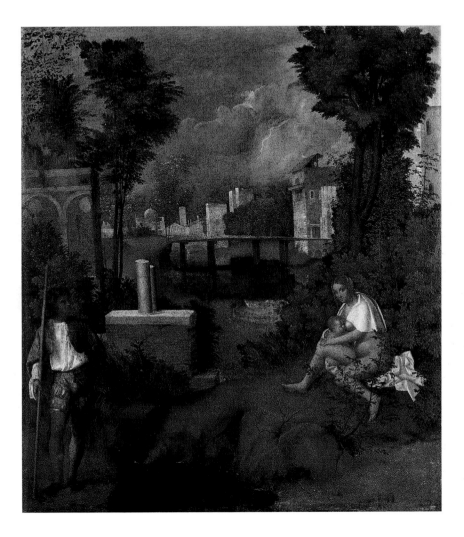

3 Giorgione, *The Tempest*

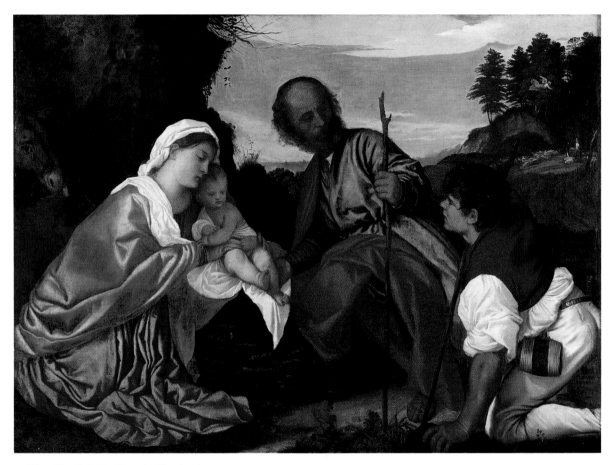

4 Titian, *The Holy Family and a Shepherd*

the shapes; touches of white were added at various stages, and then often again at the end. But it wasn't an unvarying or streamlined process: a lot of chance and movement were allowed.

In Giorgione's paintings, as with Titian's, X-ray photos show major changes – for example, in *The Tempest*, where the soldier now stands, there used to be a nude woman – and this supports the idea of an approach that tolerates and encourages a lot of impulse and improvisation. Even though the whole process was a slow one, and the conscious aim was to achieve an emotional effect that certainly was pre-conceived. It's just that the effect would be arrived at more by doing than planning.

The early Renaissance convention was that a scene was conceived – based on the requirements of the patron – and then a lot of studies were done. These were eventually combined into a single study, which was then laboriously transferred onto the canvas (or plaster or wood), and then the painting was done. But with the late Renaissance Venetian method, which Titian inherited initially from Bellini and Giorgione, the image shuffles into place right on the canvas.

The earliest known oil painting that's definitely by Titian and that has survived in a good state is *The Holy Family and a Shepherd* **4**. It's from about 1510, a few years after Giorgione's *Tempest*. The paint has its own life: he's moving it around in a way that suggests he's sometimes being led by it, he's not bossing it or defeating it. The white shapes that make up part of the Virgin Mary's clothes, as well as the wisps of whiteness that form Christ's clothes, make up a single shape that finds a balance in the white clothes of the shepherd. This whiteness is a fiction since a farm labourer would never be wearing white, but it's the visual hinge that holds the painting together. Titian finds the balance not by calculation but by trial and error. So this is Titian learning to be Titian.

Ecce Homo **5** is Titian fifty years later, being himself to the max. The painting might be unfinished or it might be finished – he might have thought that at some point he was going to touch up the flames of the torch at the top left of the canvas. But while there is a lot of stuff in art books about the issue of finished and unfinished in Titian, this type of discussion is never resolvable, or even actually all that important: the loosest, roughest and mistiest Titians always have their own coherence. They've already entered the system of art. They've already affected our ability to read them as complete.

About to die, Christ is displayed to the crowds. Pilate puts the responsibility for the murder on the Jews and removes it from himself. The story is given life by the physical stuff of the paint: there's a repulsive fatness about the white of the ermine, which is a comment on the emotion of Pilate's face – the worldly man. The white on the edge of Christ's outfit is misty and intangible: it's a comment on the purity of the spiritual man – divine humility opposed to corrupt glossiness. This is a powerful rendering of a story, with painterly handling taking the meaning onto a whole new level, where the philosophical and emotional content of the narrative is given a direct, visceral expression.

Now let's look at someone non-Venetian doing religion. **6,7** Michelangelo's decorations for the Sistine Chapel in Rome tell a story too, but their expressive power is in the contours of the figures and in the heroically modelled forms: the relationship between inner form and outer contour. And in the way everything seems to inhabit the overall space so rightly and nicely, without the ceiling ever appearing to be crowded. But none of that is painterly. Michelangelo separates the colours from each other by line. Colour is balanced throughout in a charming way but it's still drawing and shading that are the essential elements and not, as with Titian – who's Michelangelo's opposite – the action of the brush.

Michelangelo doesn't put one colour next to another so there's a colour vibration, as Titian does: that's something you're only likely to pull off convincingly if you're really interested in colour, which Michelangelo clearly isn't. The difference is that you feel the figures in the Sistine Chapel could be peeled off and moved around, whereas with Titian, limbs and bodies often don't have sharply defined contours: there might be just a glow there, a sense that the body stops and something else starts, something maybe not even all that different. In Titian's *The Death of Actaeon*, **8,9** for example, the stuttering trees and foliage are like the stuttering contours of Acteon's torso. With Titian, flesh, clothes and objects are conjured up out of a lot of loose paint: they *are* the paint, and it's the paint that carries emotion.

Titian's *The Entombment* **10** isn't full of feeling because it's a sad scene, but because of the way he presents a flow of loosely brushed forms each with their own colour-texture: the red into the blue into the dead white, with its green-brown shadows. That's the painting's emotional centre, so the whole scene is

5 Titian, *Ecce Homo*

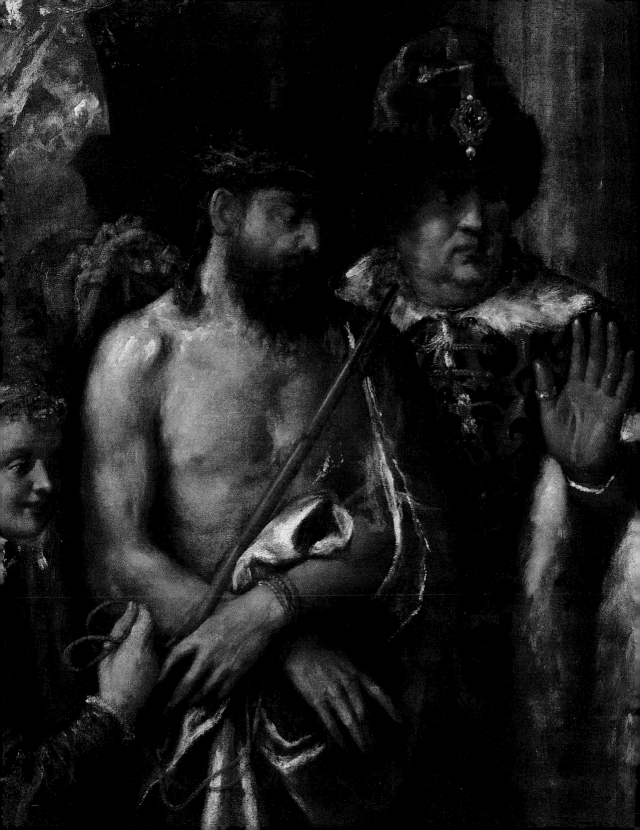

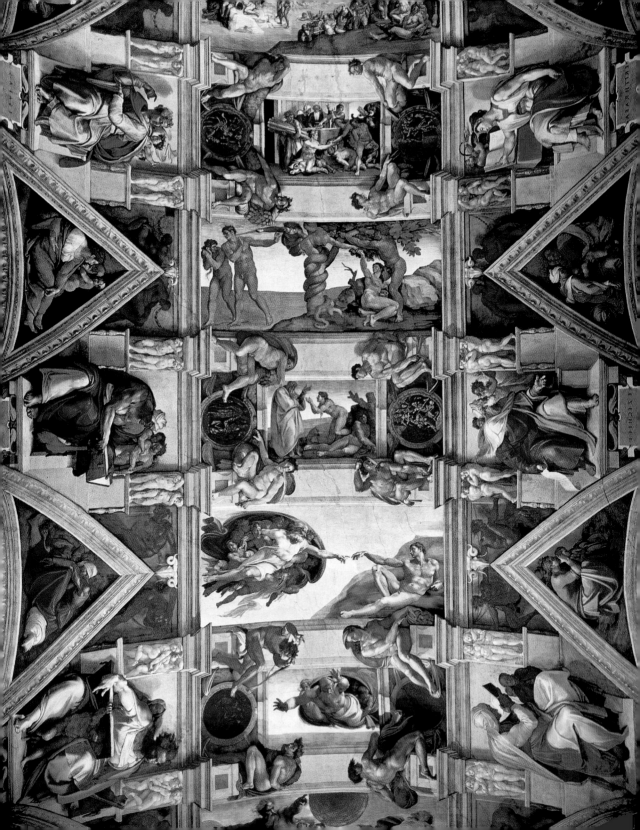

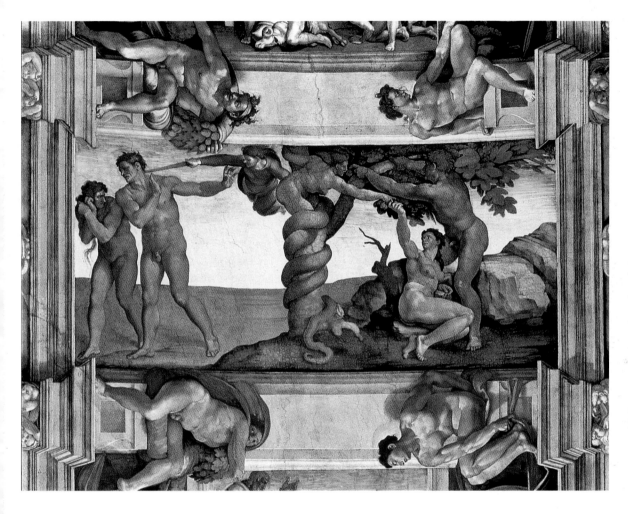

6 Michelangelo, *Sistine Chapel Ceiling*

7 Michelangelo, *Sistine Chapel Ceiling:*
The Fall of Man and the Expulsion from the Garden of Eden

8 Titian, *The Death of Actaeon*

9 Titian, *The Death of Actaeon*, detail

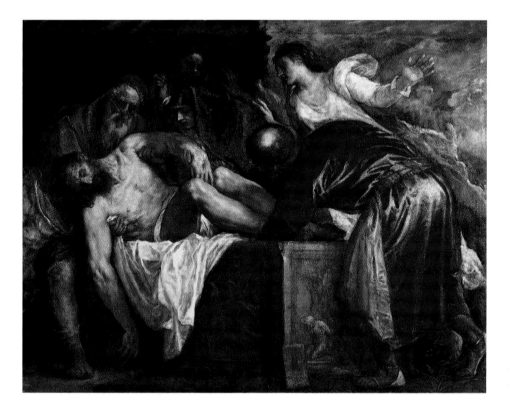

10 Titian,

The Entombment

emotional anyway, regardless of whether whoever's looking at it believes religion is real or an illusion. That passage continues what's happening in the scrawling, broken, apocalyptic sky, where automatic flicks of the wrist have made those free white marks. And the sky texture in turn is picked up and answered by the patchy white of Mary Magdalene's clothes, which is picked up again in the corpse, and then again in the different white of the shroud.

The eyes in *Tarquin and Lucretia* **11** aren't full of feeling because the woman's being raped, which is the narrative meaning: Lucretia, the wife of a Roman nobleman, is raped by Tarquin, who's had his mind a bit frazzled by the husband's boasting about the wife's appeal. The painting is intense because of the way the white in the eyes has been put on and how it connects to white throughout the painting – the texture of the silk sheets, the tear on the woman's cheek, her weirdly formless, transparent body, and the shimmer along the tip of the dagger.

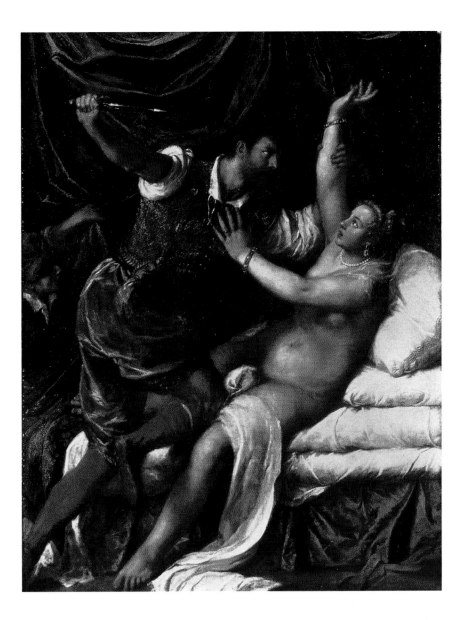

11 Titian,
Tarquin and Lucretia

Michelangelo met Titian: we have the record of his private comments after the visit: he thought Titian didn't concentrate enough on drawing, that he was a good colourist and dramatiser of a scene but he'd be a much better artist if he put more effort into drawing. It became a cliché of Renaissance thinking about art: drawing and colour, each having its separate and opposite implications – *disegno* versus *colore*. *Disegno* equals drawing and conception; while *colore* equals handling and feeling. Michelangelo is the boss of *disegno* and Titian is

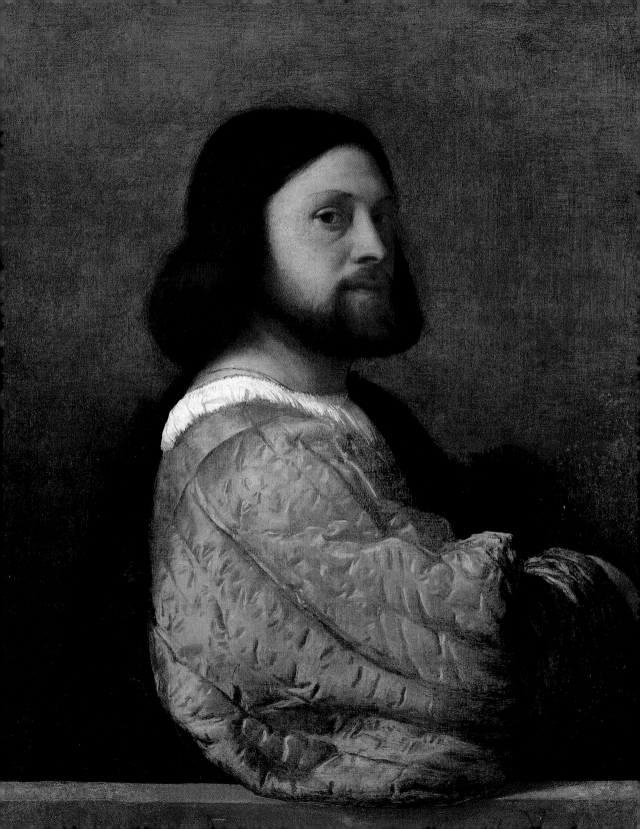

the king of *colore* – or *colorito*, the Venetian term, which actually has a slightly different meaning: colour handling, or colour manipulation, rather than merely pigment.

Titian-style colour isn't just bright colour, which is what people usually think 'colour' means in art. It's colour worked and organised and constructed, so it's doing something more than you would get if a modern designer chose some colours from a colour chart. It's producing something symphonic and harmonious out of a lot of differences, so there's a sensation of surprise and delight. This description would fit a Paul Klee or a Matisse, or a Pollock or a Rothko – which is right, because that kind of modern art, small like Klee or vast like Pollock, harks back to the sparkle and suavity of Venetian painting. So when there's a subject of solemn grandeur and heaviness and tragedy, like *Tarquin and Lucretia*, all that visual surprise and delight is in the service of the content of that scene: its psychologically conflicted nature. And the visual gorgeousness and the psychological electricity remain, even if other aspects of the scene are a bit dead for modern viewers.

Titian is a paint engineer. He gives paint the feel of different surfaces in the real world. These fabricated surfaces are always set off by one that he renders with an incredible range: the surface of flesh. If he paints that well it's because he sees it as one of the trappings of luxury. The Venetian world of power and money is all about who's got more and who's got less. Titian's flesh is opulent. It goes with oil's richness. Oil is the way to get the glitter and the lustre of the luxury stuff with which his powerful clients want to surround themselves.

Titian's *Portrait of a Man* **12** was painted in 1512, soon after Michelangelo finished the Sistine Chapel ceiling. When Rembrandt copied the pose a hundred and fifty years later he believed it was Titian's portrait of the Italian poet Ludovico Ariosto. Nowadays, since other portraits of Ariosto have come to light that don't look like this, it's considered that if it isn't a portrait of a wealthy Venetian nobleman it might be Titian's self portrait. The sophisticated colour scheme of light-blue, yellow-brown and yellow-pink, with black, white and grey, and the powerful starkness of the composition: a dark-edged pyramid within a light-filled rectangle, support and amplify the facial expression: brightly engaged, confident and intelligent. That dark eye is exactly centred between the two outer horizontal edges. If the painting does show Titian, he'd be in his early twenties. He'd be saying, 'Hey powerful guys! I've got what you want!'

12 Titian,
Portrait of a Man

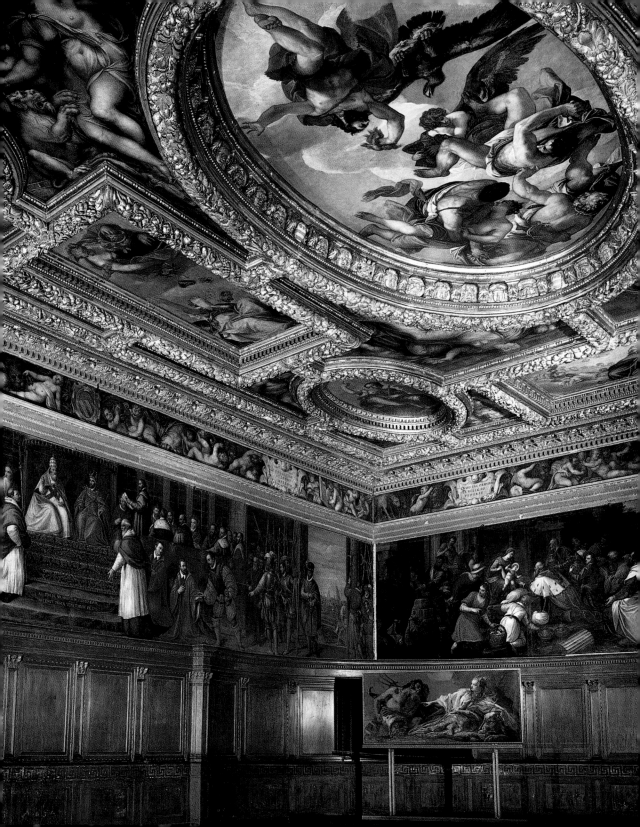

13 Veronese,

Ceiling of Doge's

Palace, Venice

14 Veronese,

Juno Showering

Venice with Gold

Luxury flesh

Renaissance people saw themselves in Titian's art: it captured existence but also amplified it. This mixture of the believable and the real with a sense of otherworldliness is also evident in the art of his younger contemporaries. Whereas Titian's output is now mostly scattered and we tend to see it outside its original context, a lot of theirs is still *in situ* in Venice **13**. So it's through them that you can get a good idea of how Titian's art originally fitted into the social world he inhabited.

The most significant of Titian's influencees are Veronese and Tintoretto. Veronese builds on Titian's decorative perfection and sense of placement, Tintoretto extends Titian's crumbly, vivid, alive style of mark-making. Veronese is always broad and calm. Tintoretto is austere, dramatic and rushing. He has a lot of scrawly emptiness, while Veronese is always voluptuous. Titian was more than thirty years older than both of them, and both in a way are Titian-ettes, since neither would be possible without his lead, and neither possesses his range.

Veronese moved to Venice in 1553 when Titian was already nearly seventy. It's possible Tintoretto might have been trained in Titian's studio as a teenager (there's a myth that Titian chucked him out because he was afraid he was too good). As with Titian the subjects they both paint are religious, mythological, and portraits, and their styles match the subjects: sensual and immediate. Subtlety and quietness are contrasted with drama; tenderness with violence, emptiness with action, greyed colour with rich explosive high colour.

Their paintings were done for the churches, monasteries and government buildings of Venice, and for private homes and palazzi: the bedrooms, private chapels and private libraries of Venetians who'd made money from trading (Venice was ruled by merchants). In its own time, this art was part of the way in which power and luxury expressed themselves. The forms of the paintings picked up and echoed the forms of the palaces where they were installed. The

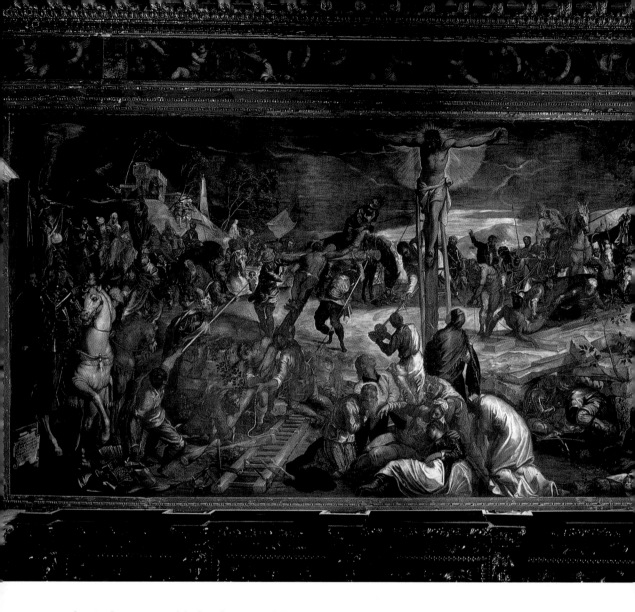

depicted scenes amplified and animated the message of serene wealth and might that the buildings were designed to convey.

Juno Showering Venice with Gold **14** is an early painting by Veronese on one of the ceilings in the Doge's palace in Venice. From room to room in this building, you pass from one visual orgy to another. The undulating surfaces and the darting play of forms, from tiny bits of carved decoration to vast marble statues, arches and balconies, and the patterned mosaic floors, vast ceilings and paintings that repeat all that visual action: this environment is all about celebrating

15 Tintoretto, *Crucifixion*

Venice's prestige. The city is frequently personified as a deity – a beautiful woman; blonde, conforming to the ideal type of the period (which on the earthly plane had to be achieved by hair dye since Venetian women tended to be dark) – who is often accompanied by other deities and who always lauds various types of civic virtue: triumph, justice, peace, and so on.

Another ceiling painting by Veronese, *The Triumph of Venice*, nine metres long, points towards Tintoretto's *Paradise*, the longest oil painting in the world. Below Paradise are the high wooden seats where the government senators sat, the central one reserved for the Doge. The impression given is that their power to make earthly laws is blessed by the divine powers above.

In this universe of luxury, luxury itself has different modes. The visual effect must always amaze, impress and seduce, but the context can be one of power or poverty. Non-patricians very rarely saw the inside of Venetian palaces, but Tintoretto's decorations for the Scuola di San Rocco, in Venice, were aimed at an audience of the poor – or at least, they express an ideal of charity toward the poor. With Veronese the poor never appear, but Tintoretto shows them getting bread and wine from the Apostles. The Scuola was a hospice where the poor and sick were tended by a brotherhood of Christian carers. Venice was always being afflicted by the plague – on average there was an outbreak every sixteen years – and plague victims came here to die. So the Venetian style can be adapted to a setting where death and suffering is the thing, but actually it's very striking in the Scuola di San Rocco, where every inch of the walls and ceiling is lined with paintings illustrating stories from the Old and New Testaments, how outrageous show-off confidence is *also* the thing.

In Tintoretto's *Crucifixion* **15** on the upper floor of the Scuola, the scene is made vivid by the organisation and nature of the colour: complex, atmospheric, full of rich darkness. All the action across a vast wall-sized area is geared around a central white ellipse. The crucifixion rises up from the centre of it. There are

groups of swaggering guys in luxury outfits either side: in armour on the left, and in turbans on the right. Behind the cross are bands of blue-grey, hazy pink and grey-brown, which set off the grey, black and rose colouring of the various groups of people and animals – mourners, labourers, soldiers playing dice, soldiers on horseback. Standing in front of this painting, the wall slightly askew from the whole building's subsidence over the centuries, the vast scene looming out at you, you think: 'So this is art, this is what it can do'.

All these paintings, their opulence, spread, richness and drama, their animating power, the way they extend and comment upon and echo and complement the places they were done for, is what Titian presides over: they're part of a kind of culture of him. Of course the culture wasn't mapped out then in the way it is for us now. No one had ever heard of museums. His audience bought his paintings to put in its own special power-places.

We're not the same as his audience. They were educated aristocrats and there were very few of them. There are millions of us. We expect democratic values and we don't expect a lot of kowtowing to social hierarchy. And connected to that, we don't expect to encounter a hierarchy of pleasure in art. We want it all to come at the same level, plus we want it all at once, and not for too long, so we can get on with other things. We don't want to put any work in. (Personally I think some of this might be a mistake!) In any case today's audience contains different levels of education, expertise and familiarity with the insides of museums, and we certainly don't have the shared symbolic order that Renaissance people had: we experience Venetian art now as tourists, a bit randomly, on holiday.

It might surprise many people to know that art books have a degree of chanciness about them too. One way to get something out of old master art that isn't just after-dinner platitudes is to read about it. But if you go in for that you'll find you're constantly coming across the same old phrases, the same cluster-shapes of facts, dates and terms, which can often seem incredibly distanced from anything real. As if what you're reading is merely something the writer believes has the sound of art writing, without the words actually possessing any urgency of meaning. (In contemporary art writing it's the same drone, just dressed in the clothes of modernity: 'She is very subversive...' instead of 'His depiction of the sumptuous brocades, damasks and silks is faultless...') So

you've got to accept a bit of struggle and effort in this self-educating process. And you'll find that even with relatively lively and alert writing on old master painting, that it's not an established, immutable reality the writer is conveying, one that he's been clear sighted enough to comprehend and is now describing for you, but only a few facts, a few re-phrased received ideas, and a little bit of new imagination.

Here's the basic story of Titian's rise. Giorgione dies of the plague in 1510, at thirty-four, and six years later Bellini dies of old age. After these convenient deaths Titian takes the lead in Venetian painting. He has already been given Bellini's former position as the city's official artist: the government awards him an annual fee for life, which is the beginning of the great wealth he eventually amasses. He sets up his own workshop in San Samuele with assistants, some of whom come from Bellini's studio. Later he moves to a much bigger place on the Biri Grande, on the Fondamenta Nuova, where he stays for the rest of his life, which is an extraordinarily long one: his professional painting career lasts over seventy years.

After his official appointment he receives more and more prestigious commissions, both from the city and also, as his fame grows, from powerful clients beyond Venice. For the last twenty-five years of his life he's on a retainer from the king of Spain, and during these years he more or less only works for this client, painting more or less whatever he likes. He travels to various cities to do commissions for the ducal families that rule them. He goes to Rome to paint portraits of the Pope and various cardinals, and he does a few mythological subjects for them, too. He goes to Bologna, Madrid and Augsberg where the Spanish kings – Charles V and then Charles V's son, Philip II – have their moveable courts. He does their portraits. When he travels it's all very formal and he has a ceremonial entourage and bodyguards, as if he's royalty himself. On the whole, though, he stays in Venice, sending his work out to countries across the world. As early as the 1520s, still in his thirties, he becomes the first modern-style, international art star.

Let's imagine him at work. He's just been summoned to a duke's palace somewhere in Italy to do some paintings, but he's doing them in Venice instead because of the models there, who all come from brothels. The duke's agent has to explain to his boss that their city has a shortage of brothels.

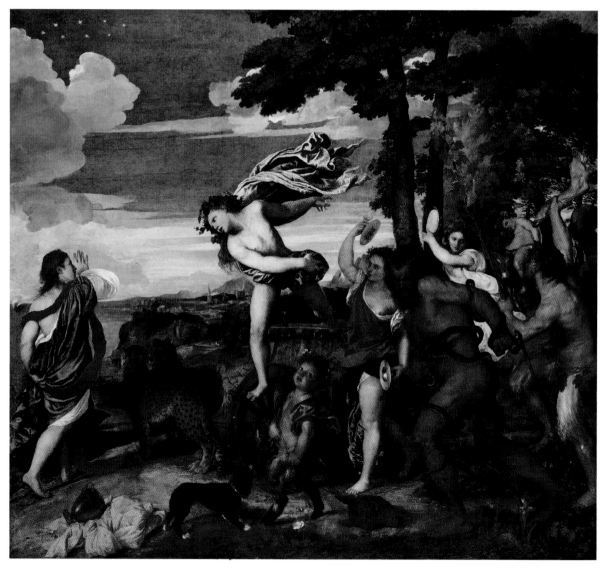

16 Titian, *Bacchus and Ariadne*

Other court agents and ambassadors are round to the studio to arrange other commissions – can Titian paint a portrait of the Doge of Venice, or the Pope in Rome, or the Emperor of Spain? Humanists lounge and pose about the studio – humanists are poets, intellectuals and scholars who know about symbolism in art. Courtiers from other cities hang on Titian's every word; myths about his greatness are arising all the time. The Emperor of Spain bends over to pick up a brush that Titian has dropped – 'Oh no, Titian, allow me!' This is from Vasari, the first art historian, who's in the studio writing Titian's biography.

Titian's assistants grind up the paint. They didn't have tubes in those days; there are just piles of pigment on tables, and pestles and mortars, and jars of linseed oil. Titian's friend, the poet Pietro Aretino, the author of sonnets that are read by anyone who's anyone in society, is in the studio writing some verses about Titian's painterly genius. He's going to read them aloud to some cardinals later: 'The light falling on the Venetian palazzo in the morning is like a brush-stroke in a painting by Tiziano!'

This would be the kind of thing that went on in Titian's studio, more or less, if not all on the same day. An old building, now a stonemasons', still standing on the Biri Grande, at the north end of Venice, is probably the exact location of Titian's studio. Now let's have a look at what he might have been working on.

Bacchus and Ariadne **16,17** shows the god Bacchus about to make love to the mortal Ariadne. It's one of a group of paintings commissioned by the Duke of Ferrara to go in a smallish room to which the duke can retire at the end of the day and show off his education, sensitivity and fashionable modernity to his friends. He wants the works to imitate descriptions of paintings that exist in ancient texts. Titian has to have a subject for these visual translations of imagined paintings, so he's given some ancient poems – translated from Latin into modern Italian so that Titian, who isn't a scholar, can understand them. One of them describes the myth of Bacchus and Ariadne: Ariadne is deserted on the shores of Naxos. Her lover Theseus departs in the distance. She's in despair, Bacchus spots her. He makes love to her and turns her into a constellation of stars.

Titian has to come up with a look for this, as no one knows what an ancient painting looks like: Titian certainly believes that none survive (Pompeii hasn't been discovered yet). He only knows about ancient sculptures. (and in fact he

bases the poses of most of these figures on casts and drawings of Roman sculptures.) All it says in the old writing is that the ancient paintings were very 'lifelike'. Titian has to get that buzz of life through composition, colour and handling – and that's what he does.

The painting is a squarish-horizontal divided into two more-or-less triangles: warm, brownish-orange colour dominates the lower right section and cool blueish colour dominates the upper left. There are invasions of one colour into the other colour area, so it all seems to lock together. The brilliant blue skirt of the maenad with the cymbals is surrounded by warm orange and brown and by brown-green and pale yellow-brown. Tiny pale blue flowers in the corner of the painting are surrounded by different greens: dark, warm, yellow-brown and tawny-brown. And the light pink-brown figure of Bacchus with its white-red cloak and warm brown hair is surrounded by blue. The richest human-drama bit of the scene is the right-to-centre rush of Bacchus's followers: the snake wrestler, maenads and little satyr. They're all tearing wild animals apart, because that's what you do in a Bacchanalian frenzy. Then there's the vertical cut through the diagonal rush made by Bacchus. He leaps and the cymbals strike, and that's the instant of Bacchus's love for Ariadne – which is what the painting's about.

This is all Titian's own visual invention. He's made it up. It's based on a few lines of old poems and descriptions of old paintings. But he's come up with something that's visually entirely new. The story is what the painting is about but the goodness of the painting doesn't depend at all on you knowing the story.

17 Titian,

Bacchus and Ariadne,

detail

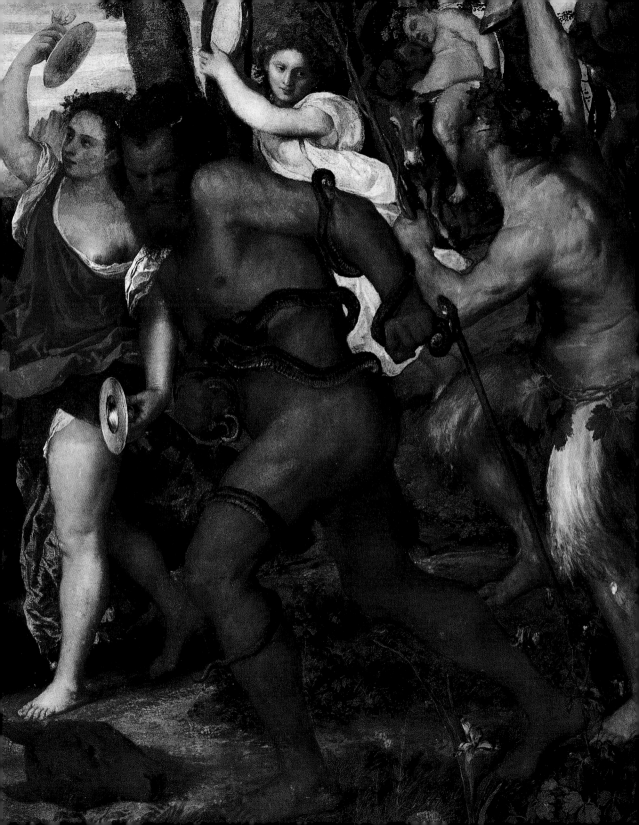

Lazy languorous female flesh

Titian's *Venus of Urbino* **18,19** was painted about fifteen years after *Bacchus and Ariadne*. The main colours are green, white, red and grey. These set off the flesh colour of the nude, making it seem very warm. There's a lot of enjoyable echoing and rhyming: the flower pattern on the mattress comments on the flowers the woman holds; the angular pattern on the marble floor comments on the whole painting's angular design. Sheet, dog, petals, flesh and hair all have their own individually fabricated textures. Everything's calm, ordered and delicious.

Women, what do you think: does this painting empower you or freak you out? There are conflicting theories about that. 'Venus' always means love but Titian didn't give the painting this title, Vasari did, ten years after it was finished. Paintings of anonymous beauties had been a convention in Venetian art since the 1510s. They tended to be given titles like Flora or Venus in later centuries. No one knows what their original titles were if they even had any, or why they were painted or in most cases for whom. The Venus of Urbino isn't wholly in that tradition because of the non-mythological surroundings: a room in a country palace (there are trees out the window) with servants in the background. This is the only modern domestic interior Titian ever painted.

The model was very likely a prostitute. According to records there were eleven thousand in Venice when this was painted. Given the city's population of about 170,000, that meant the ratio of prostitutes to male Venetians was about 1:15. A courtesan was high-class, distinguished from a *meretrice* (mere prostitute) and *puttana* (street whore). Courtesans often owned their own homes, and were sometimes famous. There are records of some of their names and characteristics: Lucrezia Scquarcia, who wrote poetry (supposedly, it was 'bad'); Vienna Rizi Stellina ('only fifteen'); and Lucia dagli Alberi ('beautiful and well-born').

Titian himself hardly figures in all this contextualising. Traditionally we're supposed to think of him as a sexy guy. He's imagined to have slept with all his models; or they're all the same woman, his secret mistress – and she's the daughter of Palma Vecchio. The Palma Vecchio stuff is untrue, since this artist, one of the painters who produced portraits of unknown Venetian sexpots, didn't have a daughter. In fact Titian was married with three children: Lavinia, Orazio and Pomponio. Letters and contemporary accounts suggest he was devoted to his wife.

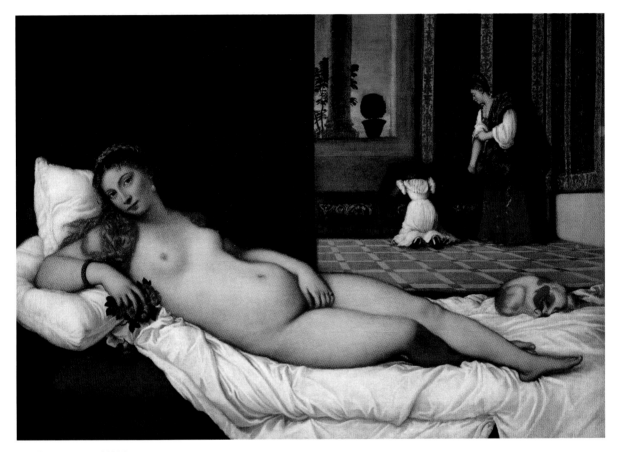

18 Titian, *Venus of Urbino*

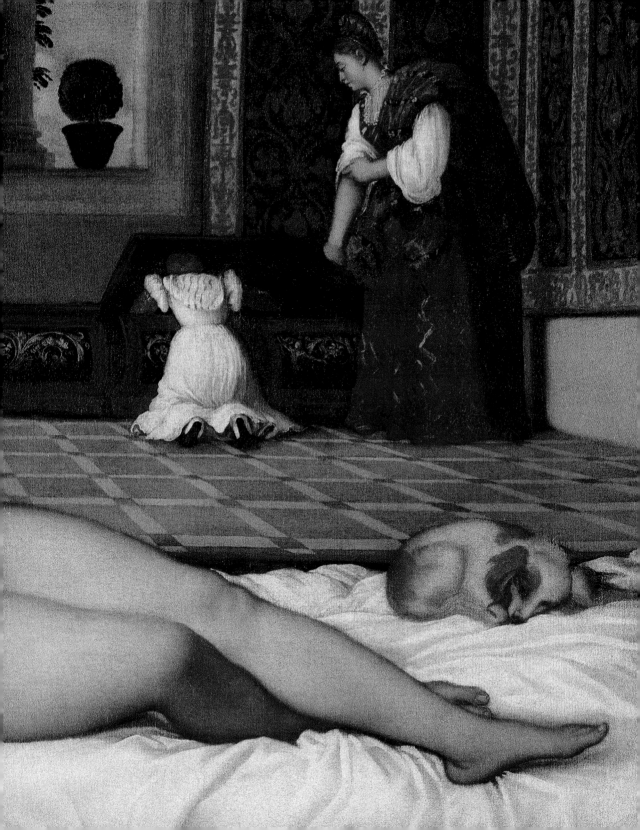

We know he employed prostitutes as models, which was common for artists in Venice. We even know what kind of rates they received: ten *soldi*, for being drawn nude, and twelve if it was to undress only to be stared at – compared to eight *soldi* if you were a male beggar off the street, hired to pose as a saint, say. But we don't know anything about a secret sex life that Titian might have led. And even if he did use a courtesan as a model, it doesn't mean the *Venus of Urbino* is a representation of a courtesan, any more than a painting that uses a beggar to pose as a saint represents a beggar.

19 Titian, *Venus of Urbino*, detail

At this moment the agreed symbolism of the *Venus of Urbino* is in the process of changing from one meaning to another. Paintings' meanings change all the time. You can have an eye for how they look: in this case, the delightful dream-like disunity of the fictional space, and the lovely geometric unity of the shapes and the colours. Everything fits visually, even though the standing servant is much too tall for the logic of the perspective, and also the green curtain suddenly breaks off in a surreal way in the centre of the painting, cutting the scene in two. And you can enjoy what seems to be a bit of Freudian symbolism – the line of the edge of the curtain leading directly to the part of the body that maybe the whole painting is really about. But you'll always only be a prisoner of whatever is in the air at the time: intellectual fashion and ideas in art history. You'll never have all the answers to what it is you're really looking at.

It's from art history that we get meanings in art, but art history isn't the Bible, or even the *Highway Code* – you've got to challenge it, not unquestioningly believe in it all the time. Until recently art history assumed that Titian's *Venus* was light porn, a way of having sexy female nudity in art by imbuing it with a bit of respectable ancient mythological symbolism: 'Venus, goddess of love!' (False swoon!) We're supposed to think that the respectable ideal was invoked but that no one was fooled, that they knew what it was they were seeing.

Art history as a discipline, as opposed to just chronicles of great artists' lives, was begun by some German guys in the eighteenth century. The main ideas were set up: categories, styles, movements and isms. From the ideas followed assumptions and attitudes. These changed as the conditions that art was made in changed – as society changed. The way the art of the past was understood changed too.

Manet's *Olympia* **20**, painted in Paris in 1863, and shown in a huge public

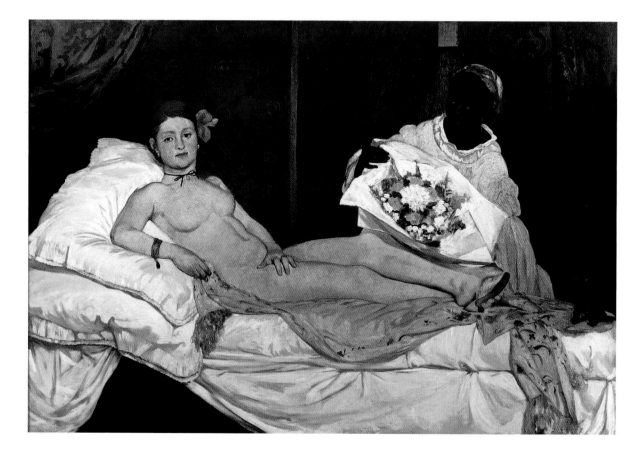

exhibition two years later, was both a sincere homage to the three-hundred-year-old *Venus of Urbino*, and an attack on the cult of it within academic art circles in Manet's own time. With *Olympia*, respectability is taken away and the shock of sex is put back. Manet wants to liberate the tradition of painting, not sex, but he uses an obvious sign of sexual scandal as the vehicle of liberation. His nude definitely is a prostitute in a brothel – that's the set-up. The little cat graphically represents what the woman's hand conceals. The broad roughness of the handling and the brazenness of the brothel setting show Manet wanting to get painting back into gear, to rev up the great tradition again, to make it strong instead of twee, which it had become in the hands of the straights of Manet's time. He makes explicit what academic artists of the nineteenth century, who painted nudes based on the *Venus* tradition were coy about: their mythological nudes

20 Edouard Manet, *Olympia*

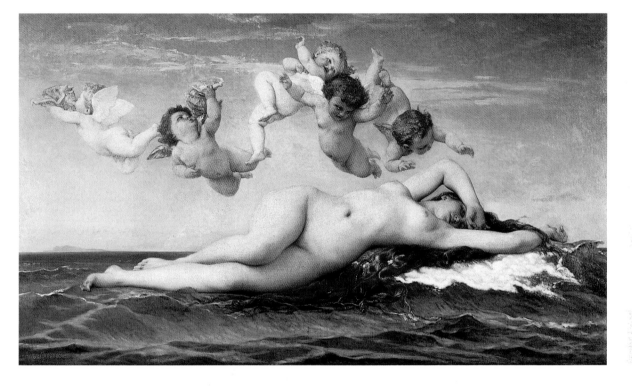

21 Alexandre Cabanel,
The Birth of Venus

were bad. Not because they were anachronisms: Titian's ancient gods and god-desses are that, too, but because they make you ill to look at them.

Alexandre Cabanel's *The Birth of Venus* **21**, from the same year *Olympia* was painted, represents the official taste of that era: a gruesome sweet smoothness, hideous as art, but exciting as an idea for the academic mindset of the time. Pol-ished bright nudity is right there to stare at, with nothing challenging going on.

Olympia explodes all this: Manet's painting is exciting because the paint is aggressive and the psychological complexity of the whole situation is deliber-ately exposed. That's why he's a good artist. Of course at the time it was just baffling because Manet hadn't changed anything yet, and Olympia was just an anti-force not yet a posi-force.

Olympia is bigger than the painting it's based on: it seems twice the size, but in

fact it's a little under that. The colours are colder, and the tone of feeling is harder. The *Venus of Urbino* aims to seduce on every level, but in *Olympia* the cartoon cat is a mocking joke, and it's clear that the target of the sarcasm is the painting's audience, its idea of what a picture should be.

In the *Venus* there's a couple of servants in the background, one of them opening a chest. In *Olympia* there's only one servant, a black woman who shares the main space of the painting with Olympia. The bunch of flowers she presents to Olympia is an enormous flamboyant bouquet, presumably delivered by the client, who's just arrived, and whom Olympia's now looking at. The shape and colours of the bouquet and the servant are a counterpoint to Olympia's shape: they each make up two triangles, about equal in area. But the servant and flowers have complicated dramatic expressive handling, while the figure of Olympia is comparatively flat. This is counterbalanced again by her being the dramatic focus of the whole scene.

22 Titian, *Venus of Urbino*, detail

In the twentieth century, Titian's *Venus* was always seen in the light of *Olympia*: as a pre-modern art sex bomb waiting to go off. *Olympia* was a shocker when it was first shown in Paris. The subject was the first bit of the scandal: she's a prostitute! The treatment came next: he can't paint! She's got no bones! But hardly any critics who complained about it noticed that it referred to Titian. Those who did acknowledged the sophistication of the reference but thought Manet was just playing a game with it, employing sophistication in order to be crude. You can just hear the critical cries: 'We know your references! We don't care! We are sophisticated, too!'

Manet provides a modern context for an ancient tradition: the sensual handling of materials. So Olympia has a lot of eye-catching intricate pattern but in a different way to Titian. The vigour of the loose brush strokes that form the sheets, flowers and figures in *Olympia*, is much more aggressive than Titian because the painting's got a different aim to accomplish: it continues a tradition but it's also the beginning of a new one, the tradition of shocks. This is the tradition of the avant-garde, where artists want to shake everything up, and a scandal is right for that. The legacy of Olympia is Tracey Emin's unmade bed in the Turner Prize: both are very frank about sexuality. Of course that's to leave out the painterly thing that Manet does, but that's what the upside-down official avant-garde art of now does, it leaves that

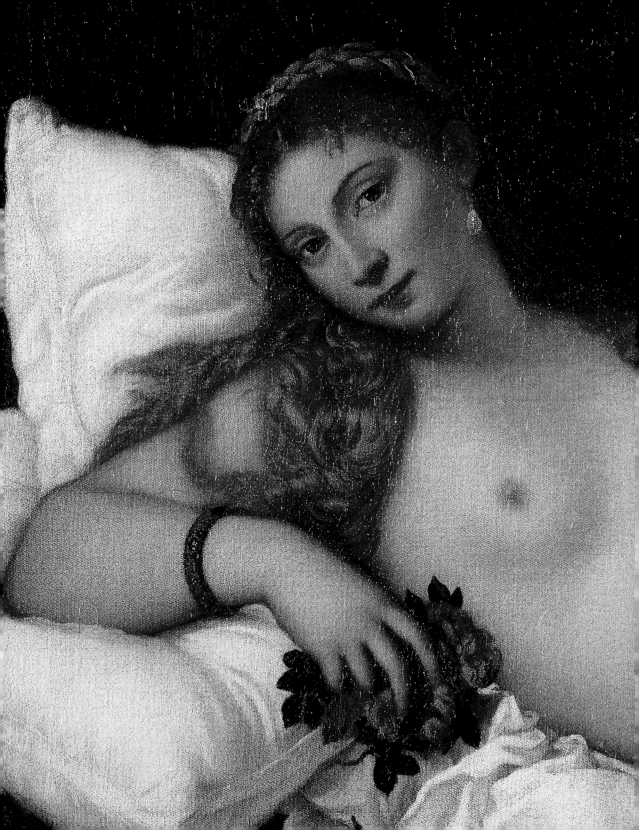

painterly thing out.

As more is learned about Renaissance society, it turns out that at the time it was painted, Titian's *Venus* probably had a respectable meaning. It was bought in 1538 by Guidobaldo II della Rovere, who was Duke of Camerino at that point. A few months after he made this purchase his father died, leaving the son his title, Duke of Urbino. The painting was picked up from Titian's studio by the duke's agent in Venice: the first record of its existence is a letter to the agent from the duke, instructing him to pick up two paintings from Titian, one of them a portrait of the duke and the other a painting of 'a nude woman'. The '*Venus*' bit of the present title comes from Vasari, who provides the next mention of the painting. He saw it in the duke's palace at Pesaro, and twenty years after that sighting, in the second edition of *Lives of the Artists* he records his impression: 'a young Venus reclining ... holding flowers ... very beautiful and well finished'.

23 Titian, *Venus of Urbino*, detail

What enables Vasari to identify the figure as a Venus is her pose, which mostly conforms to the traditional look of the goddess of love. But while the hands and arms are in the conventional position of modesty, the expression on the face is not demure, eyes cast down – but alert, looking out. And there isn't a Cupid on the scene, and no paradisal landscape. The atmosphere may be dreamy, but the setting is recognisably modern. This absence of many of the traditional attributes of Venus and the presence of ordinary bedroom paraphernalia, is the reason why it's been assumed over the years that she wasn't painted to seem like a goddess but merely to seem sexy. But maybe that's wrong.

24 Titian, *Venus of Urbino*, detail

Recently the idea has come up in art history studies that rather than describing what it might be like for a rich client to visit a prostitute, the painting actually celebrates marriage. Guidobaldo bought the painting when he was twenty-four. He'd been married for four years. His wife still wasn't quite fourteen, which would have made her ten years old at the time they married. This is bad for modern times and makes us cross but in the sixteenth century betrothal at ten wasn't unusual, and there was a whole system of propriety

and customs that went with it – although, yes, in the end, it was a misogynist time. But the Venus still might not be a misogynist or even demeaning-to-women painting.

She isn't necessarily reduced to a mere object. In fact she confidently returns our look with her look **22**. Roses stood for love **23**; a myrtle plant had the same symbolism, because it's always blooming **24**. They may both suggest sex but what about the dog? Titian had already painted portraits of the duke's parents: in the one of his mother the same dog appears. Dogs stand for carnal desire **25** but also for fidelity. This one is pretty small. Maybe it's Titian's pet. Maybe it just kept walking into his paintings. But that's unlikely in a world of constant alertness to the symbolic potential of everything, which is what the Renaissance world is. Nothing in paintings just happens, it always means something, and the dog in this painting isn't barking, so whoever the woman's looking at isn't a stranger: why shouldn't it be a husband?

25 Titian, *Venus of Urbino*, detail

In fact, the Venus is probably nothing so literal as a real prostitute or a real wife, but a principle, an ideal. The chests in the background would be associated for a Renaissance viewer with marriage: it was the custom in upper-class life to give pairs of wooden chests as a wedding gift. They would have had noble scenes from classical literature carved on the outside, and inside the lid would be scenes of Venus and love. Titian himself painted chests like these when he was young. The *Venus of Urbine* is likely to be a painting-on-canvas version of a scene painted inside a marriage chest, demonstrating the place of sexual love in matrimony. The principles of duty and pleasure are combined, and there is a certain sexual slant, and although it would all have been fresh and new, it would have made sense to Renaissance people.

The main elements of this interpretation of the *Venus of Urbino* go back to scholarship from Manet's time: it was because of his *Olympia* that research was done that dug up the new information. But it's only in our time that these researches began to be taken seriously. The news wasn't considered sexy enough before. When you're living through a period when everyone shares one belief about art, it's hard to believe it's ever going to be replaced by another, even though experience shows that it will be. But what makes Titian always exciting, like the myrtle plant always

blooming, isn't facts about mythology and prostitutes, which is all for Planet Scholarship anyway, but what Titian does with paint. The flesh Titian paints is seductive not because flesh is always like that, but because he paints it like that.

Decayed flesh

Titian's 1548 portrait of Charles V **26** can be seen today in the Pinakothek in Munich, next to another painting by him from about ten years later of Jesus being tortured before being crucified, *The Crowning with Thorns* **27**. One is about magnificently understated earthly power; the other is about the mystery of existence.

As a Renaissance Catholic, Titian would have believed in the duality of light and dark, that existence is made up of opposites. As an artist, however, he mixes things up. Imagine two information patterns overlaid and each telling you the opposite thing. One is about playfulness, invention and love: the love of texture, paint and the weave of the canvas. The other is about torment, darkness and death: a profound questioning of everything positive. This contradiction is what a late Titian is like. All his confidence, ease and daring bravery – putting paint on however he likes – is now in the service of an image of doubt and anxiety. As his viewers, we can accept that we, too, mix modes: passionate belief, because these paintings

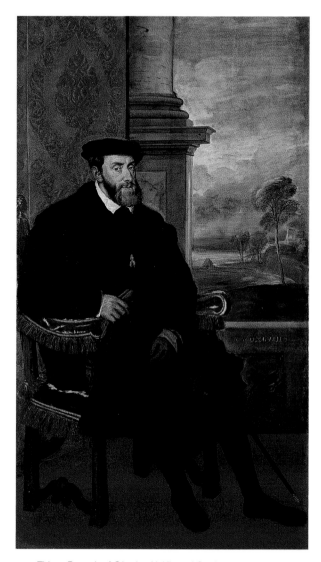

26 Titian, *Portrait of Charles V, King of Spain*

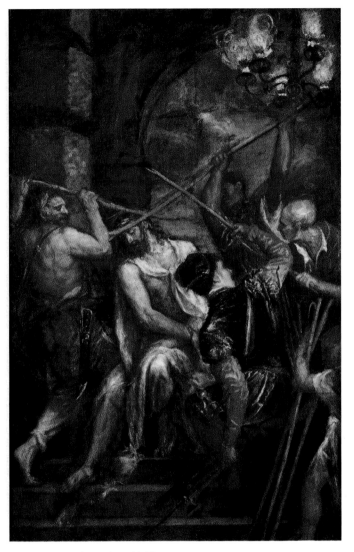

27 Titian, *The Crowning with Thorns*

are fantastic, but also scepticism, because we're modern and restless – we want to think and find things out for ourselves.

We assume artists were all more sincere in those days. Why not think instead that they did it for the money, since after all they did? You could be both great and kind of straight: these weren't opposites in the way that modernists assume they should be. Titian pushed his career by taking the right commissions and getting the right introductions. By the time he was in his late forties and had painted the *Venus of Urbino*, he'd been world famous for two decades. The Duke of Urbino knew about him because he'd painted the portraits of his parents – other dukes whose portraits he'd done introduced him to them. In fact, portraits were the main reason for his rise to international fame: through a kind of portrait chain he was introduced to the Duke of Ferrara, who introduced him to the Duke of Mantua, who brought him – some time toward the end of the 1520s – to the attention of Charles V.

By 1530 he'd painted his first portrait of Charles V and by 1533, the year of the King's coronation as Emperor, he'd done more: and by

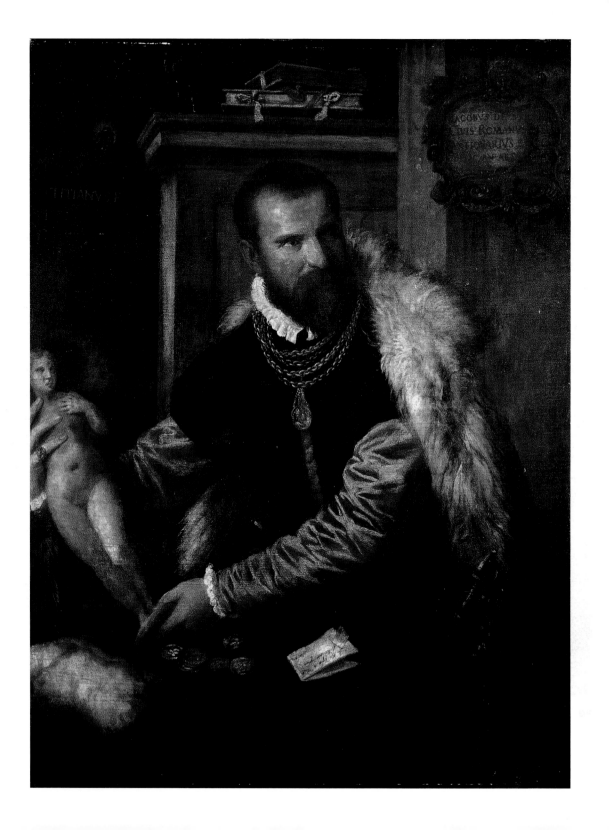

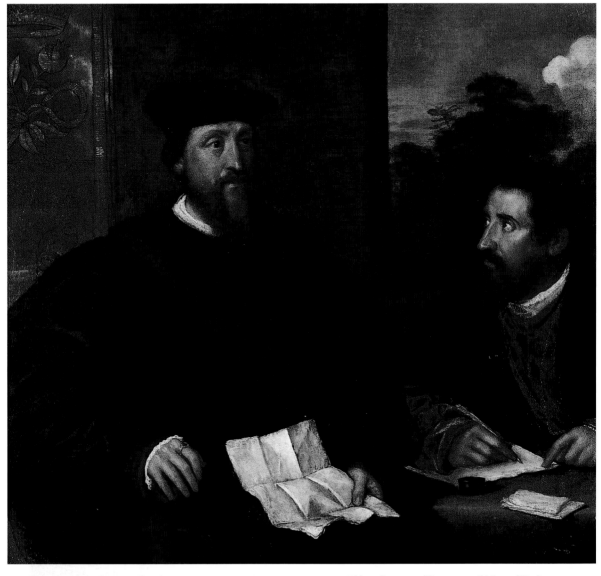

28 Titian, *Portrait of Jacopo Strada*

29 Titian, *Georges d'Armagnac, Bishop of Rodez, with his Secretary Guillaume Philandrier*

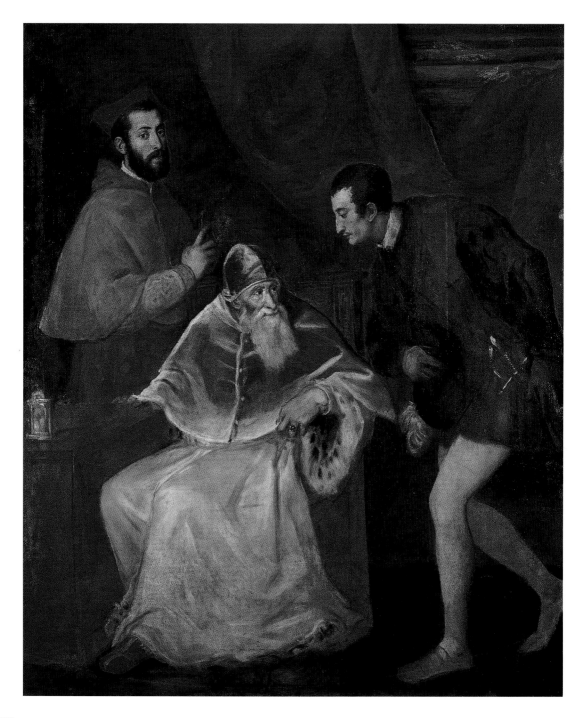

now the Emperor was calling him his friend, had made him a count and given him and his sons lifetime bursaries. Spain ruled much of Europe, including parts of Italy. The Pope's power in Rome was secondary to that of the Emperor, whose mercenaries had sacked the city in 1527. Becoming the Emperor's friend, then, was a shrewd piece of manipulation on Titian's part.

Portraits were a currency for Titian **28**, they brought him power – but he also brought something radical and new to them. Before Titian, they tended to be about half the size that he painted them, rigid, often in profile: the idea was to make them seem like an image on a coin, an emblem of the sitter's status. But with him the hands are in, there's often a dynamic three-quarters view, and there's a lot of suggested movement. The face is expressive. The lifelike quality, the atmosphere and feeling of the whole thing: the psychological depth: these all come from his formal innovations and from the restlessness of his paint. It's hard to appreciate now how new all this was when Titian did it, because these qualities remained current in portrait painting right up to modern art, so we assume they've always been there – but it was Titian who made them into the accepted norm rather than occasional aberrations from the norm.

In Titian's *Georges d'Armagnac, Bishop of Rodez, with his secretary Guillaume Philandrier* **29**, from the end of the 1530s, there are undefined spaces, where he's just blocked in colours. Then there's the thing in each block that tells you what's there: a cloud tells you about the sky; a piece of paper on a table tells you about the surface of that table. A hand on the edge of a chair tells you about the chair, which would otherwise just be brownish texture. A fall of light tells you about a decorated panel. He blocks in an area and then gives it animation and believability with a few carefully placed bits of detail. The impression is that this high level of detail is equal everywhere, but in fact it's not.

In Titian's portrait of the Pope with his two grandsons **30**, the Pope sinks into his own old body. The young men are sleek and fresh. They might all be plotting against each other: the pious gesture of one grandson might be false, and the other grandson might be warning against hypocrisy. There might be a metaphor for secret intrigues in the interwoven composition of the bodies and limbs, and in the way the three different gazes direct your eye around the space. But even if any of that were really intended, it would still be part of the reason why the painting was commissioned in the first place and why it was thought to

30 Titian, *Portrait of Pope Paul III with his grandsons*

be a success by the client: to vividly convey a sense of dynastic power; to serve the aims of power, not to undermine them by slyly analysing and dissecting them and serving them up in deconstructed pieces. From his earliest years, there was a natural alliance in Titian's psychology between, on the one hand, being an operator with an eye for the main chance, and on the other, having an inventive and original creative imagination.

When he was still in his thirties he painted the *Assumption of the Virgin Mary* **31** for the Church of Santa Maria Gloriosa dei Frari – or the Frari, as it's known. He finished it in 1518. He accepted the commission for a low fee, not because he was pious but because he saw it as a good opportunity to advertise his skills: he was a bourgeois businessman and he never forgot about the business side of what he did. When he was knighted by Charles V fifteen years later the significance for him wasn't so much that he had achieved nobility, it was that he'd become incredibly successful: he could now get sales all over the world. That's what being an artist then involved, being creatively independent, but still subscribing to the values of the Church and kings. Not being alienated from them but rolling along with them.

31 Titian, *Assumption of the Virgin Mary*

The trendy idea of art today is a mixture of amusing unhinged anything goes stuff and a moralising idea of the artist's exalted role as rebel-outsider. For all our twenty-first century daftness, we're still a bit unconsciously driven by the ideals that drove the Abstract Expressionists in the 1950s: they wanted not to be seductive but to be high-minded. In the back of our minds this remains the model of art: mere loveliness seems wrong as an aim. But in the philosophy of Venetian painting being seductive goes with being high-minded not against it: the Abstract Expressionists are 1950s people not 1550s. They think painting is in a war with society: it's going to tell society off. But Venetian painters think society is great. For one thing there's hardly anybody in it, just a handful of humanists and dukes and courtiers, and some genius artists.

In his late middle-age Titian was known as the most artistically daring and inventive artist there'd ever been **32**, as well as the richest. He had money flowing in from government leaders, Church people, aristocrats and royalty all over the world. He could paint what he liked. He ran a lot of different commercial enterprises in partnership with his son, Orazio, including a timber business. He

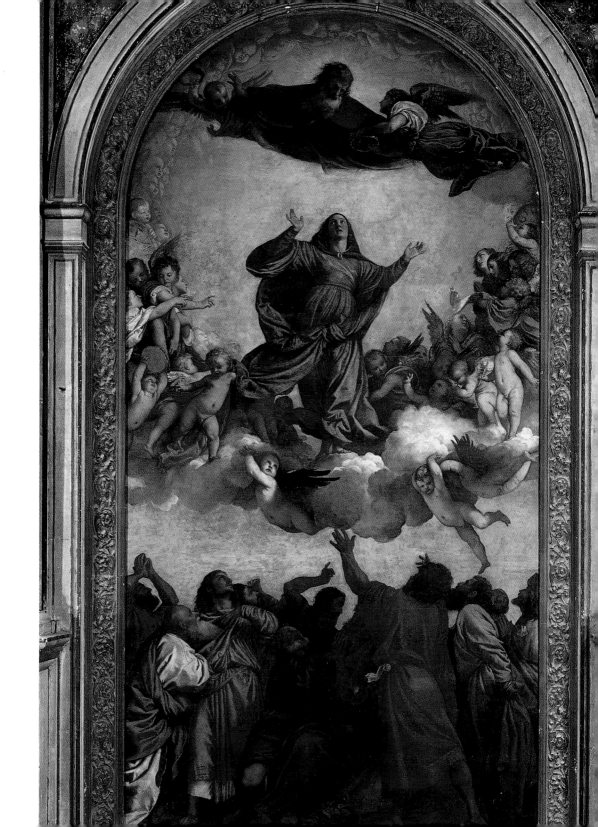

called the shots at every point. But in his very late paintings, the arc of his story seems to curve steeply downwards: having achieved the highest position, he now journeys into his own inner darkness. He's not a glossy hedonist any more, but a restless disturber of luxury: he questions life's pleasures instead of celebrating them. The flesh in his paintings seems diseased, and his colour wavers from rich and brilliant to slightly decaying.

Nothing is known of Titian's thoughts about *The Flaying of Marsyas* **33**, which he was probably still working on when he died. The first impressions are of a single colour-texture – a broken-up, blackish, yellowy-tawny grey – and at the same time several points of strange and revolting dramatic interest. The latter include two men skinning another man, with the skinned man's body upside down. The knives are small and sharp. We see their size clearly and imagine the sharpness: we see the skin coming away below the left armpit, like clothing. It's not completely clear whether the torso has already been mostly skinned, and we're seeing all raw flesh, or whether only a couple of cuts have been made and the rest is still to come.

Points of red become apparent throughout the picture: the faded red cloth binding the satyr and his pipes to the tree; the blood on the ground and running down the main satyr's arm; the faded red of the main skinner's boots; an alizarin-crimson cloak, and a purple-blue-grey cloak. All these reds and variations on red find a lovely rich counterpoint in patches of blue-grey or black darkness.

The skinned man is actually a satyr. We see his goat legs: the right one is bound. Another satyr stands amazed or horrified, carrying a bucket. We assume it's for the blood. At the bottom of the painting a little dog actually laps up fresh blood. A king looks thoughtfully at the torture, while somebody else plays a lyre. A child-satyr, or satyr-kid, stands with another dog. The dog looks at what's going on, while the kid looks out at the audience, with an expression that could be curiosity, anxiety, joy or ecstasy. The only other face turned to the audience is that of the skinned upside-down satyr. It's young and smooth. As well as the glinting highlight in the eye there are other points of relative clarity throughout the blurry scene: the hands with knives; the glistening metal rivets on the wooden bucket; the head of the king, the crimson folds of his cloak and his golden crown; the shoulder of the foreground skinner; the blueish-pink

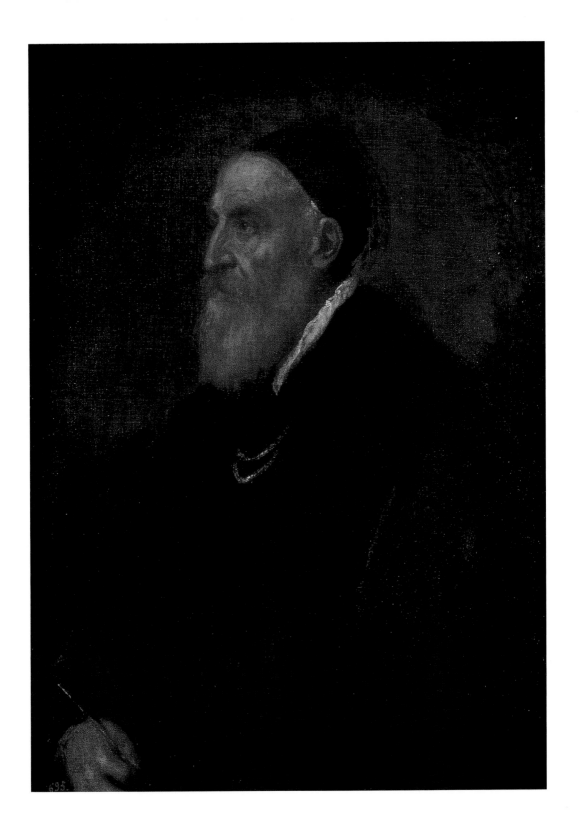

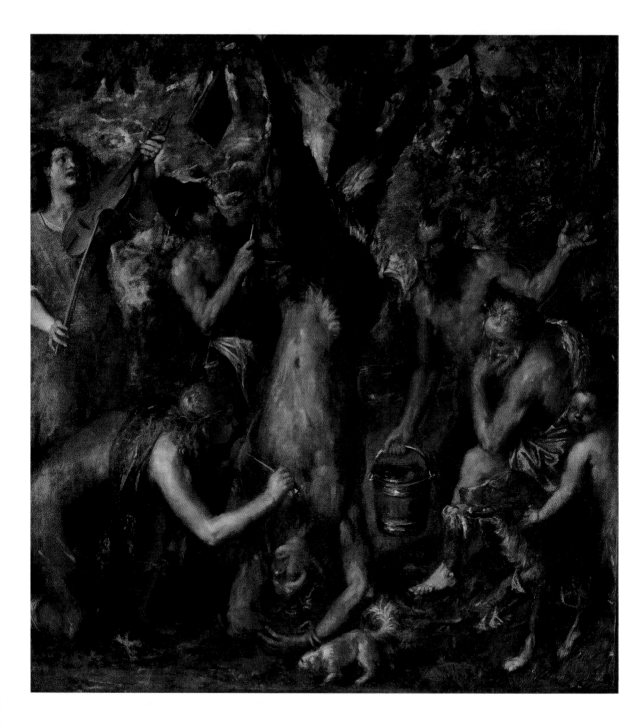

33 Titian,

The Flaying of Marsyas

clothing of the lyre-player; the black hat of the second flayer, and the animal-like face of the second satyr.

No figure is completely formed. Each seems to emerge from a fuzzy smokiness or to be sinking back into it, just as the entire scene appears to be made of hazy wisps. You see the feathery white strokes that describe the hair on the body of the skinned satyr, and from which the atmosphere or the air is also rendered. Mysteriously and horribly this depicted atmosphere seems to match the solid forms in weight and to be a kind of form in itself.

This is all to take the picture pretty much on direct visual terms without the benefit of detailed background information. Now let's look at it in the light of some of the few things that are known about it. It's likely it was done for Philip II. The same subject was painted by Giulio Romano, a friend of Titian's. Titian probably owned one of Romano's initial drawings **34**. The sadism in the Romano has a graphic sexual aspect – hey, these guys are perverts! But through his painterly treatment of the scene Titian raises up all Romano's cross-currents of torture, bestiality and music, which are already pretty interesting and makes them into something magnificent.

There are two conceptually interconnected surfaces: the real surface of the painting and the pictured surface of flesh. The painting seems to be all surface, as if the churning of it is a metaphor for the skinning alive that's going on, or *vice versa*. The story is from Ovid's *Metamorphoses*: Marsyas, a satyr, loses a musical competition with the god, Apollo, and the agreement is that whoever wins can do what he likes with the loser, so Apollo has Marsyas skinned alive. Apollo stands for reason and the mind and Marsyas stands for the body and sensuality. The foreground skinner and the lyre-player are probably both Apollo. In the legend, the theme is mind's triumph over body. Titian paints himself into the legend: it's his features on the old king – this is Midas, who like Marsyas was punished by Apollo for the crime of faulty judgement **35**. The expression is philosophical and the pose of the body suggests fascinated concentration.

Because the physical substance of the painting is so dominant, physicality itself might be the element Titian is questioning, as if at the end of his days when he's nearly a hundred – or maybe more than that, since no one knows how old he really was – he's doubting the worth of his own immediate, sensual, physical type of painting. A type of painting often done with the fingers more than

34 Giulio Romano,
*Apollo Flaying
Marsyas*

35 Titian,
*The Flaying
of Marsyas*, detail

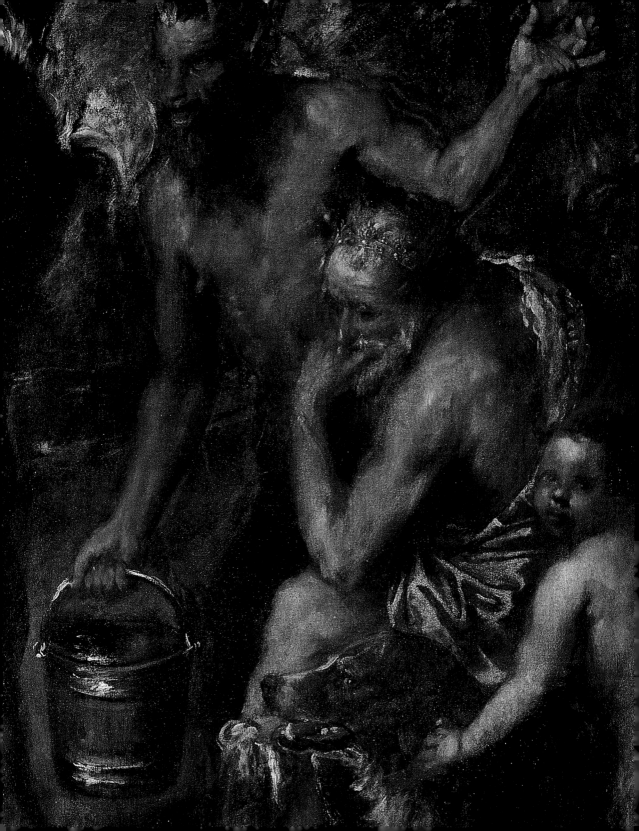

brushes, and which at all stages involved dripping, smearing and dragging paint. Because of the sombre mood, the impression is that the tone of the questioning is despairing. But because Titian himself has created the mood, and with such compelling force, we read it as triumph. I think it only does paintings a disservice to revere them too much, but now and then one like this comes along that really does make your hair stand on end.

Titian's last assistant, Palma Giovane, reports that Titian's technique was to paint rapidly, turn the painting away, work on other things, and then after weeks or months turn it round again and paint rapidly again: so he was really painting both fast and slowly. Whenever he turned it round to work on it again, he looked at what he'd done 'as if it was his mortal enemy'. He never painted figures in one go, but in patches, like a surgeon correcting deformities: a bulge in an arm or a wrongly turned foot.

The hidden subject of Titian's *Pietà* **36**, another painting he worked on right up until his death, is likely actually to have been his own death. A *pietà* is a traditional scene showing the Virgin Mary lamenting the death of Christ. In this version of it, when you look into the body of Christ, there's no real anatomy: the right arm is just a spectral presence, and the whole painting has a look of mashed cobwebs. You see crumbled thick white paint; and massive seams running across the surface, where several different canvases have been sewn together. Each is a different weave and thickness, and X-rays reveal that one even has a different painting under the over-painting.

It's now 1576: Titian is extremely old. He's probably been working on the *Pietà* for several years. His wife has been dead for twenty-five years and his sister and daughter are dead. In the last few months an outbreak of plague has hit Venice. When it first occurs he starts twisting the traditional subject of the paint-ing, making it into an invocation to the power of the Church to be spared death. He begins to complicate the traditional symbolism with autobiography. The arch recalls the typical shape of the altarpieces of Bellini, Titian's teacher. The golden mosaic in the cupola recalls the decorations of Venice, Titian's city. The sculp-tures on either side recall his rival in Rome, Michelangelo, long dead. There's emptiness, yards of it, like death, countered by significant detail, such as the little canvas that Titian has painted leaning at the bottom of one of the statues. In this painting of a painting, the kneeling, gesturing figures in the bottom right

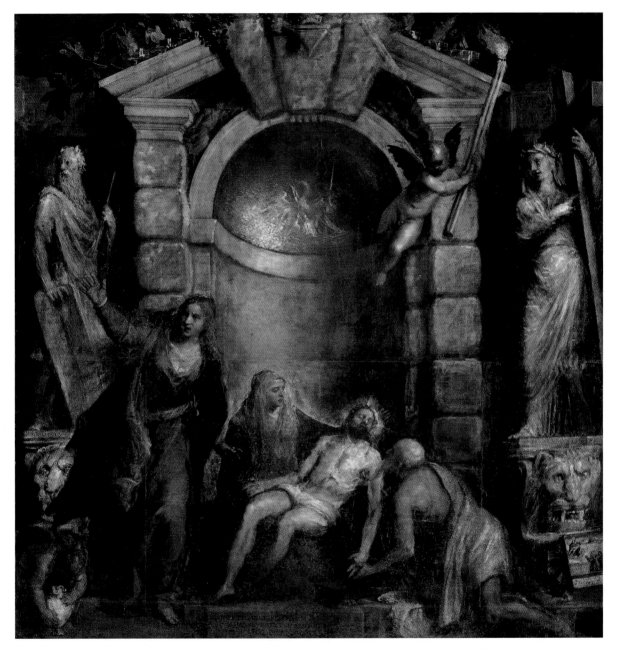

36 Titian, *Pietà*

OVERLEAF **37** Titian, *Pietà*, detail

are Titian and his son, Orazio, praying to the figures at the top left, the Virgin Mary with the dead Christ in her lap. Your eye is led upwards diagonally from that little scene to Titian, Christ, the Virgin Mary and Mary Magdalene – the reformed sinner, wildly grieving – and out to the whole vast scene. A scene of memory: Titian's life as an artist, devotion, his belief in the afterlife, and prayer, which is the message of this painting – 'Save us!' **37**

With these last paintings in which he gives himself significant walk-on parts, Titian looks back on his own story: the wrangling and power-broking, the inspired creative leaps and breakthroughs, and he appears to see it in a cloud of doubt: the beauty and light of his paintings versus his own fading light. When he started painting the *Pietà* it was intended for the Frari, the church that commissioned the *Assumption of the Virgin Mary* from him when he was young. He'd done all the work on the *Assumption* in a special studio set up in the church. It took two years. The friars considered the painting a nightmare. They'd never seen anything like it before. They thought the figures were much too big and they kept bothering him to make them smaller. Then when he finished it, with its blazing light and towering forms, it was considered an amazing success and it marked the beginning of Titian's great rise in Venice. Now, in his old age, he'd decided to make a deal with the Frari to be buried there.

When the plague arrived in April 1576 it was the worst outbreak since the Black Death in the fourteenth century. By winter it had killed off a third of the population, including Titian, who died on 27 August and was buried in the Frari a day later. The ceremony was hurried because of the sickness still raging in the streets. Titian's age was entered in the register as 103. A couple of days later Orazio also died. A mob looted the house and studio on the Biri Grande and a lot of Titian's belongings, including paintings, went missing. Not the *Pietà*, which was safely on show at the Frari, as agreed. Only not for long, since for some unknown reason it was returned to Titian's assistant, Palma Giovane. It never went back to the Frari and is now in Venice's Accademia museum. Maybe the friars thought there was something wrong with the painting, or maybe they thought there was something wrong with the deal.

Titian invented modern painting: its playfulness, independence and profound seriousness **38**. The flesh he painted – in furs, lying naked, glossy, muscular, old, young – changes in modern painting into just colour, pattern, form and

handling. The recognisable stuff – the human imagery – gradually drops out. And that's the modern-art ship drifting out to sea, as far as most people are concerned. Then when imagery comes back again in the kind of art that began in the 1960s and that we still have now, it's not connected to a painting tradition, but to movies and TV and ads: it shows us ourselves, our shallowness, our lust to be amused all the time. 'Bring back painting!' we hear, as if you could just reel it in again, exactly as it was. But it was like it was then because the whole culture was set up that way. Ours is set up differently.

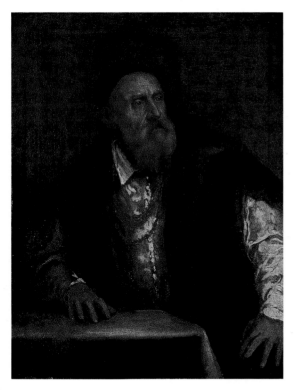

38 Titian, *Self-portrait*

Rubens
EPIC

Route to epic

Rubens' *The Disembarkation of Marie de Medici at Marseilles* **39**, now in the Louvre, is thirteen feet high. It's one of a set of twenty-four paintings, most of them this size but some even bigger, making up a single narrative cycle that describes the life and great deeds of the French Queen Mother in allegorical form. You look up at this one and there're a lot of big-arsed goddesses in the sea, and a lot of curtseying and trumpeting, and a lot of larger-than-life swooning going on. It obviously isn't today's idea either of art or the ideal bottom shape.

But this overwhelming blast of whatever it is: visual stories spun out of incredible old-master technique that we can't imagine anyone alive today being able to do – this epic pomp – is what Rubens brings to the painterly stream. He stands for grandness and for turning the stuff out. He was the most prolific old master ever. He painted three thousand pictures. His workshop system was the largest the world had ever seen: for certain jobs he had every painter in the seaport city of Antwerp, where he lived, working for him.

What makes this epic style tick? It's about propaganda, politics and power, and its about being someone who wanted to be an opportunist and to make money – and who did. But it's also about someone who can make a cosmic explosive action painting like *The Disembarkation* entirely out of thousands of delicate little patches of brushy nothingness.

Rubens was born in Germany in 1577, the year after Titian died. His family originally came from Antwerp, in what was then known as the southern Netherlands. It was a time of religious conflict, where if you chose the wrong religion you could be killed. His father, a lawyer, converted from Catholicism to Calvinism, and was charged with heresy, which was punishable by death. So he ran away to Germany with the whole family. Then he was caught having an affair with the wife of a Protestant prince, who'd hired him to do some legal work. He was imprisoned, and once again the death penalty loomed, but then he was released and pardoned, this time because of Rubens' mother's skilful diplomatic pleading with the authorities. It's an amazingly scandalous and glamorous background to Rubens' childhood, with sex, war, religion and international travel: all elements that Rubens would keep going in later life, but with the scandal somehow magically removed.

Rubens became known for a kind of art that was all about great arousals and

39 Rubens,
The Medici Cycle:
The Disembarkation
of Marie de Medici
at Marseilles

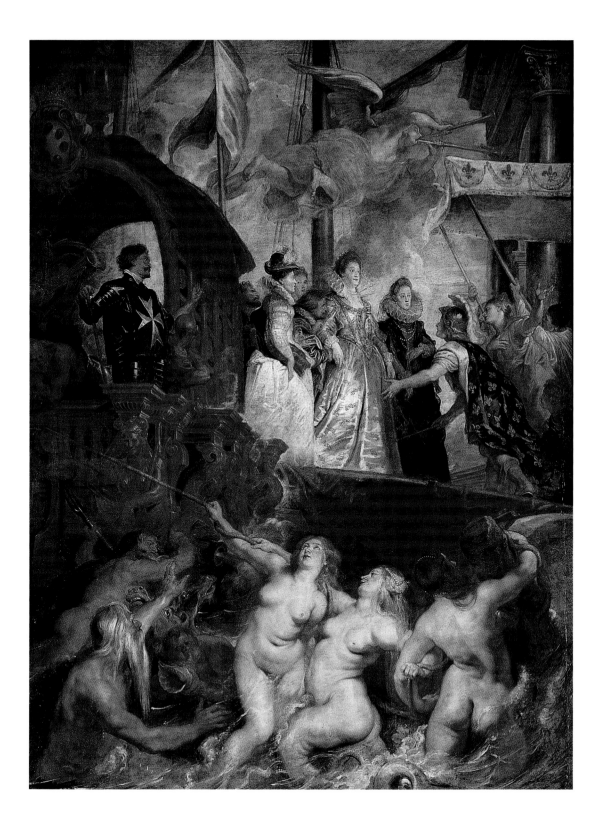

satisfactions, appetites and passions: and for life lived to the absolute full in every direction. But in his real life he was famously moderate: he was never drunk and never had any affairs. He was pious. He always went to mass. He advocated restraint in everything. 'A healthy mind and a healthy body' was one of the Latin slogans carved into the Renaissance-style portico he had built in his garden in Antwerp. He was highly educated. He read the classics, and had them read to him while he painted. As well as being the most sought-after and best-rewarded artist of his time, constantly lauded as the 'new Titian', he was an international diplomat, an ambassador to kings and governments all over the world. He was welcomed and showered with swanky gifts at whatever foreign court he turned up at. He was constantly praised for his perfect manners and the infinite sweetness of his conversation.

We have to put some of this down to the conventions of the period: 'conversation' had just been invented as something to be a master at. But even so it's an unavoidable fact that Rubens wasn't a rebel. He was born posh and he spent his whole life making himself even grander. He only stepped back finally from hanging out in courts with viceroys, vicerenes, dukes, queens, lords and emperors at the end of his life, in order to spend more time in his private castle, Het Steen, on his estate in the Belgian countryside – of which he was now a genuine lord himself, having purchased the title 'Lord of Steen' along with the land.

It's hard to find him sympathetic as a person, because all you ever read about him are things that are hard to identify with: there's no hook of the quirky. He seems an entirely public figure. All persona. No inner self. He doesn't even really seem to come from anywhere real. He once wrote in a letter: 'The whole world is my country'. He paints history; not only that, he believes he can actually alter it. He writes to kings to solicit commissions, claiming that 'There's no theme so vast that my courage can't handle it', and the kings believe him. It's the artificiality and rhetoric that make modern viewers uncomfortable, and perhaps blind them to the aliveness and sensitivity; the flowing, curving, space-creating, magic signature stroke and the overwhelming emotional impact of Rubens' set-ups – which, if you can tune into the right wavelength, are part of the mix of elements that makes him what he is, besides perfect personal behaviour.

His father died when he was ten. Rubens, his mother and the rest of the family immediately converted back to Catholicism and returned to Antwerp. He

remained a devout Catholic all his life. Religion went with politics, and war was always in the mix too. The southern Netherlands, where he lived, was at war with the northern Netherlands. The south was Catholic and ruled by Spain, the north Protestant and at war with Spain, aided by England. The war was over religion. There was a war of propaganda as well, conducted on behalf of the Counter-Reformation, which aimed to curb all the various Protestant heresies and seduce the lost Catholics back into the fold. It came out of Rome, reached into all Catholic countries, and saw all of art as its domain. This was what painting meant to Rubens when he was learning it as an apprentice in Antwerp.

The scandals in his family life meant that the family was often poor, but it was still high up on the social scale. He was expected to become a lawyer so he received a classical education. For a few months, when he was twelve, he was a page in a minor court near Brussels. Traditionally, this was the first stage of being a courtier, but then at fourteen, he began studying art with a series of Antwerp painters: the first did landscapes and the second figures, and the third taught him about symbols and the language of allegory. This lasted seven years.

There was a lot of painting in Antwerp. There'd been a purging of images from all the churches in the sixteenth century during the Reformation and then a filling up of the churches again in the next century because of the Counter Reformation. The typical Netherlands style was realistic and careful. He finished training in 1598 and then worked as an artist in Antwerp for a couple of years with a workshop and assistants. Then in 1600, at 23, he left the southern Netherlands to go and live in another Catholic country, Italy. He travelled there by horse, with one servant.

His first stop was Venice, where he admired the art of Titian, Tintoretto and Veronese, which he'd known previously only from engraved copies. While in Venice, he met the agent of the Duke of Mantua and through him got a job working in the Mantua court as the duke's painter. For eight years he travelled around the different Italian states, each ruled by their dukes, whom he met and for whom he sometimes worked. He painted portraits of them, altarpieces for their chapels and churches, and copies of the Renaissance and modern paintings they had in their collections, to send back to his boss.

After he'd been in Mantua for a year, he went to Rome and painted his first altarpiece. Two years later he carried out his first diplomatic mission, carrying

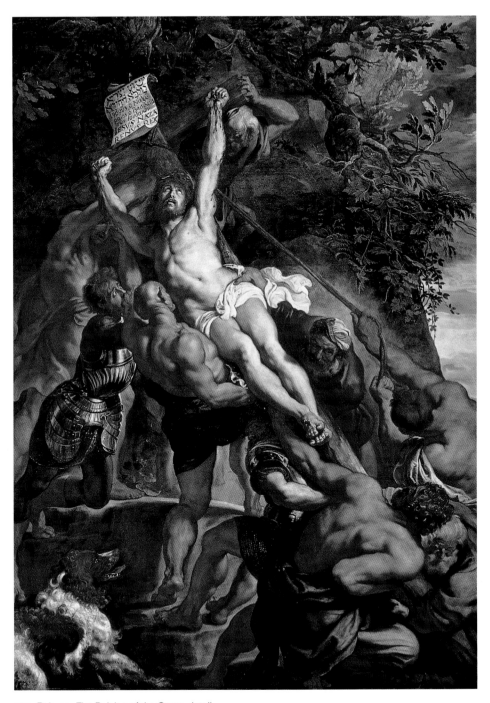

40 Rubens, *The Raising of the Cross*, detail

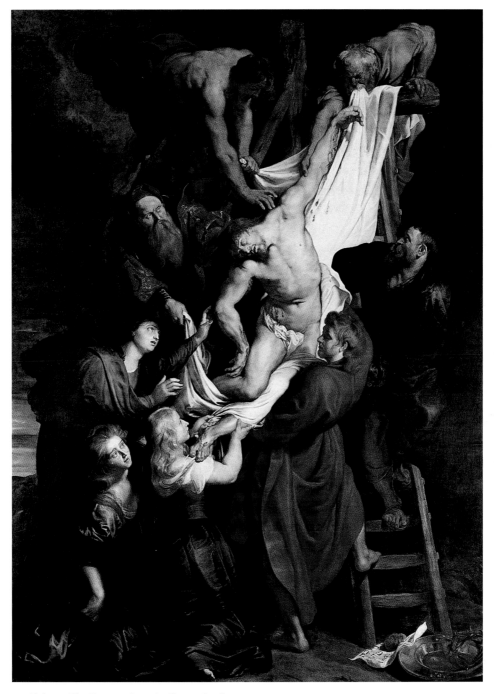

41 Rubens, *The Descent from the Cross*, detail

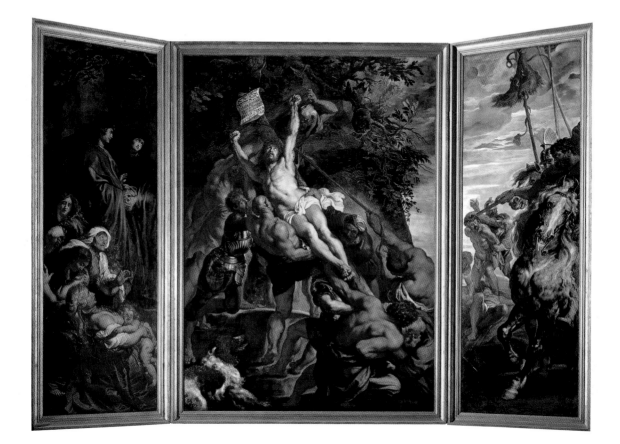

gifts from the Duke of Mantua to Philip II in Spain. In Madrid he painted por-
traits of some of the ladies of the Spanish court, and a portrait of the Duke of
Lerma. He returned again to Rome in 1606, and lived there on and off for the
next couple of years, mostly with his brother Philip, who was studying law. His
commissions became grander, his style more complex, ambitious and original.

The Raising of the Cross **40,42** is an altarpiece Rubens completed in
1611, when he was in his early thirties. Christ is being crucified. He's been
nailed to the cross on the ground and now the cross is being pulled up into the
air. There are rocks, trees, a barking dog, heaving bodies, and the body of Christ

42 Rubens,
*The Raising of the
Cross*, triptych

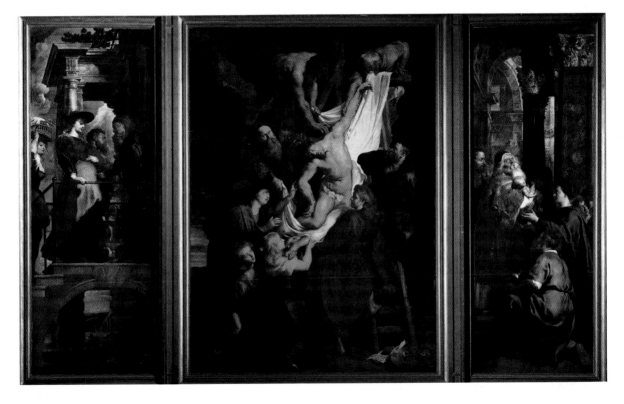

43 Rubens, *The Descent from the Cross*, triptych

with its outstretched arms; in the space above Christ's head is the piece of paper with its ironic inscription in three languages, Aramaic, Latin and Greek: 'Jesus of Nazareth, King of the Jews'.

In *The Descent from the Cross* **41,43**, which Rubens finished a few years later, in 1614, some saints lower Christ's body from the cross. The yellow-white corpse with its cold-white shroud – the shroud shape is an elaboration of the corpse shape – is the focus, within an epic downward movement.

Both these paintings are triptychs: a main image and two narrower adjoining panels either side. In *The Raising of the Cross* the scene spreads out across all

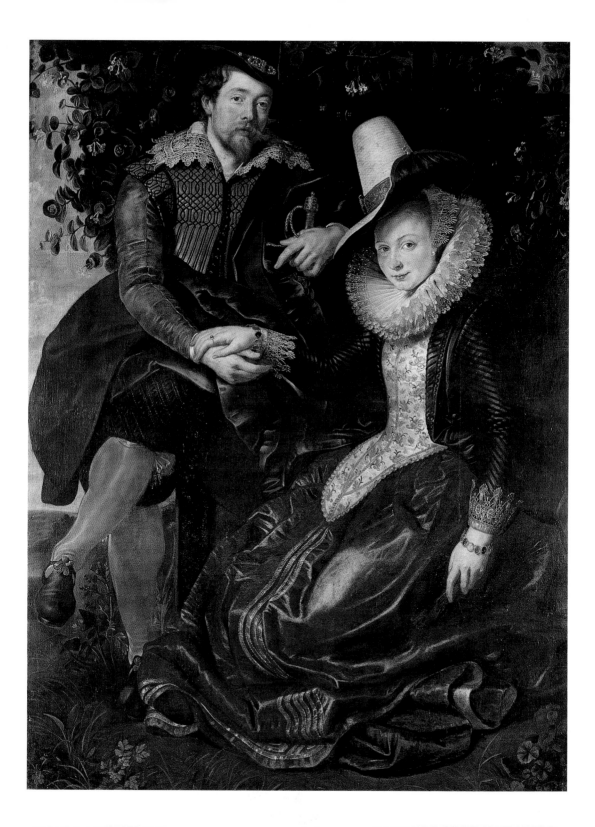

44 Rubens,
Self-portrait with his
wife, Isabella Brandt

three sections but at the same time there are separate elements in the outer panels suggesting slightly different stages of the narrative. In *The Descent from the Cross*, by comparison, the outer scenes relate to the narrative meaning of the main scene but don't visually flow into it: there's a presentation in the temple on the right, and a visit by the pregnant Mary to the pregnant Elizabeth on the left. Because the patron saint of the guild that commissioned the painting was St Christopher, who bore the weight of Christ, according to legend (in fact the legend was officially cancelled by Vatican decree not long after this painting was done) the triptych has the theme of sacred carrying as a kind of sub-theme in all three sections: Christ is carried in the Virgin's womb on the left, by a priest in the temple on the right, and after death by the saints in the middle.

The main theme of both triptychs is the crucifixion, the most momentous event in the history of the universe according to the Catholic view of the universe, but both are really about power here on earth: and to get that, you've got to think about a few things besides Rubens' skills at making a crowded scene appear dynamic, persuasive and overwhelming. These are real qualities that define his art, but they also have a political dimension: they're put to the service of something. What else is it, besides talent, that makes paintings as muscular, masculine and powerful as these be what they are?

For a start, the place they're in isn't Italy but the main cathedral in Antwerp. Rubens left Rome towards the end of 1608, when he heard his mother was dying from an asthma attack. By the time he reached Antwerp the following year she was already dead. He'd intended to return and live in Rome but instead he stayed on in Antwerp, married the eighteen-year old Isabella Brandt, and started taking commissions for work **44**. There was a great difference compared to when he'd last lived here. Constant war – and with it the demoralising grind of enemy barricades – had suddenly stopped, because of the Twelve-Year Truce between the northern Netherlands and Spain, the negotiations for which were being concluded at the time Rubens was riding between Rome and Antwerp. The economy was good and there was a big demand for art.

He was invited to be the official painter of the Spanish rulers of the southern Netherlands, the Archduke Albert and Archduchess Isabella, whose court was based in Brussels. He had to think twice about this, because although he was good at negotiating courtly existence he didn't particularly like it. But then he

felt the offer couldn't be refused: the pay was high; he didn't have to move to Brussels; he could stay in Antwerp, live in his own house, work in his own studio, be with his wife and bring up their family. And he could take commissions from anyone he liked, on top of his court commissions. There was now a rush of church expansion and refurbishing going on in the southern Netherlands, because of the truce with Spain. And being now in an exalted position the job of decorating them was likely to go to him.

With the money coming in from his court appointment and commissions from the clergy, wealthy city leaders, religious orders and confraternities, Rubens bought a house in the centre of Antwerp, on the Wapper canal: No. 9, The Wapper. Over the first few years he lived there he transformed it so that it was like a mini-version of the Italian palaces he'd worked in. He had a marble space with a cupola inspired by the Pantheon in Rome specially built to house a lot of classical sculptures: pagan gods leering and flexing their muscles, and busts of Roman poets and philosophers. There were elaborately carved wooden cabinets, chests and furniture everywhere. On the cool white walls of the picture gallery adjoining the sculpture gallery there were Italian paintings mixed with northern paintings. And throughout the house he mixed Italian architecture with northern architecture. He built an extension onto the back of the place, for a studio, with walls thirty feet high. Beyond the studio was the garden with the portico, and at the bottom of the garden was a classical pavilion. Statues of gods representing commerce and wisdom stood on the portico; the garden had stone fountains and bowers with carvings of satyrs and maenads. His own painting space was on the ground floor of the studio, while his assistants worked on an extra mezzanine level. It was from this Italian culture theme-environment that Rubens turned out a massive production of altarpieces for churches in Catholic countries throughout Europe.

Only *The Raising of the Cross* was actually painted for Antwerp Cathedral; *The Descent from the Cross* was moved there from its original church, which burned down. Both paintings now seem part of the building, one of the largest Gothic cathedrals in the world. They can't both be seen at once: you have to move from one to the other. The experience of looking at them goes with the experience of the building as a whole: the smell of wax, the intermittent sound of bells, and the contrasts of different kinds of light: the brilliance of the stained-glass win-

dows, and the white light coming through the non-stained, high-up, gothic, arched windows; and the flickering votive candles and the dim electric lights. It was always a beautiful place but it wasn't *about* beauty, it was about religious feeling. And the religious art in it had the job to complement all that intensity of feeling, to intensify it even more.

So now we've got to remind ourselves of one of the main difficulties of Rubens' paintings' for a modern audience: their impersonality, which they have as much as they have spectacular passion. For art to fit with the religious mood of the time, which was one of absolute forward attack – 'We won't put up with any more Protestantism!' – there had to be a big revving up of the senses, and of all sorts of visual excitements. Rubens was a genius at expressing a kind of visual generosity, where everything has an implication or resonance of vitality, and of heaving sexuality and power. But he used his genius to express a vision of religion that was invented for him by the power set-up of the day, the Catholic Church with its bases in Rome and Spain.

The concept of *The Raising of The Cross* is suffering, death, and the end of the world. But the action is sweaty and compelling: you're overwhelmed by it and you want to be part of it. The mood of the whole triptych isn't particularly dominated by sorrow or high-mindedness. Noble suffering is at least equalled by mania, by electric fleshy charging excitement. The imagery is all muscular heaving, a riot of textures: the thick calves, thighs and broad rippling backs of the labourers; the hair and turbans; the bald head; the barking dog; the soldier in armour pushing from a different angle to the other men; the explosion of leaves and branches out above the main group. The sadistic torture of the middle scene is given different kinds of twists by the two outer scenes: a mounted soldier directs the action, while saints weep and banners wave. One thief treads on the face of another. A sexy woman with her breasts out rolls her eyes.

There's sadness in the left-hand panel, with the saints lamenting, but then suddenly there's a change from exquisite feeling to lusty feeling, with the red dress, yellow hair and exposed breasts of the mourner in the foreground, and the fat rippling flesh of her naked baby **45**. This is all happening at the bottom of the painting in the viewer's space, while the more dignified mourning goes on higher up in the shadows at the back. The earthier scene connects to the naked rippling muscles of the labourers in the middle, and the snorting horse out on

the right. The energy is fantastic. It's death, but it's triumphant death: Christ is dying, but hey, he's going to be born again – he's going to live forever!

The immediately striking things about *The Descent from the Cross*: the slash of white light in a dark void, and the detail of the labourer gripping the shroud in his teeth, are both original inventions, neither of them essential to the story. They draw you in, just as the underlying structures in both paintings also work to draw you in. You're looking at a drama, something staged, every one of the depicted players alive with feeling, their bodies expressing emotion at every point, and at the same time you're looking at an intricate, thoughtful, powerful bit of abstract arrangement. Against the steep curved diagonal made by the shroud in *The Descent from the Cross* is another diagonal almost exactly opposite but made up mostly of negative space and shadows. The first diagonal starts at the elbow of the labourer at the top right part of the cross. It goes down through the corpse and the highlighted faces and limbs of the two female saints at the base of the cross. It ends on the hand and wrist of one of these – with a last echo in the highlighted folds of her dress down in the corner. The counter-diagonal begins with the faintly lit edge of the cloud in the upper left corner of the painting. It runs through the empty space between the edge of the beard of St Nicodemus,

who supports Christ's body above the female saints, and then through the cluster of limbs in the centre, and into the blast of red of St John's cloak. Then the wooden ladder picks it up and takes it down to the bowl in the bottom right corner – with the red blood in the bowl, the crown of thorns, the bread and the inscribed paper. This little still life symbolises the Eucharist, the cornerstone of Catholic belief: the transformation of bread and wine into blood and flesh – which here is the literal cornerstone of Rubens' composition.

45 Rubens, *The Raising of the Cross*, left-hand panel

Religious epic, courtly epic and spying

The Counter-Reformation began with the Council of Trent in 1543. The Council went on for twenty years. Its edicts had to be obeyed by artists, as well as everyone else. Painters were instructed that they had to conform to what the Bible said about the scenes they were painting. So Rubens – after everyone's had these dictates drummed into them for decades – knows he can put a few things in that aren't in the Bible: he just mustn't distort what is clearly described there. 'At the foot of the cross stood the Virgin', it says in St John. So in *The Descent from the Cross* the Virgin in her blue outfit can't be swooning on the ground: she has to be standing up. That's accurate, but it's also good box-office, because it emphasises victory. This heroic event will decide the history of the world – and the winners will be the Catholics!

The Counter-Reformation was incredibly successful in the first half of the seventeenth century, and Rubens was a significant force in its success. Between 1610 and 1620 he painted sixty-three altarpieces for churches throughout the southern Netherlands and other parts of Europe. When he finished *The Raising of the Cross* in 1611, half of Europe was officially Protestant. By the time he died thirty years later, only a fifth remained Protestant: the rest had all converted back to Catholicism.

The look of twisting, writhing sensuality that characterises the two altar pieces we've been looking at is a mix of the realism of Netherlands art of the time, and the look of the art that Rubens absorbed in Italy: classical sculpture from the ancient past; Renaissance art that harked back to an imagined ideal of classical art; and also the new modern Italian style of Baroque painting that was just starting up when Rubens was there. 'Baroque' means realistic-seeming things: bodies, muscles, women, animals, torture, painted with the sensuality needle up very high, but at the same time a sense of extreme artificiality, as if it's too much for mere reality. That sense of being transported in a kind of ecstasy was something anyone could get. Educated or not, when faced with this kind of painting people felt they were being taken to a different emotional place.

Baroque was a fifty years later version of the Renaissance. They were both based on the past but the past was given different spins: with Baroque instead of calm you got extreme action. There were iconic models of this principle. In

46 *Laocöon*

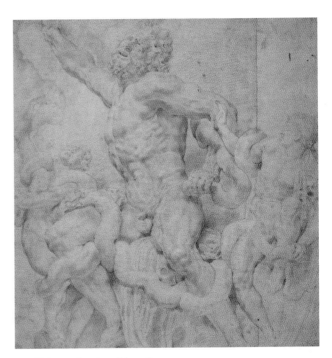

47 Rubens, drawing of *Laocöon*

the early 1600s the marble sculpture group known as the Laocöon: an ancient copy of an even older Greek original, discovered in Rome a hundred years before, showing the Trojan priest, Laocöon **46,47**, being strangled by snakes along with his two sons, was revered by artists because it stood for a Renaissance ideal of noble heroic suffering. But it also pushed the ideal along a bit: it was about going 'Mmmm' about suffering – kind of enjoying it.

In both *The Raising of the Cross* and *The Descent from the Cross* Rubens translates that sensuous electric charge that the smooth white marble of the Laocöon gives off, into agitated painterly forms. Now there's *more* action, more expressions and gestures, more shades of passion, and more pleasure, which fires up the audience and at the same time fits with the religious rapture that the Counter Reformation tells them they should be having. 'Fantastic, I'm a Catholic!' they think. The other side, the Reformation Protestant church, wasn't even sure that any images at all should appear in a religious context because of the danger of anyone having a sensual feeling in front of Jesus. They were always angsting about it. So the Catholic Church defined itself by being gung-ho about having lots of imagery, with really high sensual feeling. And it got amazing results in terms of getting the numbers up of Catholic converts. 'Ha ha' said the Catholic Church: 'Those Protestants picked the wrong thing to angst about there!'

48 Caravaggio,

Seven Acts of Mercy

The great figure of Italian Baroque painting was Caravaggio, who died from a stab wound in 1610, just after Rubens returned to Antwerp. Caravaggio was Rubens' opposite in the way he lived: not pious and moderate but irreligious, sexy, violent and always being imprisoned. Rubens never met him but he organised

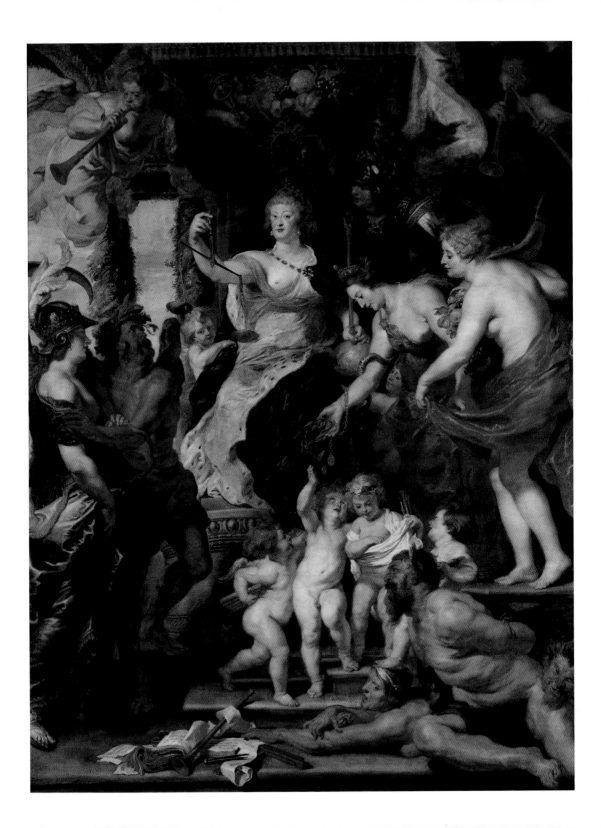

the sale to the duke of Mantua of Caravaggio's *Death of the Virgin*, and later he painted a full size copy of his *Flagellation*. Caravaggio's *Seven Acts of Mercy* **48** in the church of the Misericordia in Naples, is a good example of Caravaggio's treatment of darkness and movement. The idea is from a passage in the New Testament in which the notion of Christian charity is expressed in simple bodily terms: feeding the hungry, burying the dead, giving shelter to the weary, and so on. It sounds innocuous but the goings-on in the painting are inescapably dark. Some of it is ancient imagery given a new Christian context, which because Baroque style harks back to the classical past, is really a new-old context. Caravaggio creates an extreme, vertical, twisting and writhing abstract structure. Faces, arms, breasts and backs loom out of darkness as if they're describing a towering invisible spiral staircase. Lurid sexiness and death are glimpsed on the way down.

Where blackness in Caravaggio is always a solid darkness, darkness with Rubens is never really black: he amps it up with sheens of colour. The rainbow-effect dresses in *The Descent from the Cross* make the darkness in that bit of the painting appear to be warm and vibrating. This level of visual stimulation – one colour dynamically activating another – is happening without the audience being particularly conscious of it: they think the experience is all about God not about complementary colours. But it's still adding to the general sensurround pleasure blast.

As he worked to change the minds of the religious masses, Rubens continued to develop his studio and living environment on the Wapper canal. Every space was infested with deities, the walls were inscribed with classical aphorisms that told him what to think: noble sentiments, like those of his art. Of course we don't have that mindset today. For us the meaning of those Latin slogans, which you can still see in his house today, with voluptuous sculptures nearby, is just that this is a different world to ours, one where higher beings command: 'Paint big bottoms!'

This is the oddness of Rubens' courtly allegories, the greatest of which is the Medici cycle in the Louvre. We're used to artificiality being stripped away being the hallmark of good art, not having the pomp piled up **49**. There isn't a magic solution to this problem of emotional distance we feel from Rubens. Somehow we can be emotionally gripped by him yet feel distanced, too, because he

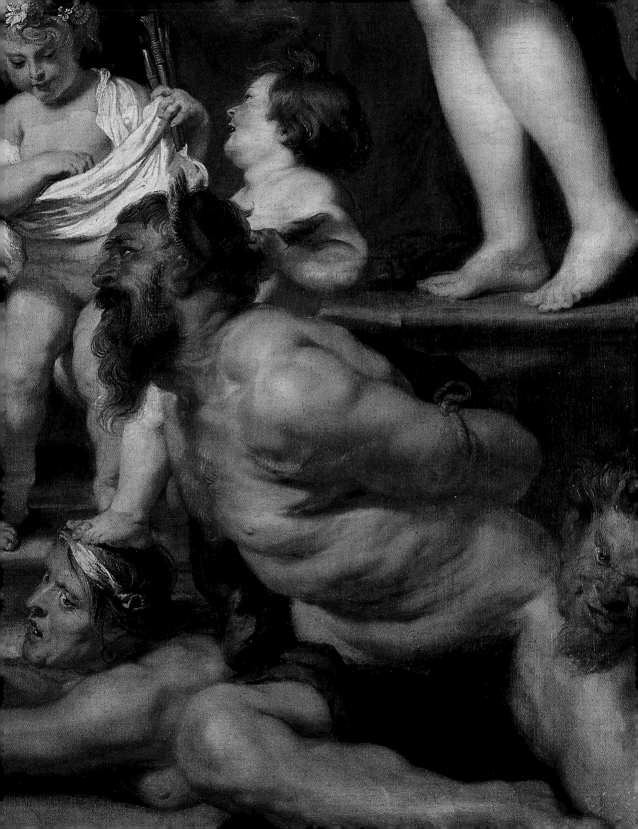

50 Rubens,
*The Felicity of the
Regency of Marie
de Medici*, detail

doesn't provide anything existentially gritty: no troubled facial expressions full of restlessness that we can imagine are the artist somehow seeing into the modern future – which Titian, for example, often supplies. Instead Rubens gives us staginess and somehow it's powerful: it makes our modern frameworks for assessing good and bad in art appear inadequate. That anguish on the face of the satyr in the corner of *The Felicity of the Reign of Marie de Medici* **50** isn't real but acted: it's deliberately different to reality. Rubens plays with extremes of the over-ripe to create a pleasure we can't avoid responding to even though we feel we no longer have a name for it.

Rubens was offered the work to visualise the life-story of Marie de Medici, the French Queen Mother, in December 1621. The background to the commission is that the Queen Mother's been banished from France for years because it's thought she might have had a hand in the murder of her husband, the French king, Henry IV. But now their son Louis XIII, who banished her in the first place, says she can come back. She builds the Palais du Luxembourg to celebrate and she wants Rubens to come and decorate it with paintings showing the main events of her life as a series of triumphs, watched over by deities. Rubens travels to Paris by coach and stays until January to set up the deal: twenty-four paintings for thirty thousand lire. He has to do the figures himself. Assistants can do the backgrounds. The Queen Mother's always in fear of being murdered. Her power's very shaky. In fact she won't last long on her throne. But now Rubens has got the job of describing all this real-life awkwardness in paintings that soar above real life.

He knew he had to handle these allegorical scenes carefully. He had to balance the task of enhancing the power profile of the Queen Mother with the need to keep her enemies in the court sweet – and as well as that, he had to bear world politics in mind. The Twelve-Year Truce was off and the Thirty Years War was on. The war was about Spain's imperialist ambitions: Spain wanted to use its provinces in Europe as military bases from which to resist the spread of Protestantism and to re-establish total Catholicism. Rubens couldn't afford to offend France – another Catholic power, but as yet neither allied with Spain nor at war with Spain. So he had to use all his diplomatic skills, veiling and unveiling, saying and not saying. The paintings took two years to complete and were installed a year after he finished them. The Queen Mother's adviser interpreted the symbolism to the court.

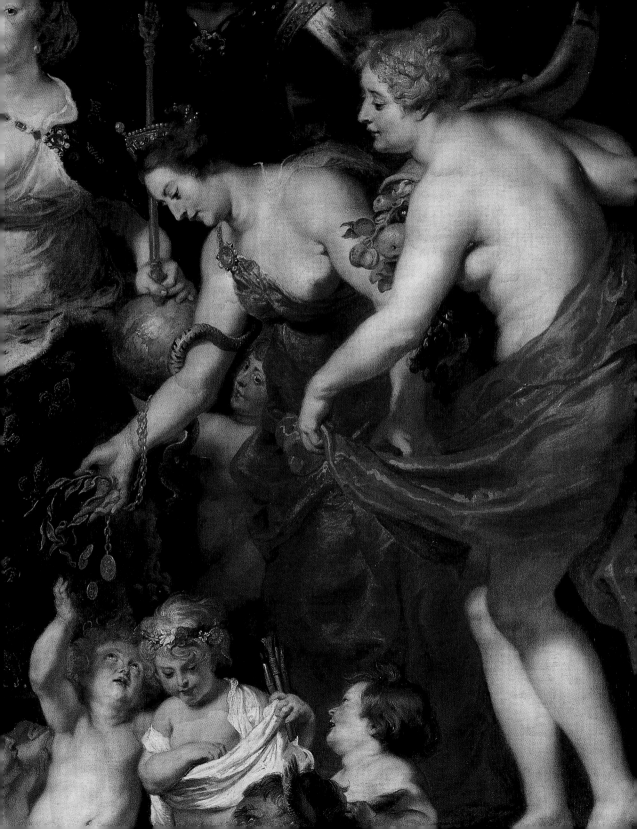

51 Rubens, *The Felicity of the Regency of Marie de Medici*, detail

52 Rubens, *The Disembarkation of Marie de Medici at Marseilles*, detail

53 Rubens,

The Meeting of

the King and Marie

de Medici at Lyons

This is the kind of thing they were told. In No.18 in the series, *The Felicity of the Regency* , Wisdom, in her armour because she's always ready to defend civilisation, is the Queen Mother's constant companion: the Queen Mother's always wise. And through prudence the Queen Mother brings abundance to the realm: Prudence and Abundance are the women on the right (the serpent on Prudence's arm is the attribute of wisdom). They display the fruits of wisdom, the cornucopia of plenty. Helmeted France is led forward by bearded Time to receive all the benefit that comes out of the Queen Mother's rule. Virtuous cherubs stamp on all the evil that the Queen Mother's going to be able to vanquish now that she's happily back in power: envy, ignorance and vice.

The Queen Mother is pictured as she really was, and also in allegorical form: she's a real person but also a goddess. In reality she's fifty-seven years old, but she would know like the rest of the court that bare breasts are normal for allegory. Hmm – but why are the women fat? **51** It's a sign of classiness. They're glossy, smooth, contented and free from want: they're not staring, thin and lacking something – which is what people in reality would mostly be in those days. Fatness relates to the symbolism of the benefits of peace: women are childbearers, and childbearing and rearing are part of peace not war. War goes on in the fields. You can't get the harvest in when everything's burning, which is what happens during war. In peace the harvest is reaped, there's abundancy and everyone's happy. Fatness is an ideal for that type of society, but actually Rubens doesn't particularly idealise fatness: he shows much more detailed veiny palpability than we perhaps realise when we think of the cliché of the Rubensesque figure.

Fatness is power **52**. These allegories are propaganda for royal power. In reality the Queen Mother was always being banished from the court, or menaced by assassins, or charged with being a murderer herself. There she is arriving in triumph at Marselles in *The Disembarkation* but within a few years of the cycle being installed she was banished again and never returned to France. That's what happens with the art of the past: we know too much about what really happened in history, so the impact of a historical painting's story element tends to go a bit blank for us, simply because we see through the lies. **53** Therefore the way the story is animated becomes more interesting. That's why qualities of light, composition and handling are worth thinking about and discussing. It's

not just so that you can pontificate in a special kind of language that intimidates anyone who hasn't studied art history.

When he was in Paris working on installing the Medici cycle Rubens was often thought to be a spy, because the French court was paranoid. But in fact he *was* a spy. He'd already began working for Isabella, the archduchess of the southern Netherlands as her political agent as well as her court artist.

The background to this development is that Isabella is the aunt of the King of Spain, Philip IV. In the war that's going on, she has to go along with whatever he wants to do. In fact, Spain just wants to keep beating up any country that won't be Catholic. Meanwhile, the southern Netherlands is suffering from constantly being at war with the northern Netherlands. But the archduchess isn't a fanatic. She wouldn't mind peace. So she starts to wrangle for that.

Initially, Rubens was her secret agent. He travelled incognito to the northern Netherlands and negotiated with other secret agents up there. His talks with one of them resulted in a promise from the Duke of Buckingham in England – whom Rubens had met in France – of an agreement of peace with Spain for a period of between two to seven years. It was up to the archduchess in Brussels to persuade the Spanish King to agree.

One of England's strategies to do Spain in was to aid the northern Netherlands with their blockades of the southern Netherlands' seaports. What Rubens didn't realise was that Spain was secretly preparing for all-out war, with France as her ally. England wasn't expecting any trouble from France. But then the Duke of Buckingham learned about the proposed war alliance between the two Catholic powers and so England went on the alert, not trusting anything that Spain might say about peace.

Rubens now realises he isn't aiming high enough. He can't offer terms to the northern Netherlands that include Spain, because he's not representing Spain directly, only a Spanish province. He works out a plan to get a peace treaty drawn up between Spain and England. He believes that such a development will reduce the tension all over Europe, bring peace all round, and reverse the economic decline that has now set in throughout his own country, the southern Netherlands, because of being blockaded all the time. Isabella agrees it's a good plan and sends him to Madrid, to get it across direct to Philip IV's ministers.

War bad

At first Philip IV doesn't know why he has to put up with a painter acting the role of a gentleman around the place. Then he starts to be impressed by how gentlemanly Rubens actually is: that is, by his skills as a courtier. And then he's impressed by Rubens' skills as a painter. And soon Rubens is enjoying daily audiences with the King. He sketches him and paints a lot of formal portraits of him (all now lost: the last one was destroyed in a fire in a Swiss museum in the 1980s). The King gives him a mighty ring, worth two thousand ducats, and promotes him in the court hierarchy in Brussels.

The diplomatic discussions grind on incredibly slowly. News arrives that the Duke of Buckingham has been mysteriously assassinated in England: the Spanish ministers know that Buckingham was a peace-with-Spain guy, so they suspect a new plot against Spain, and that delays negotiations even more.

Rubens meets Philip IV's court painter and travels with him by horse out to the Escorial, the King's palace to the north of Madrid, where he sees the royal galleries there, full of Titian's mythological paintings, the 'poesie' or 'picture-poems' Titian shipped over to Philip II in the previous century. And at some point during his eight-month stay in Madrid, Rubens starts copying Titians **54-57**. Rubens is fifty-one years old now. He already has an established style. He's the most important artist in Europe. But he goes on and on imaginatively translating Titian. Not copying exactly, but making free variations on Titian, in which he recharges the original and gives it a new life. He paints at least six full-size transcriptions of Titian's mythologies and a lot of his portraits of Philip IV's father and grandfather, Philip II and Charles V. He takes many of these paintings away with him when he leaves Madrid, but seeing him working on them completely changes the career of Philip IV's court painter, Velázquez.

It's finally decided that Rubens should go to England and take his peace plan direct to Charles I. He sails to Greenwich and travels by coach to London. He lodges with a Dutch aristocrat who combines painting and art dealing with secret-agenting. New negotiations go on in London for another eight months. Rubens writes letters to friends in France complaining about the moral character of the English nobles, how they change their minds all the time, how their

54 Titian, *Adam and Eve* **55** Rubens, *Adam and Eve (after Titian)*

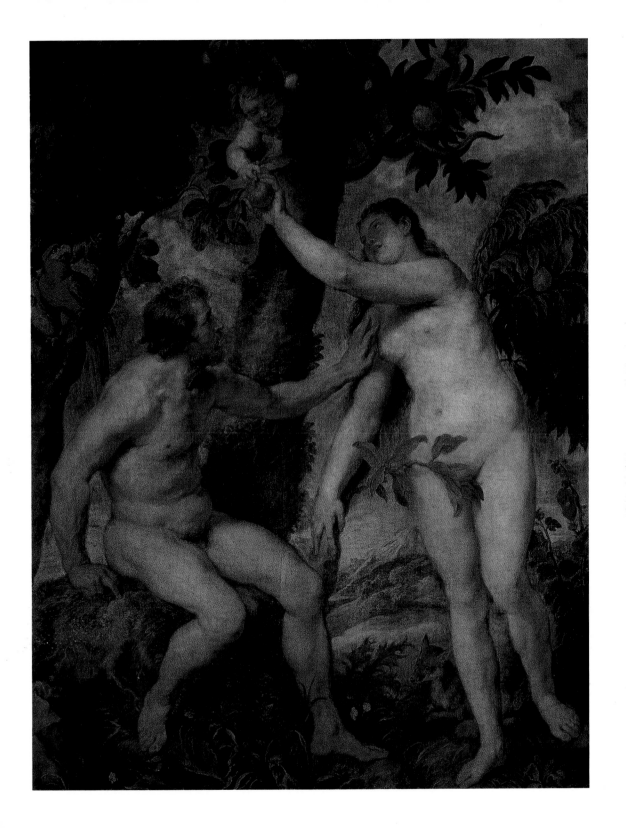

56 Titian, *Europa*

57 Rubens, *Rape of Europa (after Titian)*

58 Rubens, *Allegory of Peace*

behaviour in war is ungallant and how they love slaughter. He says they live lav-
ishly and are always in debt, and that English court life revolves around bribery.
But he also praises art and culture in England. He paints a scene of St George
and the dragon – because it's an English theme – but he keeps the painting for
himself. In the meantime Charles I falls for Rubens' famous politeness and
charm. He gives him jewellery and a ceremonial sword. Then the negotiations
start to warm up: there's an official exchange of ambassadors between Spain
and England, and Rubens has to stay on while all that's arranged. Then the
treaty's drawn up. Amazingly, peace is on. Rubens is showered with honours,
and eventually knighted three times – by the English and Spanish kings and by
the court in Brussels.

In the long run the treaty between England and Spain didn't bring peace to
the Netherlands, and the Thirty Years War went on anyway, continuing until
long after Rubens' death. But there aren't many artists who wanted peace not
war, and who actually got it, even if it was only for a few years. The equivalent
today would be Anthony Gormley's *Angel of the North* having a meaningful
influence in the resolution of the Arab–Israeli conflict.

Rubens painted the *Allegory of Peace* **58** in 1630, in London, as a gift for
Charles I, as part of his bid for peace. The idea is that war and fury are van-
quished and in their place peace, civilisation, wisdom and reason reign. These
concepts are expressed through allegory. He sets up a staged interaction between
different figures, each symbolising a virtue or anti-virtue. So 'war' is the bearded
figure to the right, and 'fury' is the despairing female figure further out to the
right-hand edge. Already-known symbolic figures are given a twist to suit the
political theme. Venus, the goddess of love, is recast as the personification of
peace. And Venus's son, Cupid, is recast as the god of wealth, Plutus, who
receives the milk of peace: the meaning is that wealth gets fat from peace. Up to a
point, Charles I can interpret the allegory because he's used to interpreting sym-
bols. But the symbols are given a new complexity, by which the King and every-
one else in his court are pleasurably fazed: they can feel flattered that it's a game
they can play, and at the same time delighted that they're in the presence of
genius, because the game is so clever and complicated.

For us the whole situation is much more fragmented: we only find the allegor-
ical meanings interesting to unravel because something else entirely has won us

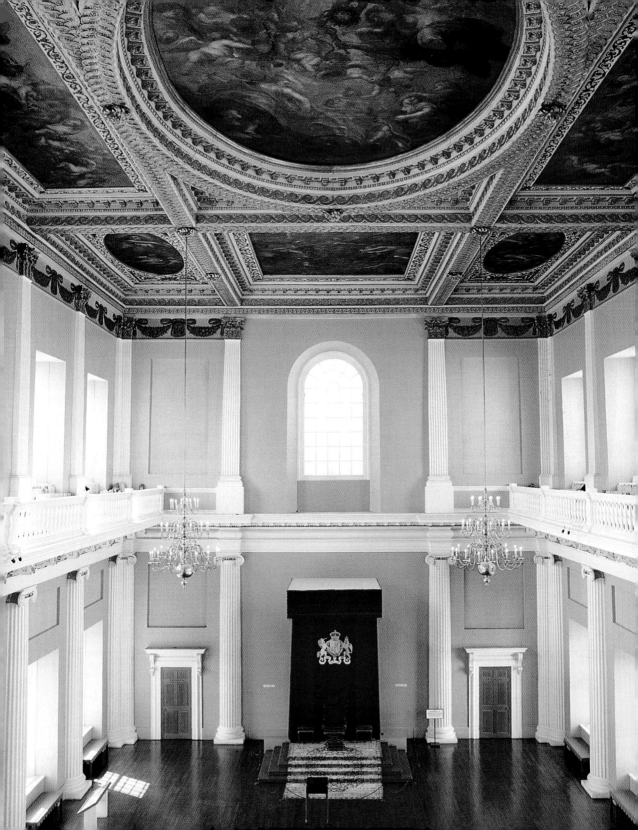

59 Rubens, *Ceiling of The Banqueting Hall, Whitehall*

over – if it has – which is the great, rich, visual flair that Rubens brings to this work. That is, it's only interesting for us to find out about the allegory because the painting already seems to have its own fascination. The viewers of the time wouldn't have found it impossible to separate things in this way – it's just that with us, we hardly find it possible to do anything else.

Minerva, the goddess of wisdom is back: her helmeted head can be seen at the top of the painting: this is the point toward which the main diagonal lines of the painting's triangular composition converge. Everything going on within the main triangle: revelling satyrs, peaceful exotic animals, fruit and wine, and happy children, stands for peace. It all connects to the figure of wisdom. Therefore peace is wise. War and war's companion, fury, are outside the structure presided over by wisdom. War is unwise. Of course wisdom isn't always against war but in this case it's against unjust war, because anything unjust is uncivilised. The meanings are clever but actually the painting has its own visual intelligence. Imagine that both the precision of an isolated phrase and the weighty content of a whole play are being simultaneously transmitted, but that it doesn't matter if you don't speak the language in which the play is written: this would be impossible for a play but for a painting it works. This is in fact why paintings are good, and why they're not plays or books.

60 Rubens, *Apotheosis of James I*

Because he'd become such a hero of the English court, Rubens was able to win a commission he'd been trying to get for years: to decorate the ceiling of the palace at Whitehall, designed by Inigo Jones **59**. The point of his nine allegorical paintings on the ceiling of the banqueting house at Whitehall, the only painting-installation by Rubens that's still in the place it was originally designed for, is to glorify the reign of James I. The benefit to Charles is positive propaganda for the Stuart family. In one of the paintings wisdom casts armed

rebellion into hell: that's a reference to the Gunpowder Plot. In the *Apotheosis of James I* – the King being received into heaven (the place where the right of kings to rule on earth is decided in the first place) – faith joins wisdom, together with victory, and fame does a bit of trumpeting **60**.

The whole ceiling was designed to coordinate with a ceremonial route through the hall, from the entrance at one end to the King's throne at the other. So it's ironic that only thirteen years after Rubens' paintings were delivered Charles I would take the same route in the opposite direction, to be beheaded out in the street with everyone cheering.

But the history meaning isn't the primary meaning. Meaning is part of a painterly rush, it's vivified by painterly flair: the brush moves across everything without lingering on anything. A single breath runs through everything. Light isn't lighting as in a director lighting a scene, but a kind of cosmic material, the magic stuff from which every object is conjured-up.

A key to this level of content in Rubens, the only one that's really alive to us, is provided by his portrait of Suzanna Fourment who was to become his sister-in-law **61**: he painted it at the same time he was working on allegorical cycles for foreign courts. The glazing of the strong, bright blue over the washy, brown under-painting, and the intensifying of the blue around the black hat, and the way her white flesh and dark eyes are set off by that blue: these are what the painting is about. If you think of Rubens' allegorical paintings while you're looking at this one – where there isn't any allegory and no gods and goddesses are laid on – you might think again about the role of handling in those paintings. That decorative blast they have is based on a painterly effect. The effect is technical, but to get that technical thing to work you've got to have a particular sensibility. You've got to have a feel for paint. The final impression is going to be made from all that. The overall effect of distanced grandness will actually be riding on little incremental build-ups of tender feeling.

Can there be an inner epic?

We've met Rubens the great visual propagandist, and Rubens the international diplomat and negotiator of tricky peace settlements in a time of world war. He seems like a colossus and we just seem like little flies in comparison. How can we

61 Rubens, *Portrait of Suzanna Fourment*

make him more like us? I think we have to accept there's no inner Rubens hiding behind the outer man ready to come and show himself. With an artist of the past you can't just impose a load of clichés about what creativity is and expect to come up with anything other than a cliché: you've got to respect the oddness and strangeness of the past. On the other hand, we can make a few reasonable conjectures about Rubens' inner life **62**.

Remember what we've learned about his paintings. His religious allegories and allegories of the court are pictures of power: the power of the Catholic Church, the power of royalty. Because society and culture are set up differently now, we find different things powerful. We revere different things. A powerful theme for us is something like desire, or what we personally long for. So when we project backwards to imagine what it is that Rubens might have personally longed for, we think it might be the modern notion of self-expression: we think that might be what the act of painting and pleasure in painterliness was for him.

The painterliness of Rubens' *Autumn Landscape with View of Het Steen* **63,64** is in its material thickness, the way he's spattering that oily paste about the place, and at the same time creating a very controlled illusion of a real place: an epic view of rolling fields, all overlooked by his own country chateau, which he bought in 1635 and retired to whenever he could. It was one of a number of real estate deals he was involved in: he usually resold the properties but this one he kept. Today the place is remarkably unchanged. The medieval tower you see on the side of the house in the painting has been taken down, but otherwise it's the same, and the land around is not much different either: the brook is still there, the fields are there – except that in the painting everything's slightly different anyway, because he's not painting reality but an idealised version of it. Self-expression in this painting is not just paint-handling, but propaganda for a contented, rewarded grand self, done for himself: he's his own wealthy client. He can look up at the painting on the wall at home and see himself relaxing in harmony with the environment, with his employees all around him: the milkmaid out with the cows far away and the gamekeeper in the foreground shooting the partridges – which are deliberately painted much bigger than they would be at this distance so you can recognise what they are.

62 Rubens,
Self-portrait

OVERLEAF
63 Rubens, *Autumn Landscape with View of Het Steen*

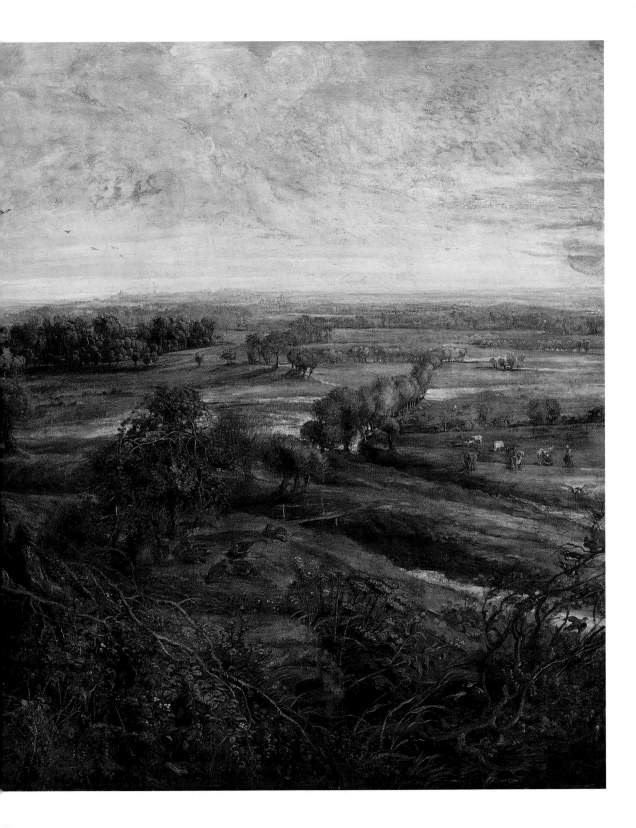

64

Rubens,
*Autumn
Landscape
with View
of Het Steen*,
detail

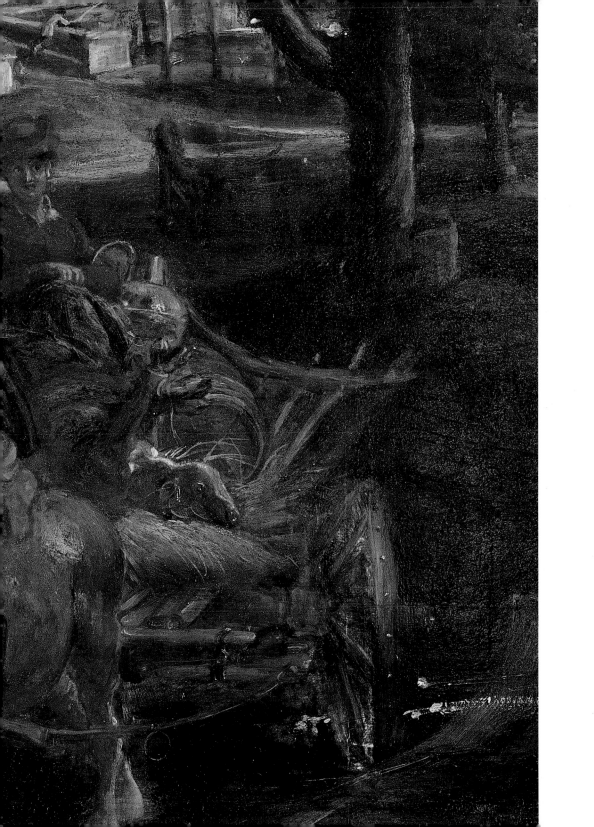

die booms werde byg in het water verandert
onde wel perfecter in het water als de booms selu

thee shadow of a tree is greater in y watter
and more parfect then y trees themselues, and
b darker.

R

The painting is a composite of several different viewpoints worked up from oil sketches, drawings **65** and written notes, all fused together in such a way you don't think to question it: in reality no one could really see so far out to that horizon as the curving of the earth wouldn't allow it. But this way Rubens literally gets more land in. He shows more of what he's the lord of. Those tiny figures near the house are Rubens with his second wife and their child and the nursemaid out for a morning walk: his farm labourer and *his* wife are just rattling by in the cart.

Rubens' first wife Isabella died of the plague in 1626. He wrote in a letter once that one of the reasons for his long stays abroad doing diplomatic work was to get over her loss. He married Helena Fourment in 1630, when he returned from London: she was sixteen and he was fifty-three. In this allegory of the good life a 39-year age difference between husband and wife isn't freakish, or something his friends really ought to have a word with him about, it's the just reward for a virtuous guy **66**.

If this is questionable for a modern right-on sensibility, there are personal pleasures he expresses that we can easily tune into: the subtle, wispy, liquid brushing in the sky part of the *Autumn Landscape*; and the flecked, dabbed, broken marks in the earth part. The white sparkle in the horses' eyes and their white noses is one set of marks in a whole play of different sets: every time you come back to any one of them it seems fresh. And when you've been in that brown undergrowth part of the painting for a bit and then you come out into the open again, the green of the trees and the house suddenly seems very luminous: this is Rubens turning a convention of the time – a way of creating a sense of distance in a painted space – into something new. With this type of landscape he virtually invented the tradition of modern landscape painting: although landscapes were already part of art they were hardly ever the sole reason for it, but now here was Rubens establishing the blueprint for Constable and the Impressionists.

When he paints himself, Helena and their son in the garden of his Antwerp house **67**, he's showing us an allegory of happiness that's more in line with his allegories of royalty. We find it easy to believe in the reality of the forms, faces and clothes. And we know the classical pavilion and fountain are real because they can still be seen on the Wapper site. But it's clear he's presenting everything

PREVIOUS PAGE

65 Rubens, *Trees Reflected in Water*

66 Rubens, *Portrait of Helena Fourment in a Fur Wrap*

67 Rubens, *Rubens and Helena Fourment in the Garden*

here as a kind of procession of ideas: the things that please him. It doesn't seem as if he's observing a scene out there in the open, where there's changeable conditions and he's probably a bit plagued by flies, doing his sketches and making his colour-notes; but rather as if he's asleep and dreaming it.

Rubens' paintings for Charles I's banqueting house in Whitehall were still being completed when he painted the *Autumn Landscape*. He did it entirely by himself, as he did all his landscapes, but the banqueting house paintings were probably done entirely by assistants. So that raises a question mark over the whole issue of painterly pleasure and sensitivity. Whose sensitivity was it? How did it work?

Rubens' paintings always start as little oil sketches. He lays out the structure: the visual idea of the painting, the colours and form of it, in a quick passionate burst. These sketches might be a foot high or a couple of feet. They have to be somehow amplified-up, and this is done partly by Rubens and partly by his team.

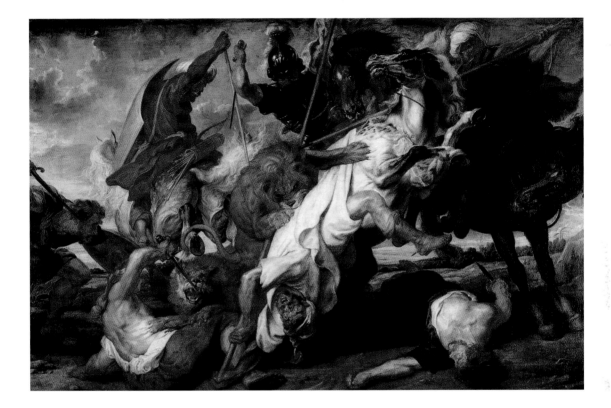

No artist of the past that we've ever heard of didn't have assistants but somehow with Rubens it counts against him, because we slightly don't trust him: it goes with him being slightly too much for us. In fact his assistants were artists who were already expert in painting different types of imagery – landscape or still life or horses, say. In the enlarging process they worked up the parts they were good at and then Rubens took over what they'd done, added his touches everywhere and made the painting back into a Rubens **68,69**.

That's why it's meaningful to talk about pleasure in paint for its own sake with Rubens, when we know he used assistants: it's his pleasure and it's their pleasure. It's their stuff he's taking over and making into his stuff. But at the oil sketch stage it's all his stuff and the vivaciousness and energy of that moment will get into the final stage to some degree. His system of prices reflected how much he was actually in the finished epic: you paid the most if a work was touched by him only, less if it was only partly touched by him and

70 Annibale Carracci, retouched by Rubens,

A Woman with Two Children

71 Perino del Vaga, retouched by Rubens,

Nessus and Deianeira

less again if he hadn't touched it at all. But the logic of his process meant that really he was always in it.

Rubens' idea of himself as an artist, and his sense of his own originality and seriousness, are confusing. He thought copying was essential: copying other people's art. When he first started out he absorbed classical art and modern Italian art by copying them in the form of drawings. Copying other people's art became the basis of almost everything he ever did. He built up a vast collection of drawn copies: ones he'd done himself and ones done by other artists, which he'd somehow acquired. Another striking thing is that whether they were by him or by a minor artist or an anonymous artist, or by a Baroque master or by Raphael or Holbein, he altered them: he retouched them and added to them, and he kept re-doing them until they felt right **70,71**. Not right like a photo but right according to something deeply felt. He imposed his own vision of the world and its rhythms on top of someone else's vision, which is how he used his assistants – so you're always coming back to Rubens' own nervous system.

When clients visited the studio, they saw the new paintings being done in all their different stages, and his assistants working from sketches. They also saw works from Rubens' past, which he deliberately held on to because he thought they represented the best he could do. One of these was *Drunken Silenus* **72**, which he finished around 1620, when he was in his forties, and then kept on display in his studio for the rest of his life.

He'd seen classical statues of this kind of figure everywhere in Italy. In mythology Silenus is a fat, falling-over demigod who's always drunk and who goes around with Bacchus, the god of wine. Although he's drunk he's got the gift of prophecy: he sings wise songs about the meaning of existence. Rubens produced a lot of different versions of the subject, painted and drawn, but none as heavy and forceful, or with such edges of weirdness, as this one.

You're not seeing objects where you thought you were: you're seeing a lot of shading and merging, which creates an impression of a contour of an object at about the point where you believed you saw it. That's part of the marvel of the painting: you may not realise it's marvellous, because you might be looking at it as though it's a view out of the window or a photo, rather than as a hallucination conjured up by Rubens' open, loose, slithery-sliding mark-making. The marks form themselves into the fur on a tiger (a traditional attribute of Bacchus), and

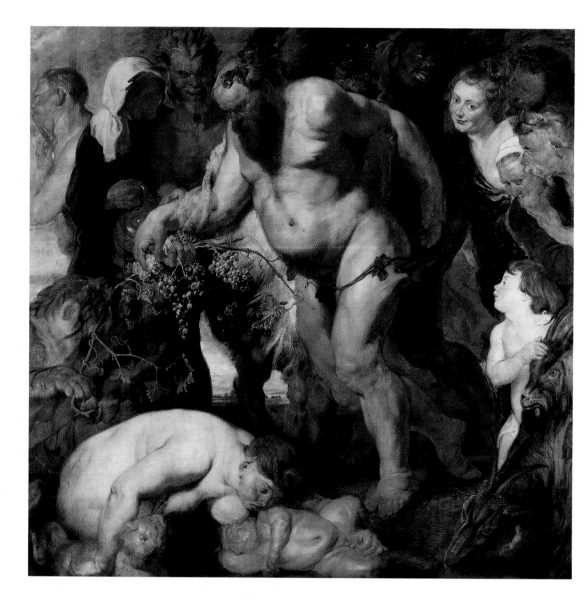

72 Rubens,

Drunken Silenus

the sheen on some grapes (another attribute), and into the wispy, white animal skin Silenus wears, which has just fallen off his shoulders. They form themselves into the individual hairs on some rutting goats, the queer, odd, glistening fatness of the satyr babies, the drip of milk on the satyr baby's cheek, and the mountainous glistening mother satyr who's suckling the babies like it's a satyr orgy and someone should be phoning the satyr social workers **73**.

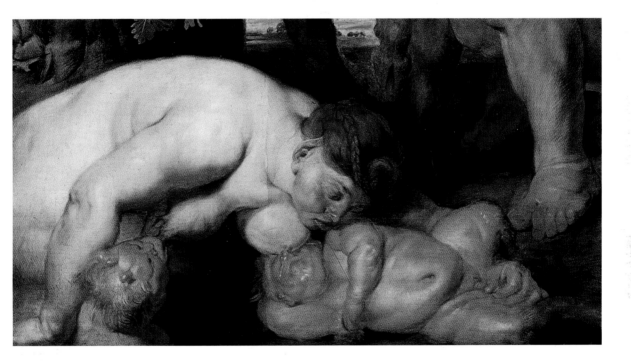

73 Rubens,

Drunken Silenus, detail

Silenus' epic toppling-over fatness, and the grinning, randy figures, and the animals and half-animals, all push beyond their traditional myth-shape, so the group seems much more sinister and real than the jolly myth of Bacchic orgifying calls for. There are rutting goats, fatty suckling glistening sex babies, man as beast and man merging with nature, all in a swirl of movement, with everything flickering into everything else: the earth flickering into the hairy satyr-baby's legs, and Silenus' blue-grey flesh picking up the blue of the sky in the background. Since Rubens kept this painting permanently on display in his studio, where there was a constant stream of visitors,

he must have regarded it as an emblem of what he did. It advertised what he was about. Not that art slavishly imitates life but that out of the pleasurable vagueness of paint and its wise language of hazy blurring, from which can be achieved an impression of marvellous precision, comes an expression: intuitive, personal, primal, like the songs that issue from Silenus' drunken mouth, of what it is that makes us human.

Not much is known about Rubens' death. For a long time he suffered from gout. The attacks got more and more severe. In the last few years of his life **74** his hands became paralysed and he gradually did less and less painting. During an attack of the illness in May 1640, he died. It was just before his sixty-fourth birthday and his wife was pregnant with their fourth child.

Rubens is always written about in art books as a great man who did great deeds and lived through great times – and he is great. No one else in art has quite his command of painterly flourish. But his greatness for us can only be on our terms, cut down to our size. And that means being realistic about how art is set up now and what we think it can and can't do. Our minds are always allegorical, always metaphorical, always making fables and similes. Allegory itself isn't dead, but Greek mythological characters like Bacchus and Minerva, Silenus and satyrs, *are* dead, except as available names for new sequels of *Star Trek*. The movies are our version of epic art; it's the movies not paintings that allegorise good and evil for us, and have the job of picturing collective fantasies. The mistake we make now is to see Rubens' paintings as if they were movies before the event: 'If only he'd had cameras. He could show us what happened next in the story!' But paintings work in a different way to movies: movies are light flickering on a screen and paintings are liquified matter spread on a canvas.

Shortly after Rubens' death his painting, *The Three Graces* **75**, which he probably finished in about 1638, entered the collection of the most powerful Catholic in the world, the King of Spain. It was given to his agent who was in Rubens' studio to buy up whatever he could for the King' collection. It was Helena Fourment, Rubens' widow, who gave it to him. Philip IV himself would never have met her and would be unlikely to know that he was looking at a picture of her. (That's her on the left.) There wasn't any nudity in Spanish art, because of the strict laws of the Spanish Inquisition. But those didn't apply to art brought in from abroad, a loophole that had allowed generations of Spanish

74 Rubens, *Self-portrait*

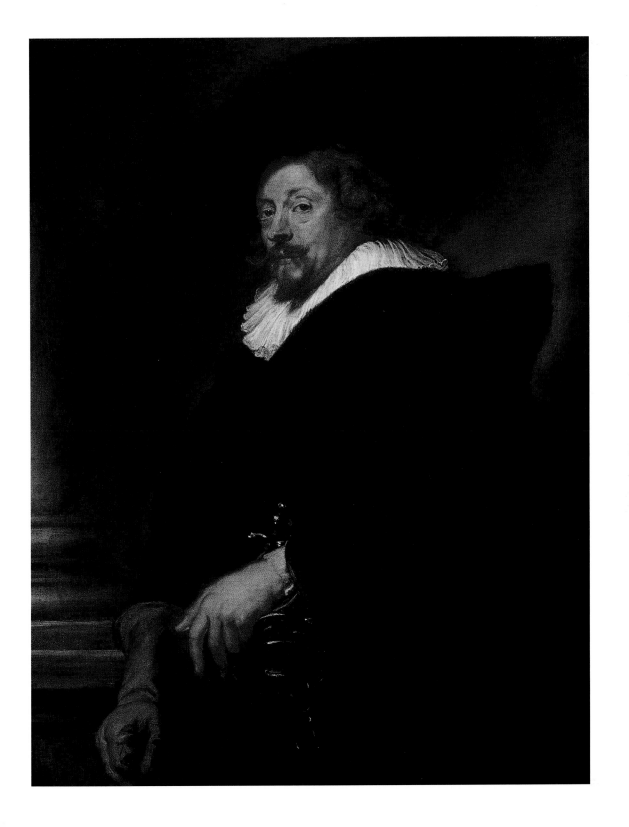

kings to build up great collections of mythological allegories featuring female nudity by foreign painters. The stories chosen allowed for the women to be shown from different angles, one angle in one painting, another in another, or several women in different positions in the same painting; that's why subjects like *The Judgement of Paris* or *The Three Graces* come up all the time, because they call for several women to be paraded naked at once.

To the King these are mythic figures, not real personalities. He's familiar with the story but is mainly interested in fat sentimental nudity. We're not interested in that on the whole, or in Greek myths, but there's something we do always want which Rubens supplies here, and that's pleasure. It's not in what you think is before you, though – an artificial, distant and slightly tedious scene – but in a different way of registering what's there. You recognise what the painting is of, but you don't realise it's also doing something mysterious: you believe in the illusion so much you don't see it's constructed out of melting paint. Focus on that. That's the bit that's for you. It's the dimension of the experience that's still alive and still wired to Rubens' nervous system. What he feels as he paints those brushstrokes on is the feeling you're now having: he wants pleasure and so do you. And now you're both getting it.

75 Rubens,
The Three Graces

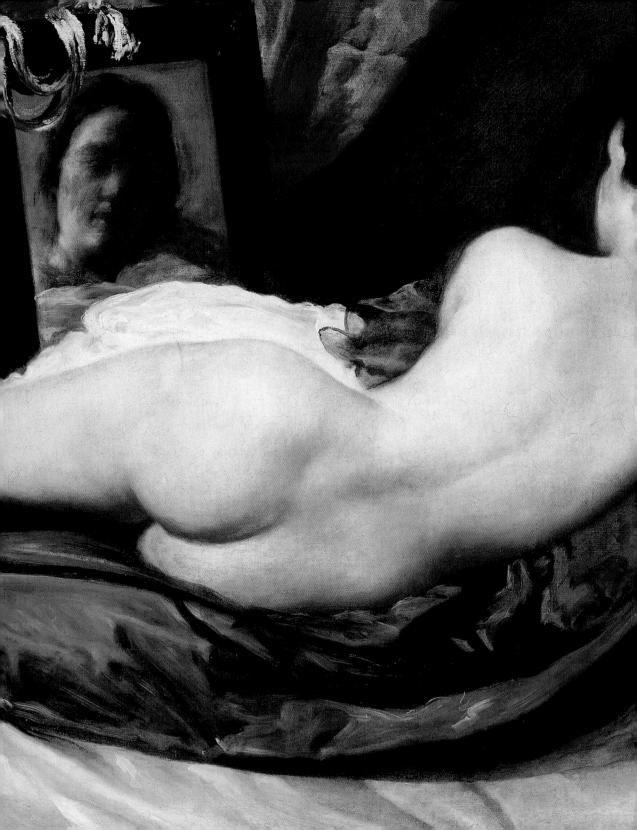

Velázquez
SELF

What am I?

Welcome to Spain in the seventeenth century. There're dwarfs, inbred royalty, nobles and ladies. Where you live now, there's modern technology everywhere, but here everything's stuck in the past. Nothing ever changes. It's all whispers and rustling and conspiracies – shadows and heat. Out of all the convention, rigidity and endless ceremonial formality of the Spanish court, and the plotting and paranoia, comes *Las Meniñas* by Velázquez **76,77**. It's a ten-and-a-half feet high by nine feet wide portrait of royalty, done in 1656.

In the middle is the heir to the throne: the Infanta, Princess Margarita. She's a tiny shining figure posed against a vast mass of grey. There are also others: why have them? Royalty, aristocratic minders and entertainers pose in a room where the artist painting the picture can also be seen, as well as everyone else. And the whole thing seems to be a reflection in a huge mirror, with the back of the canvas upon which it's being painted clearly visible.

Every person in the painting can be named, and we know precisely what room in which historical royal palace they're standing in, and even that the paintings at the back of the room are works by Velázquez' son-in-law, based on oil sketches supplied by Rubens. Despite all this information, however, no one knows for sure what the point of the painting was supposed to be when it was done, or whether the focus was really supposed to be the Infanta. Maybe it was the artist. Or the King, Philip IV, Velázquez's employer, whose reflection appears in another mirror at the back of the room, along with that of the Queen, Mariana of Austria.

In art-historical terms *Las Meniñas* is a high example of the naturalistic Baroque. This means that the compositional complexity and sophistication that's typical of Baroque painting – movement and counter-movement every-where – has here an emphasis of relaxed natural reality. The edge of the depicted canvas that Velázquez is painting on tilts one way, while Velázquez's pose tilts slightly opposite, then the rest of the figures across the scene repeat those diago-nals, so there's a whole symphony of differently angled planes from left to right, with the male midget at the opposite end directing the eye back to the Infanta in the middle, as he steps on the sleeping dog.

In this painting, abstract richness – a play of planes, shapes and spaces – goes with a feeling of utter reality: the figures, the immense room with its high walls,

the paintings lined up on them, the ceiling with its chandelier holders, the door open at the back and the light beyond it. Together the composition and the illusionism produce a feeling of believability. It's a scene you feel you could step into: the empty space at the bottom with its odd pinky-grey colour, almost invites you to do just that. The composition part of the equation is played off with such finesse that it hardly seems like composition, but just the order of things.

As well as seeming very real, everything also appears liquid and gaseous, and on the point of dissolving. The Infanta's hair is a smear, the black trim of her dress merges into it. Velázquez's fingers are pointy smears, and his brush isn't a line but a series of stabs. The whole grey flatness that takes up well over half the surface area is an alive, brushy, liquid haze.

77 Velázquez, *Las Meniñas*, detail

We don't know what Velázquez's title for the painting was. He died in 1660. Immediately after Philip IV died five years later, the painting was entered in the inventory of the royal art collection as 'Her Highness the Empress with ladies and a dwarf'. In the next century another court document referred to it as 'The Family of King Philip IV', and after that it was always called simply 'The Family' until it got its present title, *Las Meniñas* – 'the maids' – in the eighteenth century. The title refers to the Infanta's maids of honour – one of whom half-turns towards us – so it's pretty arbitrary. It might be that in a revolutionary century it seemed exciting to focus on the figures further down the power hierarchy instead of the ones at the top, although in reality those maids were aristocrats not servants, so they were higher in rank than the artist who painted them.

The Spanish painter, Luca Giordano, called *Las Meniñas* 'the theology of painting'. He described it that way when he was asked by Philip IV's successor, Charles II, to say what he was thinking as they both stood before it in the royal palace in Madrid, some time in the late 1690s. Theology was considered the most elevated form of philosophy, so Giordano was attempting to sum up the painting's high

intellectual tone as well as praise its technical achievement. But Velázquez's star was already fading, and it wouldn't shine again for two hundred years.

Before the 1860s he wasn't talked about much outside Spain, and when he was it wasn't really him: paintings thought to be by Velázquez and revered by connoisseurs were actually by other Spanish artists. Spain was isolated and so was its painting tradition. Even within Spain, it was Rubens who remained the touchstone of greatness after Velázquez's death, not Velázquez. Manet saw *Las Meninas* at the Prado in 1865, while the critical attacks on *Olympia* were still going on in Paris. A little cult of Spanish painting was already under way in Paris, but Manet did the most to push Velázquez and make him popular. He described him as the 'painter of painters' and said he made all the other painters around seem like 'fakers'.

In Michel Foucault's famous essay about *Las Meninas*, written almost exactly a hundred years later as the preface to his 1964 book, *The Order of Things*, he more or less says that it's irrelevant to ask what the painting 'really' pictures: it makes more sense to think about its self-consciousness, and the way Velázquez has constructed it to be a perpetual question, not an answer. In terms of the overall thesis of the book you're reading now, Velázquez is the next star of the painterly tradition, after Titian and Rubens; and the definition of painterliness is simply the pleasure that the painter takes in what he's doing. It's not a value that would be applauded by the audience at the time – they'd just say: 'Wow, that painting is more lifelike than any other artist could do!'

But in *Las Meninas*, painterliness is like a character in a plot: you're deliberately manipulated so that you're always aware of it. You're drawn to the marks across the fabric of those dresses, the darting points of light that make them up. And to the different, slower-moving light that runs across the ceiling and down the wall at the back. Just as you're drawn to the figure of the painter with his raised brush, and to the colours laid out on the palette that repeat the colour scheme of the whole painting – a lot of different browns, some ochre, red and white – and the expression of confident thoughtful seriousness on Velázquez's face. *Las Meninas* is now considered the great achievement of the Western oil-painting tradition, and at the same time, its great mystery. With it, Velázquez made the question of what he was – his personality, status and originality – into an object of fascination; an enigma like Jasper Johns' flags, only better.

78 Sarah Lucas, *Self-portrait with Fried Eggs*

79 Andy Warhol, *Self-portrait*

Everyone knows one thing the old masters always did was self-portraits. But why did they do them: was it vanity? We know self-portraits now are by Sarah Lucas or Andy Warhol, or Gilbert & George **78,79,81**. We know they're ironic rather than vain. They put fried eggs over their tits or they pose ironically. Or if it's Frida Kahlo **80**, modern art rather than post-modern art, then we think it's sincerity and not irony: we see one kind in terms of the other kind. But when it's an old master the terms are different again: we think a self-portrait is a kind of permission to do something that in ordinary life has something dubious

81 Gilbert & George, *Street*

80 Frida Kahlo, *The Two Fridas*

connected to it: staring at yourself. The old masters are self-regarding in an intense way. So intensity makes up for vanity.

82 Poussin, *A Dance to the Music of Time*

We assume that in the past art was deeper: it had moral, psychological and aesthetic depth and was never merely arbitrary. But I can think of an example of the self in old master-art that really is arbitrary. Poussin's patron, Guilio Rospigliosi (later Pope Clement IX), gave Poussin the subject for *A Dance to the Music of Time* **82**, but Poussin gave it something Rospigliosi probably didn't ask for: he carefully pressed his thumb into every inch of the ground when it was still wet, so its print can be clearly seen throughout the paint surface,

83 Poussin, *A Dance to the Music of Time,* detail

84 Velázquez, *Las Meniñas*, detail

unrelated to anything else that's going on in the painting, either in the imagery or in the brushwork **83**.

Poussin was one of Velázquez's contemporaries. He was French but worked in Rome. Velázquez is likely to have met him. He's the master of perfect order. Although we don't know if he was particularly well-educated, he's come to stand for reason and intellect, and a thoughtful sublimation of the impulsive, arbitrary, individual self. But here he is, imposing something personal, his body's own imprint, in such an oddly literal way that someone on *Late Review* ought to be braying out an explanation of it that they've read in a press release from the Turner Prize. It has today's art-culture's feeling of official pointlessness and unhinged values.

Painting of the past isn't always what we think, then, and nor is *Las Meniñas*. Its playfulness is that it keeps changing, while keeping up an illusion of straight-forward reality. It's believable as a scene partly because of the apparently relaxed atmosphere. The glances, the standing around, the shadows: none of this has any effort about it, as if it's simply reality expertly captured. In fact, soon after Velázquez's death his first biograher, Antonio Palomino, praised *Las Meniñas* for being 'truth, not painting'. But the number of figures, the great size of the paint-ing and the rich complexity of the space: the authority of all that is awesome, and it brings you back to the figure who invented it all **84**, even though he's only one of a number of possible focus points in the room.

Velázquez built up *Las Meniñas* in short stages of work over a period of about eighteen months. The result is that there's a feeling of reality, but also a lot of ambiguity over where everyone is in the picture and what the plot is – *why* are they where they are? We know from a record made by Palomino, who based his account on interviews with four of the surviving characters pictured in the paint-ing – that the one standing in the doorway is José de Nieto, the marshal of the Queen's part of the royal palace (*aposentador del reina*). One of his ceremonial duties was to open the doors of the palace for the royal couple, and that's why it's usually thought to be the King and Queen themselves reflected in the mirror, not just a portrait of them on the wall. Velázquez stands at the easel: at the time his court position was King's palace marshal, (*aposentador del rei*, José de Nieto's counterpart). There are the two maids of honour with the Empress, Maria Augustina Sarmiento and Isabel de Velasco, plus two dwarfs: Mari Barbola, a

German, and Nicolas Pertusato, an Italian. A chaperone, Marcella de Ulloa, and an unnamed bodyguard stand in the shadows.

If the King and Queen were physically in the room they'd be standing where you would be now, if you were in the Prado looking at *Las Meniñas*. That is, they'd be in Velázquez's studio but outside the painting; they'd be a presence beyond the space of the painting but a catalyst for everything that's happening in it – that whole rustle of movement. (The King is known to have been in the habit of visiting Velázquez in his studio and watching him work.) Or the reflection in the mirror might be the image on the canvas that Velázquez is painting: he's painting a portrait of the King and Queen – unless he's painting *Las Meniñas*, the painting you're looking at **85**. Why should uncertainty be deliberately built into the painting about whether or not the King of Spain is in the same room as his court painter? You realise there's a lot you don't know.

85 Velázquez, *Las Meniñas*

The shimmering substance of the painted surface of *Las Meniñas* is indeed pretty 'ravishing', as Manet wrote in 1865: 'He has ravished me!' Look at the musicality of the dancing rhythm that those darting black and white marks are making. But now think about those dresses not as painted things but real things. If you were looking at *Las Meniñas* in the Prado now, you'd also be surrounded by Velázquez's portraits of female royals. You might wonder about their clothing. Anything feminine has to be repressed. In the upper parts are metal plates that press down on the breasts, and the lower parts are crinolines made of anything from seven to eighteen petticoats, depending on whether it's summer or winter. These are supported by a wooden frame, the nickname for which was *verduro* – which also means 'hangman', 'torturer' or 'whip'. The women's feet can never be seen and they can never sit down **86**.

86 Velázquez,
Mariana of Austria

Velázquez constructed the perspective of *Las Meniñas* so that it felt to the viewers of his time as if there was a straightforward relationship between the painting and reality – or one, at any rate, complicated only by amazement that any artist could possess such divine powers. In fact the perspective is pretty free and changeable; it isn't bound to any rules at all. And as you realise this you begin to wonder about other things that may not be immediately apparent: the relationship between casualness and formality, between something ceremonial and something spontaneous, and between servants and bosses.

Own self

Velázquez was born in 1599 in a house just off Alfalfa Square, in Seville. Once the richest city in Spain, Seville was now in decline; Madrid, where the court was, was the new centre. Velázquez's family had a vague hint of noble blood somewhere in its past. In later life his social origins would become an obsession. He thought of himself as rather upper-class. He did work for the King and became his friend. But the connection wasn't based on nobility recognising nobility. It came about initially through Velázquez following the conventional artistic route of the period. He was an apprentice painter for seven years, he married the masters' daughter, and then he entered a guild of artists and set up a workshop. He wasn't particularly religious but the rule of religion dominated his early artistic career. The Church was the main patron of art in Seville: artists

87 Velázquez,
Man with Ruff Collar,
thought to be
Francisco Pacheco

produced the kind of art the Church asked for, which didn't tend to be anything stylistically original.

Imagine a contemporary parallel. Artists today want to be in the media all the time, be bought by Saatchi, get the Turner Prize and have a newly converted loft in Shoreditch. They can accomplish this by having shows abroad, having a top dealer to promote them, and pretending to be sophisticated theorists by never saying anything that has any rational meaning for an ordinary person – in this way, they will definitely be thought to be an artist. But in seventeenth-century Seville you didn't construct yourself as an artist: the Church did the whole job for you. A Church leader requested a set of paintings for certain niches in a cathedral space, say. He supplied detailed requirements for the treatment, using engravings of older art, Italian or Flemish. And you executed the commission. On the whole your job as an artist involved a bit of art-dealing, running a restoring business, doing a lot of copies, holding out for occasional Church commissions and getting by as best you could. You never travelled abroad. Your social rank was something like that of a shoemaker or barrel-maker; in fact, your earnings were taxed in exactly the same category as theirs.

Velázquez's master was the artist Francisco Pacheco, who might be pictured in Velázquez's *Man with Ruff Collar*, from 1620 **87**. Pacheco's painting style in his *The Immaculate Conception* **88**, from 1621, mixes established northern European and Italian styles of the previous hundred years. What seems very moving about this painting now – religious sincerity, clarity and simplicity – is actually a period charm, common to any number of artists working in Seville at the time. Everything that appears in the oil paintings and painted wooden reliefs and wooden sculptures of Sevillian art in the early 1600s comes originally from foreign art, which the artists knew only second-hand from engravings – these were part of the general equipment of their studios. They showed artists what poses to do, what clothes the saints should be wearing, and what religious suffering looked like.

While Pacheco was a typical painter in his methods and in his dutiful following of set styles, he was untypical in his advocacy of art's noble calling. He was the leading figure of the Seville 'academy', a loose group of poets, scholars, artists and private patrons that met regularly to discuss literature and art in the houses of the various noblemen connected to the group. Pacheco, who was writing a treatise on painting – eventually to include many descriptions of the greatness of

Velázquez – led the talks. He said art had an idealising purpose. It was noble because it softened, altered and changed reality in the service of an idealised reality. The world of natural appearances, the stuff you saw with your eyes, was nothing; smoothing out and idealising natural appearances was everything. He always returned these thoughts to the central place of religious piety in art's purpose, but his secondary principal was that painting was a high art like poetry: his ideas were those of the Renaissance as well as the Counter-Reformation. They were fuelled by a humanist fascination with classicism and the past, mythology and allegory, and the notion of individual artistic genius. Velázquez absorbed this as much as he took in Pacheco's religious strictness.

The academy wasn't against the system of Church art: Pachecho was so not against it he was actually employed by the Inquisition as a *veedor*, an inspector of sacred images. He had to check for nudity – of course, there would never be any. But he also had to check that exactly the right number of nails were depicted in the Crucifixion, and that the mourners at the base of the Cross were in exactly the right position. Going wrong on this kind of thing could be punished. It was rare to be tortured or killed by the Inquisition for having incorrect Christian iconography in your painting, but in theory you could be: not just a bad review in *Art Monthly*, actual death. The need to be on a twenty-four-hour piety alert was so fixed in the artists' heads that it would be considered perverse to do anything that didn't immediately signal in an absolutely clear way that some piety was going on. Finding creative new ways to express piety would have been a peculiar career choice – but this is just what Velázquez did in his first commissioned paintings.

The ideas preached by Pacheco offered him a window out of the fixed religious mindset, a way of expanding the pious model in a creative and expressive way. At that time, art was generally considered to be separate from – and below – literary culture. But Pacheco was always discussing this type of culture while at the same time practising successfully as an artist. As Pacheco's apprentice, Velázquez lived every day in this atmosphere, which made him unusually conceptually agile: not fixed as artists were expected to be because of their conditioning by Church patronage. It gave him the ability to be his own man, to be critical, analytical and thoughtful, and not merely manually skilful.

Within a very short time he became successful both with private collectors

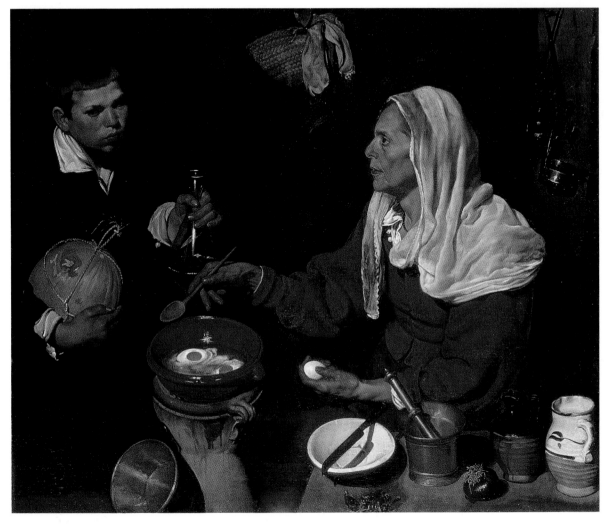

90 Velázquez, *Old Woman Frying Eggs*

and with Church leaders for paintings known as *bodegónes* **89-91**. This term, now obsolete, refers to a kind of kitchen-based still life that includes people, and the idea of it was that you had to give the objects in the scene as much vivid realness as the human figures. *Bodégon* is still the Spanish word for a cheap eating-place or tavern. As a type of painting it was considered a low form, but Velázquez gave it gravitas and a feeling of profundity: a feeling of a loaded moment or atmosphere. About twenty of these kinds of scenes still survive from Velázquez' time as an artist in Seville. All were painted before he was twenty-four. Some have the same kind of people and objects but the context is biblical rather than everyday: peasant types become sacred personages. He got the message from Pacheco that you couldn't break the rules of the Church but he also got the message that the true artist was an explorer. The Church wasn't positively against a feeling of local everyday realism, it was just that until now Sevillian artists hadn't thought of bringing this approach to religious art.

He painted *Christ in the House of Martha and Mary* when he was nineteen. What impressed his viewers then was what impresses us now: the sheen on the fish and the contrasting texture of the eggs, plus the relaxed timeless naturalism of the garlic on the table. At the same time as it's a casual scene it's monumental: it has a grand touching calm. The servant girl in the foreground grinding spices with a pestle and mortar, is usually assumed to be Martha. The old woman is a servant. In the New Testament story Martha complains to Christ that she's forever serving while her sister Mary can sit at Christ's feet receiving the divine wisdom. Mary is seen with Christ and an unknown woman. They might be seen through a hatchway, or it might be a reflection in a mirror. That is, both scenes might be going on in the same room, and Martha in the foreground who looks out at us might actually be looking out at Christ. Making the sacred scene only a few inches high and the less sacred scene much bigger wasn't a trick that would ever have occurred to a Spanish artist before. But Velázquez wasn't being sacrilegious: he was stretching a convention not attacking it.

Velázquez' natural ambition, combined with the conceptual models he received from Pacheco's teaching, was responsible for this stylistic leap, which is one of the most radical in all of either Renaissance or Baroque art. Its success with Church leaders in Seville – who wanted to commission more and more work from him – made him want to leap further, to Madrid, the centre of patronage.

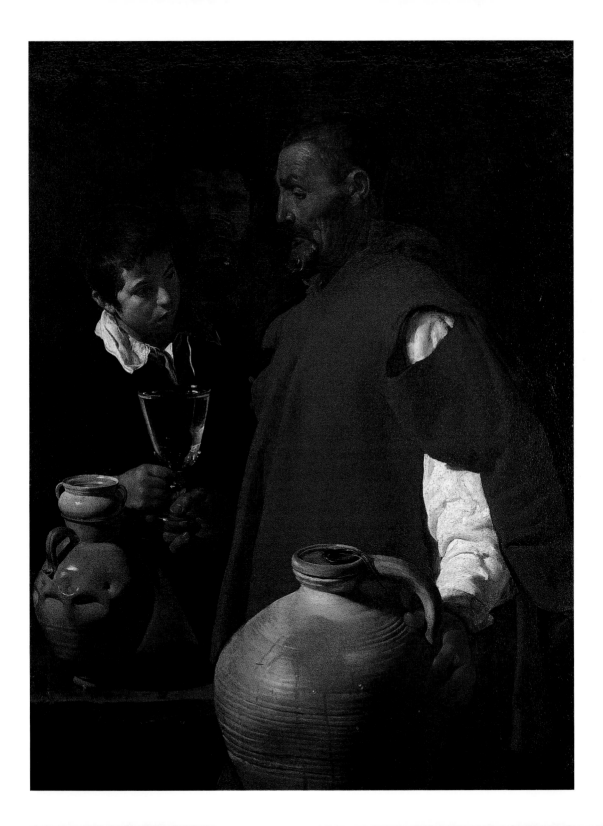

91 Velázquez,

Waterseller of Seville

92 Velázquez,

Count-Duke of Olivares

He travelled there twice with the aim of painting the King's portrait. The second attempt was successful. Both relied on contacts from the Seville academy.

One of these was the Count-Duke of Olivares **92**, the King's first minister: Olivares had spent several months in Seville before taking office in Madrid, surrounding himself with poets, writers and artists, including Pacheco, who'd painted his portrait. Through Olivares' efforts, Velázquez was allowed to paint the portrait of the King: there was a sitting lasting about three hours on August 30 1623. Velázquez then took the canvas away and finished it **93**. It was shown to the King, judged to be good, and Velázquez was ordered to move to Madrid permanently to join the six other official painters at the court – which he did in October.

Spain's power was going down. The money coming in from its New World kingdoms all went out again on wars and revolutions in Europe. There was very high taxation, but no aristocrats had to pay. The King was too young and weak to stop the decline and all the power was in the hands of Olivares. To compensate for everything deteriorating in real terms, Olivares put a lot of furious energy into building up the magnificence of the court, and the prestige and status of the King, which is where Velázquez fitted in: Olivares arranged that Velázquez would be the only court painter allowed to paint the royal portrait.

Philip IV is fifty-one in *Las Meniñas*. He was seventeen when he first met Velázquez. Velázquez was twenty-four. The king's life was completely controlled. His every movement throughout the day was planned, part of a complicated performance enhanced by visual splendour all around, which it was now Velázquez's job to enhance even more. Velázquez had entered the frozen ritual of court life: a long list of ancient Gormenghast-like job titles stretched before him: usher-ships and marshal-doms of obscure projects, domains and ceremonies. He'd be having his ideas from now on in high-ceilinged chambers and corridors called things the 'Gallery of the North Wind', the 'Hall of Mirrors' and the 'Room the King Retires to After Eating'.

The locations were the Alcazar in Madrid, one of whose rooms is the setting

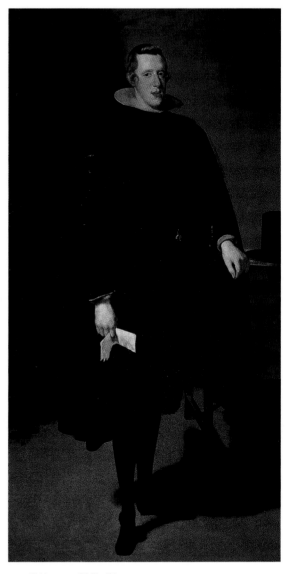

93 Velázquez, *Philip IV*, x-ray

94 Velázquez, *Philip IV*

for *Las Meninas*, and the Escorial to the north of the city. The Escorial was a pala-tial mausoleum, housing the tombs of the king's great ancestors. There were pic-ture-galleries with thousands of paintings: rooms devoted entirely to nudes by Titian. The Alcazar had been a medieval fortress: Philip IV's grandfather, Philip II, converted it into the main royal palace, and the whole of city life now revolved around it. Later, as part of Olivares' programme of rebuilding national confi-dence, pleasure palaces outside the city were built: the Buen Retiro and the Torre de la Parada. Velázquez's duties included assisting in decorating all the palaces.

Five years after his entry into the court Velázquez painted over the portrait of the King that first got him into the court: he redid the features and recast the whole pose **94**. The reason for this rethinking was the visit to the court by Rubens, who arrived in 1628 on his diplomatic mission on behalf of the Arch-duchess Isabella, to get peace between England and Spain. During his nine-month stay Rubens painted formal portraits of the King and some of his nobles. He ignored the other court painters and befriended Velázquez alone. He looked at the royal collections of art with him. He travelled with him to the Escorial to see the Titians there. He started copying Titian's paintings in all the royal collec-tions, one after the other: full-size copies – Velázquez was amazed. He was famil-iar with Titian, but Rubens opened his eyes to what he'd always seen, but not known.

Rubens' fluid, loose, broken-colour handling followed Titian's patchy broken stuttering-form style – answering, echoing and redirecting it. His changes to the composition of *The Rape of Europa* are minimal, but the colour change is dramatic: the rippling fatness of the *putti* seems to increase through luminosity alone. In his version of Titian's *Adam and Eve* the figures, especially Adam, are much more like individualised human beings than in the original: and throughout the painting every shape, from the leaves against the sky to the muscles within the bodies, is completely revitalised. The painting is the same as the Titian but different, each object vivified in relation to every other object in a slightly different way, but conforming to an identical overall compo-sitional dynamic.

While Rubens was doing all that, using studio facilities provided by Velázquez, Velázquez started painting *The Triumph of Bacchus* **95**. This is the culmination of his *bodegón* style: real-looking peasants with leathery faces and broken teeth

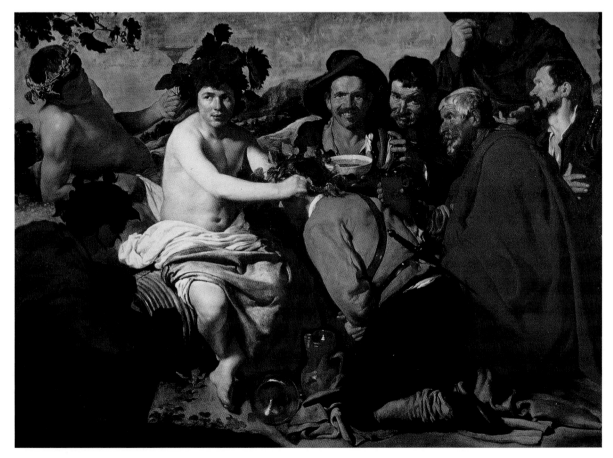

95 Velázquez, *The Triumph of Bacchus*

in a huddle getting drunk. But the choice of a mythological rather than religious context shows Velázquez now allying himself to Rubens and Titian.

The myth he's illustrating is Bacchus arriving among mortals and bringing the gift of wine: he rules the earth benevolently; he crowns a good soldier with a wreath. The real-life back-story of *The Triumph of Bacchus* involves a painting competition held the previous year in March 1627: it was the result of rivalry between Velázquez and three of the other court painters. They accused him of not being able to paint anything except heads: they said he couldn't do compositions. They all had to submit their own versions of the same scene showing Moors retreating from Spain. He won the competition, and as a result received two court promotions: he was made gentleman usher of the privy chamber and also first court painter. Now he'd jumped ahead of his rivals. The judges of the competition were noblemen, friends of Olivares, so Velázquez won because of his contacts rather than his skill. Now the other painters resented him even more. During the next decade he had the power to be able to hire whoever he wanted as court painters: he chose relatives and old friends, including his son-in-law and a fellow apprentice from when Velázquez was studying with Pacheco in Seville.

The Triumph of Bacchus is usually interpreted as an allegory of the King's favour. Bacchus is a divinity, and Philip IV is revered as if he were divine: he's known as the Planet King because the sun is thought to be fourth in the position of the planets. So Bacchus equals the King, and the soldier he's crowning equals Velázquez: the King's favourite, his first painter. Although the style is solid and sculptural, like Velázquez's *bodegón*, the allegorising anticipates *Las Meniñas*, in which royal power and artistic genius are also aligned.

A few weeks after Rubens left Madrid for England, Velázquez left for Italy: Rubens had advised Olivares to send him there to 'perfect his art', as Velázquez's still-surviving official travel documents state. Most of his time was spent in Rome, but he also visited other cities, including Venice. He drew copies of Tintoretto's *Crucifixion* in the Scuola di San Rocco, and painted a copy of Tintoretto's *Last Supper* – also in the Scuola – which he presented to the King when he got back to Madrid. He was given an armed guard to accompany him in Venice, because of anti-Spanish feeling in the streets at that time. Because of his position as the King's first painter he was received cordially wherever he went: in Rome he was given rooms in the Vatican Palace, but moved after a while because

96 Velázquez,
Philip IV in Brown and Silver

97 Velázquez,
Philip IV in Brown and Silver,
detail

it was too lonely. Throughout Italy he studied the art in various palaces, following Rubens' theme of absorbing ancient and Renaissance art and meeting the living artists of the time.

When he came back his painting style was transformed: transparent, sketchy, liquid, with solidity and space now a matter of impressions rather than a kind of painted equivalent of sculptural carving, which had been the hallmark of the *bodegón*. Before his Italian trip, he painted on a ground of thick opaque red. After he came back he tried painting on white. Where the paint was previously a uniform paste he now varied it, using a lot of thin pigment contrasted with dramatic patches of thick. The thinness permitted watercolour-like effects: plays of light and shimmering transparent form that reach a peak in *Las Meniñas*.

When he painted *Philip IV in Brown and Silver* **96,97** at the turn of the decade he used long-handled brushes to apply the dragged and stabbed dotted smears of grey, black and white, which look random and gestural close up, but from a distance come together in a perfect likeness of lace. Still basing everything on a powerful illusion of reality, Velázquez now placed a new trust in the viewer's ability to organise: he started to involve the viewer more dynamically in the process of seeing. It's a leap. The King used to be great in portraits because he was painted rigidly. Now he's great because he's painted casually.

Substitute self

Why is there ambiguity in *Las Meniñas*? **98** Why not just come out and say what you mean? If an old master is being mysterious we think it's because of the artist's truth of prophecy, or heightened seeing, as opposed to the blindness of everyone else. An artist must always be having titanic wrestling matches with reactionary forces ranged against him: he's moral and spiritual while his environment is corrupt. In reality, though, Velázquez was an expert in manipulating his environment in order to advance his power in it, to get a cushier lifestyle and more money. So his truth is a pretty indigestible one for modern sentimentalists. He's as great a painter as Rembrandt, but when he shows himself he doesn't seem to show anything at all.

Rembrandt is the artist we expect to give us substance. He shows a stripped-down real self: the old worn-out vulnerable sinful self, like anyone else, speaking

98 Velázquez, *Las Meniñas*, detail

99 Rembrandt,
Self-portrait

to everyone, with everything that's heavy about life and all its punishments and disappointments expressed right there on the surface **99**. And he shows us this in a context of incredible skill.

His self-portrait in London's Kenwood House, aged mid-sixties, is very physical: the piled up matter is not the liquid flow of Titian, Rubens and Velázquez, but physical substance that is scratched into and trowelled over, with wet paint on dry and wet into wet – an accumulation of changing moods. Shadows build up and then more paste goes over the shadows. He comes back again and again: looks inward again and again. Out of the backing and forthing and the scratching and brushing, a sympathetic man from 350 years ago gives a look back to us of someone as ordinary as we are. The look says how fragile all our set-ups in life really are.

The myth of Rembrandt's life is full of failings that are more extreme than many of us have to suffer: the deaths of his children and loved ones; messy love affairs; the wrath of his neighbours because he's not religious enough; great fallings from stardom to the gutter; bankruptcy and poverty, followed by death in obscurity. His life is a mess, but that makes sense to us, because his art needs to have something it can gloriously rise above. Every inch of this lovingly wrought surface, with its energy coming through and its unmistakable and unavoidable greatness, seems to have a counterpart in the earthly story of things going badly wrong.

In *Las Meniñas* the feeling of a real face looking out at us from just as long ago is also moving, but more because it's from the past than because some kind of inner soul is being bared. In this painting Velázquez isn't an existential questioner like Rembrandt. He lays on painterly dazzlement, but he keeps a reserve. Rembrandt gives us the direct gaze, he shows us someone real, whereas in *Las Meniñas* Velázquez gives us hierarchies of power: he shows himself in relation to everything else, as if he only exists in connection to others. He sets up clues about the way he wants to be seen, but he doesn't express anything that actually seems to come from within – he's a cipher.

His paintings of the King never express an individual personality, either. The King was melancholy. By the time of *Las Meniñas* his wife and son were both dead. He had a new wife. He kept having affairs with actresses. He feared religion. He didn't trust his ministers. He'd long ago sacked Olivares and banished

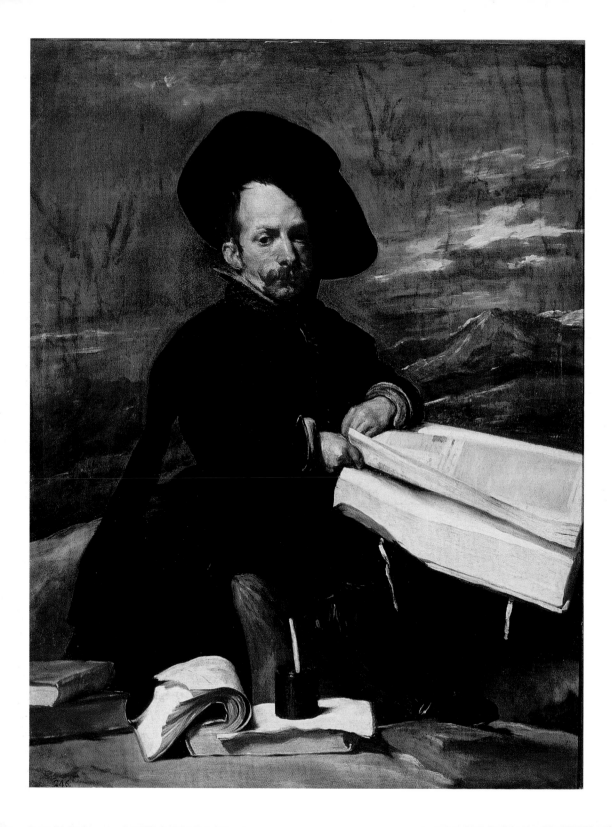

100 Velázquez, *Court Jester, El Primo*

101 Velázquez, *The Court Dwarf, Don Francisco Lezcano*

102 Velázquez, *Don Sebastian de Morra*

him for failing to save the empire. At first he'd said he was going to rule on his own. Instead he hired another nobleman, Olivares' nephew and rival, to do the job. He sent armies abroad to recapture lost territories. He retreated out to the Escorial more and more to pray, and he went on long hunting trips. He looked at paintings. He knew a lot about art. He recognised Velázquez's specialness. They were each other's closest intimates, meeting every day, but Velázquez never hints at any of the richly contradictory character of his friend. He only does understatement, expressing grandeur by handling and atmosphere, by subtle editing and placing. He's economical with shapes, shadows and objects, and always blanks personality. This conforms to court etiquette: royalty never showed emotion in public: they never smiled.

When Velázquez paints dwarfs, though, he's very moving about human psychology **100-102**. The tradition of having dwarfs in court life went back to the Middle Ages: its origin was charitable. They became entertainers, and some were famous and well paid. When Velázquez first worked at the court he was classed as a court servant and shared their daily existence. Their job was to be witty and to say the unsayable. In *Las Meninas* he might be saying the unsayable through allegory. They said it through joking.

Velázquez's portrait of Francisco Lezcano was done to go over a doorway in one of the King's private chambers in the Torre de la Parada, next to another dwarf painting, *El Primo*, which went over an adjacent door. The backgrounds to both paintings are lofty landscapes: mountains being a joke on shortness. Lezcano was a fifteen year-old Downs Syndrome dwarf. Velázquez is objective about his appearance but also tender, he sets the head against a delicately brushed transparent wash. In the other painting the background is eerie: brush wipes cut across a misty nothingness. The scale is strange: a roughly indicated mountain slopes upwards behind the figure, so the book he's holding seems even more enormous. This dwarf is an unknown character playing the role of a philosopher. Later it was thought he might be a well-known entertainer in the court during the 1640s. He was supposed to have got the nickname, 'El Primo,' because he claimed to be the cousin of Velázquez: the 'first' painter.

In the painting of Don Sebastian de Morra the brush is dragged over the forehead, lace cuffs and lace collar. The dwarf's natural colouring is dark: black cropped hair, black beard and black eyes. The fists are balled, the legs foreshortened with comical rounded feet pointing upwards, soles outwards. The figure fills the canvas: the impression is of a sphere in a rectangle, a man rolled into a ball. The statement is shock, frontality, nothing hidden or disguised: 'I'm being absolutely frank with you. I dare you to stare at these limbs and into these eyes.' The statement of the beautiful greeny-black and red outfit with its gold trim is: 'I can afford to stare at you because I'm a success, but I dare you to stare at me.'

If the dwarfs are vulnerable types through whom Velázquez expresses emotion by proxy, like Andy Warhol's superstars in his 1960s underground movies, the *Rokeby Venus* is a different kind of actor: a mystery woman who keeps her mystery. **103** Named after its eventual English owner, the painting shows a

traditional mythological scene: Venus and her son Cupid. Velázquez might have painted it during his second trip to Rome, at the end of the 1640s, when he was sent there to buy sculptures for one of the new palaces. During his two-year stay he lived a free existence. He had a mistress. She might have been the model. She had his child, who was born after he returned to Madrid. Art history records only that it was a boy, Antonio, who was given to a nursemaid to look after – which seems a bit heartless of art history.

He might have sent the *Rokeby Venus* back to Madrid in one of his shipments of art acquired for the new palace decorations. It might have been inspired by the sculpture of a hermaphrodite he bought for the King, which has the same pose – and which is displayed today in the same room in the Prado as *Las Meninas*. But the small body and the tied-up hair suggest a live model.

Anyone involved with the painting – the author, the owner – must have had protection at the highest level to avoid being arrested and interrogated by the Inquisition. It was first documented in 1651 as belonging to Don Gaspar Mendez de Haro, the son of the new prime minister: since he'd just got married, it might have been given to him as a wedding gift by his father, or by the King. Or he might have commissioned it himself. He would have kept it in a bedroom behind a curtain, which would very rarely be opened. Later it was recorded as being kept on a ceiling, also veiled.

The paint is disturbed, brushy, but the scene is still, everything lies flat against the picture plane. There's nothing dynamic about the composition. The suggestion of movement comes entirely from the blurriness of the reflection in the mirror: so the mirror is key because it changes everything. The figure is turned away. We're not shown the breasts or the rest of the front of the body. Where they should be reflected, given the position of the mirror, we see her face instead. The painting has some of the same games with mirrors and reflections that *Las Meninas* has: you're looking in at her, but because of the position of the mirror she's looking out at you.

In *Las Meninas* the mirror with the King in it, bathed in light, would suggest to the King the divine virtues of the monarchy **104**. The King is always sacred and any image of him is sacred too: traditionally, a subject could only look indirectly at him. When we look at the royal image in the mirror in *Las Meninas*, we're brought back to the mysterious powers of the artist who created it: it's just

OVERLEAF

103 Velázquez,

The Toilet of Venus

('The Rokeby Venus')

163

a blur but the blobbed red is perfectly readable as drapery and the familiar long facial features are perfectly recognisable.

In Velázquez's time there was a deep-rooted social prejudice against artists: they weren't gentlemen. For the other court officials, Velázquez's artistic abilities set him below rather than above everyone else – his gifts brought him power in real terms, since he was the King's only friend, but they would always bar him from official social status. In Italy, he knew, this was all supposed to be different. The struggle to raise the status of the profession of art began there in the fifteenth century, and by the sixteenth it was pretty much settled: artists were always being given honours and titles by dukes and kings. Because of his exposure to the ways of art abroad – his personal contact with Rubens, as well as his meetings with artists in Rome, Florence, Venice and Naples – Velázquez knew it would be considered ignorant and vulgar to treat painters in Italy as mere craftsmen. On the other hand, many Italian nobles and educated people still hadn't got this message, as the story of Salvator Rosa's self-portrait in London's National Gallery demonstrates **105**.

104 Velázquez, *Las Meniñas*, detail

This painting, done in Florence in the 1640s at the same time that Velázquez was painting the dwarfs in Madrid, is one of the most convincing and attractive portraits of what an artist should look like that I can think of. It shows the artist as an unattainable – for most ordinary people – model of integrity, of dignified restraint and seriousness. The strain of being so different to everyone else, so prepared to make the sacrifices that being an artist calls for, means that you've got a self that's ravaged by inner conflict. 'Keep silent unless your speech be better than silence,' the inscription on the stone slab reads – it's from Stoic philosophy, which comes from ancient Rome. Stoicism is about being highminded and refusing to be weak. Rosa wears the outfit of a scholar: he has the look of someone who lives and breathes at the highest levels of moral and philosophical being. His pinched, dark, famished, strained features speak of an internal struggle that mere ordinary guys like us couldn't ever have. But actually he wasn't that. The painting is about impressively lofty ideals rather than a way of life that was actually lived by Rosa.

Another oddity in this chapter's gallery of clashing artistic selves, Rosa is a deliberate fabricator of multiple self-images, all designed to elevate his social status. In order to establish a market for his line of stark, blasted landscapes, and

105 Salvator Rosa, *Self-portrait as a Philosopher*

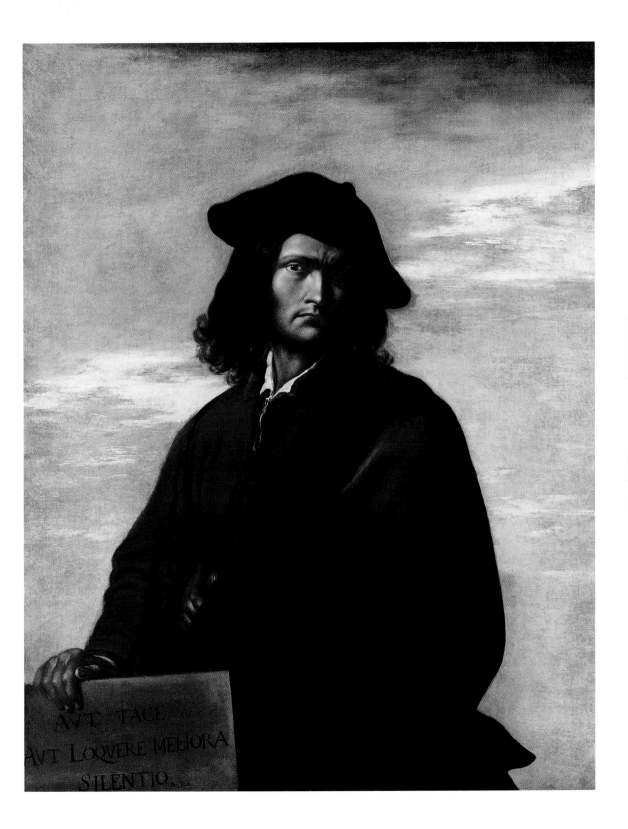

his portraits of philosophers, he kept up a negative publicity campaign against anything soft, delightful or too easily enjoyable in painting: he made himself the star of the campaign, portraying himself as philosopher, actor, poet and soldier, even as an artist.

Rather than keeping silent, as the inscription in the National Gallery painting instructs, he never shut up. He declaimed his own verses in public. He praised his own genius. He performed in self-penned satirical plays that insulted his rivals. He talked about the need for patrons in Florence and Rome to recognise the nature of genius, personified by himself, and to be patient for commissions they'd paid for but which he hadn't finished yet, because he was waiting for the muse of inspiration to strike. This painting shows him to be a great artist, but he was a narcissist and poseur as well: the statement is that you can be searingly good, but you needn't necessarily be all that authentic. You can be searing and a fake – because getting ahead might call for that.

Noble self

We've seen the arbitrary self of Poussin, the stripped-down authentic self of Rembrandt, and now the self-acting-a-role of Salvator Rosa brings us to Velázquez's hustling, slightly unpleasant self. In *Las Meñinas* he's nearly sixty: he's been a courtier all his life, having held one position after another. He's recently been appointed *aposentador del rei*, supreme marshal of the palace. For nearly two decades he's been distracted from painting because of having to organise ceremonial stuff, buy art, come up with architectural advice and act as a kind of seventeenth-century equivalent of a head curator in a modern art gallery. Ever since his appointment in 1643 as Assistant Superintendent of Works, and then as Gentleman of the King's Bedchamber, he's been engaged in this kind of work, and now his *aposentador*-ship is the reward for those services. The post involves seeing to the King's linen, making sure the reed matting that covers the palace floors in winter is in good upkeep, procuring fire wood for the King's fires, organising the cleaning staff and holding the King's chair at banquets. He gets multiple salaries. He's rich. He holds a special key that opens every room in the palace. He lives in a six-room painting and tapestry-lined apartment that directly connects to the King's quarters. But there's still something he doesn't have: a knighthood.

It's likely that Velázquez's obsession with being knighted started when he met Rubens. He knew that Rubens and Titian were both knighted by Spanish kings. The obsession developed and grew over the years in Velázquez's mind, just as his painting style developed in accordance with Rubens' and Titian's styles. Today *Las Meninas* is thought to be both the great culmination of that style and the expression of the obsession, a plea for noble status – or a kind of staging of innate nobility in the hope that noble status will inevitably follow.

Velázquez's ambition to be knighted seems creepy, I agree, but you have to be careful comparing the obsessions of a different age to the kinds of things that turn us on today. We have Sir Nicholas Serota who runs the Tate; Sir Anthony Caro who's an artist, and Sir Peter Blake who's another artist; and we have Sir Mick Jagger: soon we'll have young British artists being Sirs and Dames. It's great to be knighted, of course, but it doesn't necessarily have anything to do with creativity. We see it more as the arbitrariness of the honours system and the hustling and hype of the culture industry.

But in Velázquez's mind, because of the social framework of the time, there was a link between artistic and social nobility. Even his loose handling of paint seemed to him to have a correlate in social style; casualness itself had a social correlate. The projection of a sense of emotional distance, or cool, or sublime aristocratic nonchalance, that seems to be there in Velázquez's facial expression in *Las Meninas*, and that pervades the whole scene because of its relaxed, fluid handling, is a studied effect. In fact it was literally studied, because we know he was a reader of Baldassare Castiglione's *The Courtier*: a handbook from the Italian Renaissance about how to appear truly aristocratic. Castliglione instructs his readers that looseness of execution in painting implies disdain for sweat and labour. The impression of skill is greater if you don't appear to be doing much. To dash off just enough strokes to achieve the job of representation is the ideal, as this suggests reserves of power, as if you could render the object with even more perfection if you wished, but you're too much of a gentleman to do that.

Velázquez didn't get up the social ladder by being a sincerist: he played a sophisticated game of deception and power. With his portrait of Pope Innocent X, painted in 1650 **106** during his second trip to Italy, it turned out that you could portray corruption in a way that actually pleased the sitter and wasn't at all taken as an insult. The Pope had a reputation for political scheming, and for

moods that ranged from coldness to rage. Writers from the time described him as 'ugly', with a face that was 'the most deformed born among men' and a 'repugnant' head – 'insignificant' and 'vulgar'. Velázquez's portrait doesn't deny any of this. Instead, it makes it good instead of bad: he shows a dynamic, alive, exciting human being, seventy-five years old, full of brightness and danger. No wonder Francis Bacon liked this picture and based all his screaming popes on it. (He always used the same reproduction from a book. So if you go and see it in the Galerie Doria Pamphile in Rome, you'll be doing something Bacon never did, you'll be looking at the real thing.)

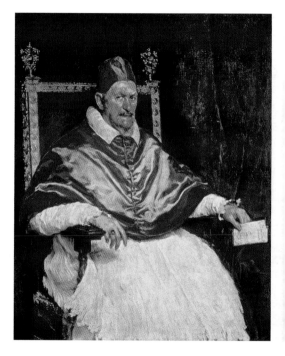

The blast of different types of red that dominate the painting, the rush of flowing white in the Pope's dress, the great looseness of the handling throughout, are Velázquez directing his skills toward self-advancement. The letter in the Pope's left hand is Velázquez's request to the Pope to intervene in his application to enter the Order of the Knights of Santiago, the highest order of nobles in Spain. Soon after the portrait was finished, the Pope's secretary wrote to the King's secretary in Madrid to urge that the procedure to ennoble Velázquez should go ahead.

It's a long, humiliating process. The royal nomination isn't submitted to the Council of Orders until eight years after the Pope's letter is received. Now investigations into Velázquez's credentials begin. Over a period of six months 148 witnesses are interviewed about his background. Two weeks after the interviews end the claim comes back rejected on the grounds that Velázquez is deluded about his noble ancestry. He gets the King to solicit the Pope for a dispensation excusing him for not having enough noble blood and for ever having accepted payment for his art: a gentleman never does anything for money. The dispensation arrives and it's submitted to the Council. Another nobility flaw is discovered, and the King has to write off for another papal dispensation. By the time Velázquez is knighted on 28 November 1659,

106 Velázquez,
Pope Innocent X

everyone knows it isn't because he's really noble, but because he can swing enough dispensations. And the victory is useful only to Velázquez: it doesn't change the lowly status of painters in Spain, which continues to be much as it was in medieval times.

All this would be tedious if it wasn't likely to be central to Velázquez's intended meaning for *Las Meniñas*. He needs that ambiguity of positioning **107** where you're not quite sure where everyone's standing, because it's a metaphor for social position: his own low position because he's a painter, compared to that of the King, whose position is the highest on earth. The game with shifting perspectives – the centre of interest shifting around, from princess to artist and from King to artist – is about moving power around. His job is to supply formal portraits of the King, but there's no precedent for the portrayer of the King's image to be shown in the same image. The seeming casualness of the arrangement, the feeling of a natural, snapshot-like spontaneity, veils a carefully constructed allegory of the dignity of painting and the nobility of the artist. Astounding technical skill and mastery are used to solve a problem: how to elevate yourself by showing yourself in the context of royalty – when you know perfectly well, as an expert in power, that etiquette demands that that must never happen?

Velázquez's drive for personal ennoblement was against the prejudice of the time, which was to see artists as low. But it conformed with the view of aristocrats as virtuous, even though their laziness was really mucking up the economy. Today we don't believe anyone is naturally superior by birth, least of all the aristocracy, whom we know to be daft. On the other hand we're genuinely confused about artists: we see the ones of today being aesthetically unoriginal, all lining up to be identical nouveau conceptualists, as well as conformist in their social behaviour, hanging out with Elton John, and so on. Even in the face of this we hold on to an ideal of the artist as a rebel against society. But the striking thing about *Las Meniñas* is that in it Velázquez rebels aesthetically, in order to be accepted socially.

Velázquez actually died as a result of his duties as *aposentador* or supreme marshal. In 1559 Spain and France's bit of the Thirty Years War ended. Philip IV and the French King had to have an immense ceremonial meeting to say war was over. This took place in June 1560 on the Isle of Pheasants near the Franco-Spanish border. To seal the peace, Philip IV's daughter from his first marriage

107 Velázquez,
Las Meniñas, detail

was handed over to the French King as a bride. Velázquez had to work in Madrid for six months on the decorations for this event, and then had to travel with the King and arrange the accommodations for the royal entourage on the journey up to the border, with its twenty-three stops on the way. All this appears to have done him in. He was only back in Madrid for a short time before he fell into a fever, and then three weeks later, aged sixty, he died. The time of death was 2 p.m. on 6 August 1660. He'd been officially noble for less than a year.

The kings and the office politics all fall away through time. The appearance of things becomes more and more mysterious. *Las Meniñas* is the highest point the painterly tradition reaches. It won't be until Impressionism and modern art that any artist is as audacious and playful with paint again. As well as being a model of what painting is, it's also an instant in time: a scene in the daily life of a vanished dynasty. The King enters: Velázquez raises his brush. The plotting and conspiracies are all dust now. Only the shimmer remains **108**.

108 Velázquez,
Las Meniñas, detail

Hogarth
LIFE

A Rake's Progress (VII The Prison)

109 Hogarth, *Marriage à la Mode (IV The Countess's Levée)*

Art says yes to life

The Countess's Levée by William Hogarth **109** shows a lot of eighteenth-century types sitting around wasting time in an aristocratic boudoir. The Countess and her lawyer are carrying on an affair. The Countess's syphilitic husband is away at the moment having sex with a child prostitute. The lawyer points to a painted screen depicting a masquerade. He's suggesting they meet later at such an event. He's got the tickets in his other hand. The Countess laughs. They're both delighted at the idea of masks because it reminds them of the deliciousness of deception.

There's a lot of art in the room. The couple don't realise their fantasies are pictured around them. The old master over the Countess's head shows the myth of Jupiter and Io: Jupiter comes to earth in the form of a cloud and ravishes the beautiful Io. A plate in a basket on the floor of the room has a design on it showing Jupiter again knocking off a mortal woman, this time assuming the form of a swan. (Those gods!) A black servant points to the antlers on a little statue of Acteon: horns symbolise a cuckolded husband. The painting on the wall is by the Renaissance artist Correggio. The one next to it by the same artist shows a scene from the New Testament: Lot and his sexy daughters. The plate design is based on the pornographic prints of another Renaissance figure, Giulio Romano, whose frescos in Mantua provided the model for Titian's *The Flaying of Marsyas.*

If Hogarth uses art to comment on life in *The Countess's Levée,* art is also a player in a different way: it plays itself – it's a value in itself. Hogarth knows a lot about the tradition of painting, but he shows the richness of his relationship to it not so much in these parodies – which are really mockeries meant to shock an educated audience out of its shallow reverence for the old masters – but in the painting as a whole. Everything rides on subtle colours and orchestrated shapes. There's the hazy background of muted complementary colours, greenish and orangeish, and then there's the radiating rich brightness below. There's the pictorial architecture: curves, dips, pyramids, rectangles and zigzags, billowing contours contrasted with staccato little pattern-fragments; the shapes made by hair curlers, braid, playing cards, a letter or the edge of an open book. And there's the fictional architecture: the depicted room with its archway, curtained bed, painted screen and dotted-about armchairs.

All this calls for a sophisticated painterly eye, something for which Hogarth is hardly ever given credit, because he's assumed to be a great narrative artist, not a great visual one. Prejudice against seeing him as a painter at all goes back to his own time: though he was the best-known artist in Britain, he was popular for engravings not paintings. He once put the original paintings of his three great series of prints, *A Harlot's Progress*, *A Rake's Progress* and *Marriage à la Mode*, up for sale in an auction at his studio. He found it a struggle to get even a fraction of the amount he'd expected, though the printed versions continued to sell year after year, in edition after edition. It's partly human nature: we don't want to believe anyone can be good at more than one thing. But it's partly also the complications of his personality. He was always carrying on hate campaigns against connoisseurs and experts in old master-ness, so it slightly blew people's minds to find him campaigning for his own cause as a great continuer of the painterly tradition – this in turn blew his and made him bluster. He once wrote to a friend: 'Because I hate *them* the connoisseurs all say I hate *Titian*. Well let them!' (He had that mad dog streak.) In fact he respected the great painterly tradition, but thought you had to rework it to fit what was real about your own time. His anti-old master rhetoric was really directed at types who mindlessly went on about liking the old masters: his attitude was that you should either really like them or shut up about them.

Hogarth was born in 1697 in the Smithfield Market area of the City of London. His father was an unsuccessful compiler of Latin dictionaries. He ran a literary coffee house in St John's Gate, where the perhaps ill-advised idea was that all the customers had to speak Latin. He got into debt, went to debtors' prison, came out ruined, and then died a few years later when Hogarth was twenty-one. Hogarth was still training to be an engraver: he abandoned a seven-year apprenticeship just before it was due to end, and then, two years after his father's death, he set up his own engraving business. Before he was thirty, he'd become a well-known painter. He seems to have made the leap both through natural talent and by being open-minded and inventive in a cultural climate that was extremely unsympathetic to painting unless it was foreign.

In the early 1700s, English painters were jobbing stand-ins whom you used if you couldn't afford a real artist – a French, Italian or Dutch one. There were very few exceptions to this rule, but one was Sir James Thornhill, who had a reputa-

tion for being able to get the big commissions away from foreigners. Hogarth wrote later that he got his first sense of what art was from Thornhill's murals at the Royal Navel Hospital in Greenwich **110**, which Thornhill was still doing when Hogarth was young. He said he had Thornhill's imagery – a version of Rubens' courtly Baroque style, a century after Rubens – 'running in my head'. The type of scenes Thornhill painted, and the grand manner of doing them, were known as history painting. This meant kings, allegories, gods and battles: anything elevated and instructional, with a lot of lofty, slightly interchangeable virtues.

In one of the murals Thornhill paints himself at the bottom of some painted steps. He looks out at the audience while gesturing upwards towards the King, enthroned at the top of the steps **111**. For Hogarth, Thornhill was an awesomely glamorous figure. History painting was at the top on the accepted hierarchy of art styles. Thornhill had been trained in Europe and foreigners respected him. He was born middle-class but was now a Member of Parliament. He had a knighthood and he held the position of 'King's Painter'. He stuck in Hogarth's mind. Hogarth wanted to become as important as him.

He first got to know him when he enrolled at the drawing academy Thornhill ran in Covent Garden. Hogarth had already been going to another drawing class nearby for a few years. These places were basically clubs: groups of about thirty artists would get together to share the costs of hiring space and models, and would enjoy the opportunity to exchange ideas and pass on information and gossip. They were very low-key affairs. There was no equivalent of the great art academies that existed abroad at that time, the best known of which was the Académie Royale in Paris. The foreign academic idea of an art training was that first you copied statues, and prints in books of eyes and noses, and it was years before you saw a live model. Once you'd finished the training you were considered to be a pro, and you could get work. With the English version of an art education you just did a bit of drawing from the model. There was no other professional advantage or status to be gained by going to these casual academies. But for Hogarth they were an introduction to artistic culture where he could meet real artists and join in their conversations.

He said later that he hardly did any drawing but instead trained his visual memory by walking the streets and observing life. He said that in his twenties he

OVERLEAF LEFT

110 Sir James Thornhill, The Painted Hall, Greenwich

OVERLEAF RIGHT

111 Sir James Thornhill, The Painted Hall, Greenwich, detail

was lazy and preferred to combine 'study' with 'pleasure', so he memorised momentary actions, glimpses of faces and the look of bodies in movement, and developed little abstract schemes to remember it all by.

His printing shop was at his mother's house in Long Lane. Until the end of the 1720s when he had a painting studio in Covent Garden, he turned out trade cards and funeral announcements from here as well as occasional book illustrations, which was higher-class work. But during these years he also issued engravings satirising modern life. He published the first of these in 1721: the subject was a notorious overseas-investment scandal. Later subjects included a new lottery scheme **112**, people who lived on the moon, and modern bad taste.

The fashion for satirical prints existed before Hogarth, he didn't invent it. The system was that a publisher advertised the print in the newspapers, anyone interested paid a subscription in advance, so the money was there to pay for the printing, and then the print was issued and the subscriber received the work. As the artist, Hogarth never made any money out of the system because there were too many middlemen: he complained that like his father, he was at the mercy of publishers and printers who ripped him off. In 1724 he tried publishing a print himself. Although it made an impact with the public, the image was immediately pirated, and other publishing firms got all the money. He realised he couldn't win.

Soon after meeting Thornhill, which was in 1724, he started teaching himself painting. A shift in emphasis in his business from engravings to painting started about four years later. His clients were members of the government, aristocrats, merchants, writers and theatre people. The pleasure of his little paintings of family groups from this time **113,114** comes from the way he improvises arrangements of a great many figures, and has a visually sophisticated play between detail and space. The paint handling has a dainty loveliness, like Watteau or Lancret, his French contemporaries, although he wouldn't have seen any real paintings by them: to come up with that look he must have synthesised impressions of whatever visual art was available, from old masters to prints to pub signs, and mixed that with a lot of inspired improvising.

Because today's idea of an art world is so different, it's hard to appreciate how quick Hogarth's progress was: from jobbing printer to successful satirical printmaker to advanced successful painter, all in less than ten years. In those days, there was no system in place to facilitate such success: there were no public exhi-

112 Hogarth,

The Lottery Scheme

bitions or galleries. Normally, you had to be an insider: you sought out foreign old-master paintings, or engravings of old masters, or engravings of new modern foreign art, in sales held in little coffee shops. And this art was never English. The idea was never entertained that an English artist could compete with Continental taste, but here he was competing with it.

In 1728 he painted a scene from John Gay's 'ballad opera', *The Beggar's Opera*, produced that year at the Lincoln's Inn Fields theatre **115**. Because there was a queue of buyers he painted five further versions of the same scene. The play is about high and low society each being as corrupt and criminal as the other: The painting shows the last scene. The robber leader, Macheath, is in Newgate prison in chains, about to be hanged. The prison is brown; Macheath, in the centre, is

113 Hogarth, *The Cholmondley Family*

114 Hogarth, *The Wollaston Family*

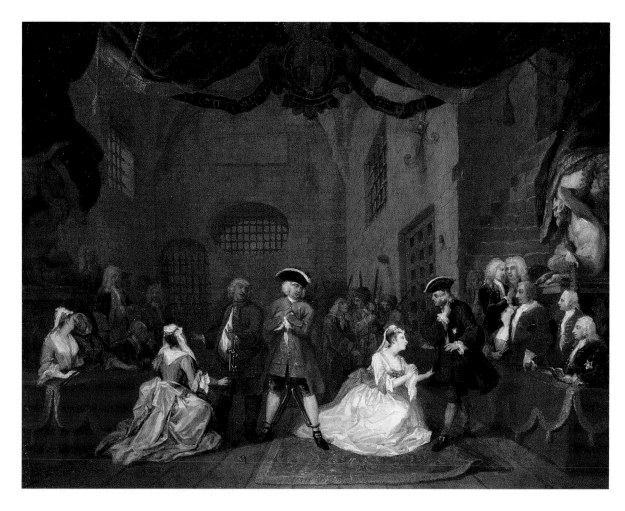

bright. He wants to be noticed, he puts on the airs of a gentleman. The warden and an informer are present: their respective daughters, Lucy Lockit and Polly Peachum, both beg for the criminal to be spared. Hogarth gets the play's audience into the painting: the rich sit either side of the action while the poor stand in the back. The reason the play was so successful was that it really did seem to mirror the audience's concerns, so Hogarth is instinctively responding to that bit of popular excitement in his composition, while simultaneously providing us with a detailed visual account of what the London stage was like at this time. The actress playing Polly is a real figure, Lavinia Fenton, who really was having an affair with one of the lords in the audience: Lord Bolton, the seated figure on the extreme right. The moral sting is part of the richness of Hogarth's conception, inspired by the play's sophistication. The play's message is 'Down with

115 Hogarth, scene from *The Beggar's Opera*

116 Sir James Thornhill, *Conversation Piece of the Family*

hypocrisy!' – but John Gay gets it over in a new way, so the audience isn't quite sure what's hit them.

The next year, on 23 March, Hogarth cleverly married Thornhill's daughter, Jane. It's likely they eloped. The wedding took place on the outskirts of London at Paddington parish church, and then they lived in Hogarth's studio in Little Piazza, Covent Garden. Hogarth's relationship with Thornhill briefly chilled, but within about a year he was collaborating with Thornhill on a painting of members of the House of Commons, and had moved himself and Jane into Thornhill's house in Great Piazza, Covent Garden. The outsider Hogarth had now become an insider in Thornhill's aristocratic world. Thornhill shows him in a sketch from the time at the end of a line-up of his own extended family, with 'Mr. Hogarth' written in underneath **116**.

Thornhill's own career had started to fade a bit. His decorative rhetorical style was out of fashion and there were no more commissions on the scale of the Greenwich murals. But Hogarth's fluent naturalism perfectly fitted the newly fashionable taste for Parisian rococo art, exemplified by Watteau and Lancret at the dreamier end of the spectrum and Chardin **117** at the more naturalistic end. Rococo is both a development from Baroque and a reaction to it, a move away from its weightiness. It goes in for sympathetic and playful sensitivity: in Chardin's famous words, 'We *use* colours but we *paint* with feeling.' Hogarth's pair of paintings, *Before* and *After* **118,119**, from 1731, travesties and

117 Jean-Baptiste-Siméon Chardin, *The House of Cards*

118 Hogarth, *Before*

119 Hogarth, *After*

rivals rococo exquisiteness: a charming pastoral setting provides the context for a bit of squalor. Rococo painting often contains a saucy element, but in this work Hogarth's explicitness goes a step beyond the awkwardness and embarrassment that the moral of the story (restraint is more civilised than abandon and the pleasure is sweeter if deferred) would conventionally demand. The government official who bought the paintings absconded to France immediately afterwards, because he'd been caught embezzling funds from a charitable foundation for the poor.

Hogarth later wrote that he didn't believe his type of painting with its fresh approach to subject matter could be done fast enough to make it worth the effort, given the low fees he charged: 'I therefore turned my thought to a still more novel mode, painting modern moral subjects. I wished to compose figures on canvas similar to representations on the stage'. He went from paintings of a real play at the theatre, and paintings that imitated the feel of scenes in a play, to art that really could compete with the stage: a whole series of paintings that together told a single story.

The first of these narrative sequences was *A Harlot's Progress*, the original paintings for which were all burned in a house fire in 1755. Hogarth painted them over a period of a few months in 1730. When he moved to Thornhill's house in the same year Thornhill encouraged him to display them in his own grand studio. They became widely talked about. The places depicted were real and so were many of the characters; people swore they'd been there themselves and seen the things happening with their own eyes.

A Harlot's Progress tells the story of an innocent working-class girl, Moll Hackabout, who is corrupted and eventually destroyed because of the evil ways of the people she encounters in London, many of them responsible types in society – doctors, clergy, lawyers and magistrates. We have to follow the story from the later, printed, version. She arrives from up north and is met at the coach stop by a brothel-keeper, recognisable to Hogarth's viewers as 'Mother Needham', a real figure who'd recently been stoned to death by a mob. Another real figure stands in the background: Colonel Charteris, an aristocrat known to employ pimps to get him naïve young girls just arrived from the country, whom he could use for sex. He'll be Moll's first client: as Mother Needham reaches out to feel Moll's face, the Colonel reaches down to feel his groin.

The story unfolds. Moll is transformed: she apes high-society manners and clothing style. She replaces her dull outfit with silks and high heels, one of her breasts is out. She's got a black servant boy with a feathered turban. A wealthy Jew keeps her in high style, with good furniture and wallpaper, and oil paintings. He arrives at the sex pad just as Moll's handsome young lover is creeping out of the room, making a gesture with his thumb and forefinger that unflatteringly describes the length of the Jewish guy's penis. Unsurprisingly, Moll is chucked out.

Now she's forced to live in a little garret in Drury Lane. She's still beautiful but shows the beginnings of disease: a few black patches, so her marketability is down. She has a maid with no nose, eaten away by the pox. The atmosphere is a bit less genteel. Instead of oil paintings, there's a poster on the wall of Macheath, the criminal hero of *The Beggar's Opera*. There's a bunch of birch rods for the clients who want flagellation, and a witch's hat for the ones who want to mix thrashing with Satanism. There are vials of medicine, for Moll's syphilis, along with gin bottles and jars of make-up. She's still vain and lazy. She gets up late, looks at the watch she stole from last night's client: 11.45 a.m. She's still not quite dressed. A real magistrate of the day, Sir John Gonson, notorious for suspiciously compulsive prostitute busting, arrives with a group of constables to arrest her. But he pauses first to enjoy a private leer.

Now Moll's in prison: flabby, her mouth drooping, she has to beat hemp, though she can hardly lift the mallet. Her deformed maid, also imprisoned, laughs at Moll as her fine clothes are mocked and she's bullied and robbed by both the prisoners and the guards. Then we see Moll in a room somewhere, swooning from the effects of venereal disease. She's got no teeth, because of the mercury she uses as a cure: other useless quick-fix remedies are all over the floor. Two wealthy, overdressed doctors (Richard Rook and Jean Misaubin, real figures of the time) argue with each other about who's got the best fake remedy for this incurable illness. Poor gummy Moll expires unattended right there in front of them. A hag steals her stuff from her trunk. Moll's illegitimate child burns his hand in the fire.

Then it's the wake after the funeral. The room is full of prostitutes. Mother Needham mimes exaggerated weeping, but no one else even pretends to mourn. The coffin plate reads: 'M. Hackabout Died Sept. 2d. 1731 Aged 23'. A parson,

120 Hogarth, *A Harlot's Progress*

(II Apprehended by a Magistrate)

The sign in the image reads: "Better to Work than Stand thus"

another recognisable figure of the day, who's supposed to be reading a sermon to set a religious tone, is instead drunk and sexually aroused, his hand down the skirt of a dreamily smiling prostitute. The other whores scowl and show each other their scars or admire themselves in the mirror. The dreamy one discreetly covers the parson's hand with a black mourning hat.

Hogarth knew history painting like Thornhill's had been considered the highest level of art, but now he'd invented a variation on that. History painting is always grand, both in style and subject-matter. But Hogarth had a new twist on the idea of high and low: instead of heaven and earth, he showed high-society rich types exploiting low-society poor types.

121 Hogarth,
A Harlot's Progress
(III Scene in Bridewell)

The first harlot scene he painted is the one that eventually became the second in the series **120**: visitors to his studio urged him to go on so he painted the next scene, where Moll still has quite a high-class client, the Jewish lawyer. And then he did the one after that, where her state's a bit more desperate **121**. Then he worked out the opening scene. (You've got to use a bit of imagination now, to see these as paintings, not prints.) Then the last ones. He thought about having the paintings engraved. The practice of a painter having his paintings made into prints, with the painter and the engraver sharing the profits with a publisher, went back to Rubens. But Hogarth decided to publish them himself, combining the roles of merchant and artist. When he decided he'd better do the engraving work himself too, because he couldn't find anyone he trusted to do the work well enough, he cut out another middleman.

Following the conventional procedure, he took out ads in the newspapers, announcing that the set of prints was on the way. His design for the subscription ticket showed little boys peeping up the dress of a multi-breasted nature goddess from antiquity. He already had a large group of subscribers made up of people who'd seen the paintings, first in his studio and then at Thornhill's, or else knew of them through word of mouth. The delay in delivery caused by deciding to do the engraving work himself meant taking out more ads to explain the hold-up, which in turn caused a much wider interest in the prints. So when they were finally ready, in an edition of twelve hundred, at a guinea a set (half in advance, half on delivery), they were an immediate sell-out, and there was a clamour for more.

It turned out he could print as many editions as he liked and they'd always sell. He went on issuing editions for the next twelve years: some weeks he took in five hundred pounds' worth of subscription orders. He solved the piracy problem by having an Act of Parliament passed, granting engravers copyright protection on their own images.

He'd created a whole new modern art world on his own, without realising he was doing it. He was his own publicist and his own dealer: he had a literary audience, an art audience, and a naïve audience of ordinary people. Just by trying to gouge out a career through intuition, one step at a time, he suddenly found he had the biggest career an English artist had ever had. It was like Damien Hirst discovering his shark.

Good life

The money made from *A Harlot's Progress* in the first year of sales alone was enough to allow Hogarth to move into a three-storey house with a studio, in what was then a newly built-up posh area, Leicester Fields, now Leicester Square: his house was on the east side between buildings that are now leased to Capital Radio and Pizza Hut. The signpost for his studio was a gold-painted bust of Van Dyck, and in his self-publicity he now began referring to events 'at the sign of the Golden Head', as if it were a pub. At thirty-four, he was setting himself up as part of the great tradition of art that included Van Dyck, pupil and assistant of Rubens, and inheritor of the painterly style initiated by Titian. Of course, he knew the figures of *A Harlot's Progress* were rather different from the elegant aristos that typically populated Van Dyck's paintings. He knew too that he himself was a bit different, since he was a squat, five-foot-tall Cockney.

Two years later, he finished *A Rake's Progress*. In this new series he satirised the new merchant class of which he himself was now a part. In class terms, the paying audience for Hogarth's art was genuinely mixed: upper, middle, lower. But it included a significant new social group, the consumer. This type was drawn to spending but also prone to feeling a bit guilty about it: so when Hogarth's subject was bad taste or wrong taste – or taste that no one was sure about, though they went along with it – then the consensus was that he was expressing something urgent and worth thinking about.

The story is told in eight paintings arranged in two rows, with the narrative running top to bottom, left to right **122**. It begins with Tom Rakewell inheriting money from a miserly father who in life had been incapable of giving love. Unequipped with a strong character, only with a delicate sensibility, Tom falls for all sorts of temptations. He chucks his loyal but poor fiancée, Sarah Young, and becomes a rake. He gambles away his money and then marries an ugly widow in order to get *her* money. He goes to prison for debt. He ends up mad in Bedlam, naked and pathetic. On the run from rationality and reason he destroys himself by his own uncontrollable appetites.

Hogarth always hangs these painting series on a simple moral. In a portrait on the wall in the first painting in *A Rake's Progress*, which is called *The Heir* **123**. Tom's father is shown counting piles of gold. Crutches leaning against a wall

122 Hogarth, *A Rake's Progress*, in position in Sir John Soane's Museum

123 Hogarth, *A Rake's Progress (I The Heir)*

make it clear he was deformed. We understand that he gave poor Tom neither encouragement nor warmth. (Today's movies would moralise in the same way: no wonder he goes off his rocker, that boy needs a hug!) But Hogarth doesn't seem genuinely concerned with the moral. It's just a rationalising starting point. His real interest is in vivid, insulting dissections of the world he lives in.

Everyone in the next picture, *The Levée* **124**, has something for the Rake, a willing victim, to waste his money on. Charles Bridgeman, the royal landscape gardener, is shown holding a plan for a new garden design. He lines up with a lot of other dubious hustlers to persuade the Rake to pay for his services. Many of Hogarth's viewers would know that Hogarth had recently applied for an appoint-

ment as 'Painter to the King', working alongside his father-in-law, Lord Thornhill, but had failed to get it. And knowing a bit about the art of landscape gardening they'd be able to tell that Bridgeman's plan shows a dull layout, not an imaginative one – even though it's marked 'Plan 2', so it's his second try.

The worst, emptiest fashionable thing, in Hogarth's view, is for anyone rich to ape foreign ways: so the absurd eyeball-swirling fencing master practising his strokes in *The Levée* is based on the real French fencing master, M. Dubois, who lived and worked in London, and had recently died. The opera on the piano is by 'F.H', which viewers would assume to mean George Frideric Handel: Hogarth would have objected to him writing Italian rather than English librettos. (In the engraved version of this painting more details are apparent, and there's a comic incongruity between the subject of the opera, *The Rape of the Sabine Women*, and the names of the performers who are going to perform it, all famous Italian castrati.) The painting on the wall in the Rake's newly bought posh house is *The Judgement of Paris*: the joke is that the Rake has very bad judgement, and the xenophobic twist to the joke is that his judgement must be bad because it merely follows the fashionable prejudice in favour of foreign art.

Ironically, considering his anti-foreign obsession, Hogarth soon became recognised as a brilliant handler of paint by Continental connoisseurs. They appreciated his skill at rendering narrative complexity in a light, unforced manner, without muddle – an ability demonstrated well in *The Levée*. The affected posing of the characters is a laugh, an opportunity to satirise pretentiousness. But he's also made it into something that is visually very nice. Every movement and gesture is coordinated: the figures line up like a wave across the painting, all the heads at a slightly different level, like points along an imaginary line. A *levée* is a daytime get-together in polite society: the term comes from the French King's practice of holding court in the mornings, to plot the day. Hogarth knew of it as a theatrical device for presenting a lot of characters at once, and setting up their relationships and interactions. So the use of the custom here is simultaneously an insult against affected Frenchiness, an adaptation of a useful theatrical device, and part of the story the paintings tell.

Hogarth never provided the equivalent of a script or a screenplay for these paintings: there is no written version, at least not by him. In some of the editions of the engravings he allowed lines of poetry to be printed below the image.

124 Hogarth, *A Rake's Progress (II The Levée)*

These simply add a generalising moral gloss, however, they don't tell you who everyone was and what was happening to them. In the editions published specifically for French audiences he allowed a few lines of explanation: it's from them that we know the names of some of the characters: (for example, the lawyer 'Silvertongue' in *Marriage à la Mode*). But even today, after centuries of Hogarth scholarship, there isn't a definitive interpretation of any of his modern moral subjects. In the last painting in *A Rake's Progress*, for example, the Rake might be in the process of being chained by the gaoler with the key because he's just had a fit of madness, or unchained because he's about to die, because it's the end of the series – either works for the story but neither is definite.

Hogarth wove in things that people knew about and were fascinated by, just as we know about footballers' wives, terrorism and paedophilia, and government cover-ups. The success of his painting-series, and the prints he spun off from them, was founded on a combination of observational skills, literary, journalistic and painterly skills, and an element of personal confession. In *The Orgy* a chamber pot spills, one prostitute's just spat in another's face, who's got her knife out to stab the spitter **125**. Another one has robbed the Rake of his watch and passed it to an accomplice: we can see it's now three in the morning. Hogarth really witnessed all this, including the detail of the black maid laughing; the story is reported by the artist Francis Hayman, who was with Hogarth in Moll King's coffee house in Covent Garden when it happened.

In the seventh picture, where the Rake has failed to

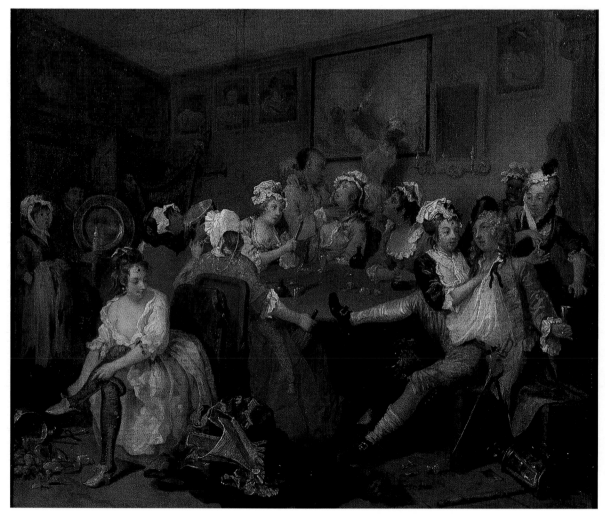

125 Hogarth, *A Rake's Progress (III The Orgy)*

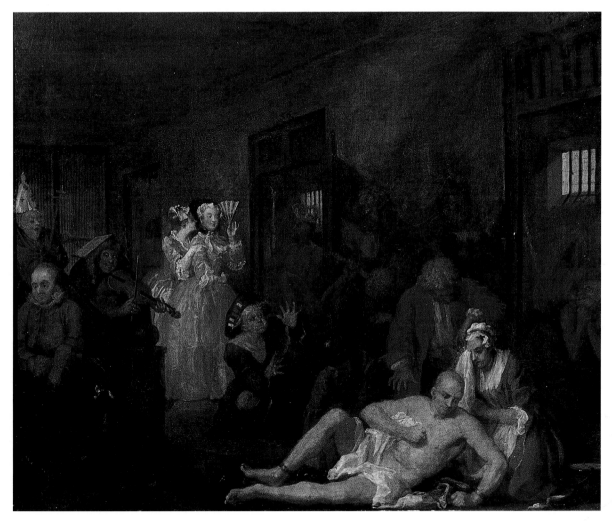

126 Hogarth, *A Rake's Progress (VIII The Madhouse)*

get back his lost fortune by marrying a rich widow, and has landed up in debtors' prison, the letter beside his hand (p.174) is signed with the initials 'JR'. John Rich was a well-known theatre producer, a friend and patron of Hogarth's, who in this fictional world has rejected the play the Rake has written in an attempt to raise some quick money.

In the background of the last scene, showing the Rake in Bedlam – 'Bethlehem': the hospital for the insane just beyond the City gate in Moorfields – a madman draws diagrams on a wall **126**. The printed version reveals the diagrams as a system for determining longitude by the firing of bombs. This was a real experiment of the time, which people really did think was mad. The bucket beside the Rake refers to the kind of porridge that the mad really were fed in Bedlam. Smiling, well-dressed, upper-class ladies watch a deluded 'king' in a paper crown urinating into the straw in his cell: the rich really did visit the place for entertainment. Later, as he became increasingly involved in philanthropic projects appropriate to his position as a great public figure, Hogarth served on the board of governors of the hospital.

As the mad travesty the great in this painting, so the Rake's final passing is set up as a travesty of Renaissance art: it's like a *pietà*, with his loyal fiancée, Sarah Young, still pathetically hanging around, standing in for the lamenting Virgin.

We've been taught to think of Hogarth as a laugh, a teller of grotesque stories, a visual version of Charles Dickens. In fact with these narrative series he aimed high in terms of painting: the movement of the brush, the flow of the scene, the clever underlying structures all imitate the old masters. The difference is that the subjects are the kinds of things people in Hogarth's own modern world thought about on a daily basis, not just when they were in a special hallowed or arty mood. There'd been a big social change: there were new morals, new pleasures, new money and new worries about newness. His response to all this began Hogarthomania and popularised art. It was amazing – it happened partly because he was talented, ambitious and a good self-publicist, and partly because he was benefitting from the winds of change.

Is there a contemporary parallel? Could the sudden trendiness of art in 1990s Britain have been due to a similar social change? Phew, it would be exhausting to map all that out! But the impression made by the yBas or young British artists in the 1990s is still very vivid in the general public's mind: they seemed part of a

new social idea. Like Hogarth, who was middle-class at the time when the middle class had only just begun to exist, the yBas seemed to be part of a new middle class that was just starting to exist in a certain kind of new way: a bit left-wing, a bit radical, a bit drunk all the time, a bit rude, a bit rough – fascinated by all sorts of emptiness. The trendy art of the 90s was full of imagery of urban squalor, always detached from any obvious moral point, and as such it seemed to perfectly illustrate, or somehow be part of (we're still scratching our heads about this), the contemporary climate of moral uncertainty.

If that description fits *A Rake's Progress*, then an important difference is that Hogarth is a builder-upper rather than a parer-downer. He starts with a simple moral, which he doesn't seem to care about or believe in: a premise of slight falseness, which has an equivalent with the yBas in their mimicking of the morally empty, iconic grabbing power of modern ads. But then he goes into an inspired spin. Content proliferates. The art of the yBas, by contrast, is ironic, flat and singular all the way, like a lightbulb that won't run out: it asks you to keep responding – 'Aha! I get it!' – to a gag that never changes. That's the nature of its richness. It's based on minimalism as well as advertising-ism. Hogarth's art has an opposite richness. He's full of ironies, but although the broad moralising is always there, the content within the moralising is all about things giddily building up and changing and becoming something else – so you can't remember what the original thing was.

Both Hogarth and the yBas are interested in the lurid vividness of lived experience. But Hogarth possesses a writer's sense of content as well as a painter's. He's always looking for ways to stoke up more narrative, as well as to visualise the narrative ideas he already has. The yBas, meanwhile, have a copywriter's idea of content and their visual sense is formed by a post-1960s idea of art, not a post-Renaissance one.

Wrong life

OVERLEAF

127 Hogarth,

Marriage à la Mode

(I The Contract), detail

Marriage à la Mode, which Hogarth painted ten years after *A Rake's Progress*, is different to the two previous series because it's carefully aimed, in its opulence and brilliance, at a cultivated audience: it's not the new moneyed middle class that's being sniped at now but the upper class, the educated aristocracy that

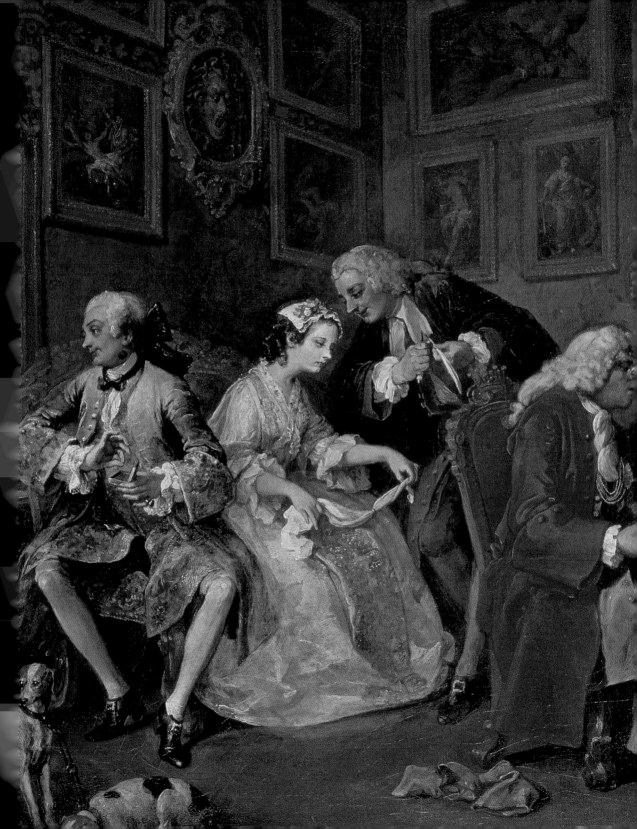

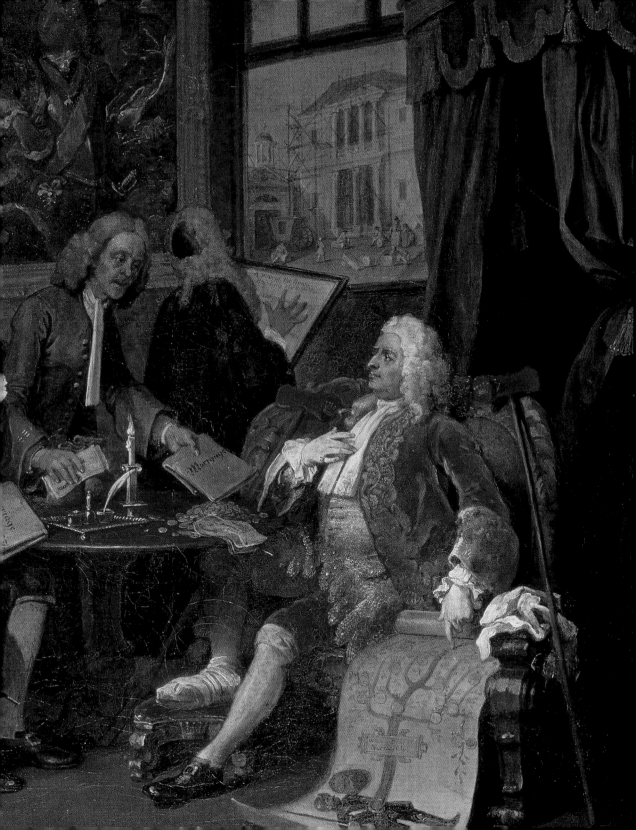

has a bit of artistic taste. So he's attacking the same class to which he's simultaneously sucking up.

The series starts at the left with picture I and ends on the right, with picture VI. Each one's like a scene in a play. The pictures look good beside each other, plus each is good on its own. The moral is that love and respect should be the basis for marriage, not financial greed or bidding for social status. The Earl of Squanderfield gives his son in marriage to the daughter of a wealthy merchant; the deal is that the Earl, who's having money problems, is able to rebuild his fortune, and in return the merchant, who wants respectability, earns a place on the Earl's illustrious family tree. Because the marriage is based on cynicism everything goes wrong. The husband becomes a sex fiend and gets murdered by the lawyer who's supposed to be handling the finances – but who in fact is having an affair with the wife, who makes herself available because she's unloved by the husband. The lawyer's hanged and the wife kills herself.

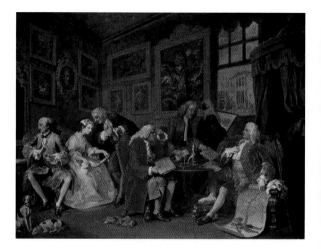

128 Hogarth, *Marriage à la Mode (I The Contract)*

In painting I, *The Contract* **127,128**. the dogs in the corner are chained together, just as the young people are about to be chained by their heartless parents. The future husband admires himself in the mirror. He doesn't show any feelings, which indicates class. The girl visibly droops, which indicates lack of class. The lawyer Silvertongue is already in the picture, soothing and wooing. The Earl is overweight and gouty. The half-built Palladian mansion outside the window is a fashionable architectural project on which he's lost all his money.

In painting II, *Tête à Tête* **129,130**. you look at the things on the table – cup and saucer and letters – and then at the wife stretching and yawning, and the realness of it all, the feeling of a scene in a house from centuries ago, is very satisfying. Then, when you look round the room, you notice that the couple mix erotic paintings with paintings of saints, and nutty little globular grotesque ornaments with delicate *Chinoiserie* and a Roman bust. You're being told some-

thing: these people are aimless! The husband's only just staggered in from the night's carousing. He's limp, his sword's broken, the dog bites the sexy underwear hanging out of his pocket. The wife's been partying at home, playing cards. They still don't acknowledge each other. The servant in the background isn't bothering to pull his socks up or to lay the table, because he's been forced to stay up all night serving and he's infected with the dysfunctional atmosphere. The husband's infected, too – with the pox, signified by the beauty spot on his neck.

It's interesting to think of these painted rooms as parodies of the family portraits with which Hogarth first transformed his career, from printing to painting, fifteen years earlier. Did he pick up what good taste really was from being in these houses? Or was he always secretly sneering at bad taste, while being outwardly polite, only waiting for the day when he could have a good old vent about it?

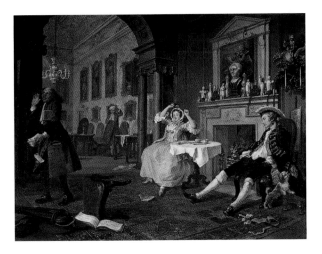

129 Hogarth,

Marriage à la Mode

(II Tête à Tête)

In the next painting the husband takes his mistress, a child prostitute, to a quack for a cure **131**. The girl dabs at the corner of her mouth, where we assume there must be a syphilitic sore. The procuress, probably the child's mother, glowers at the husband: the pox is bad for business! The husband's face gleams with the oblivious confidence of the privileged: he lounges, he laughs about some pills for venereal disease that he's got in a little box – 'Hey, I don't suppose these work, do they?' His outfit is immaculate. His shoes are like perfect black sculptures. All around him is ugliness and darkness. The old quack's outfit is shapeless and his shoes are dead.

In the next picture, *The Countess's Levée*, there are four main currents: foreigners, sexiness, art and money. It sounds fun, but of course the idea is that everything has gone bad. The husband has become a Count, and his wife a Countess, because the old Earl's finally popped it. The Count's away philandering or upstairs sleeping off the effects of philandering, while the Countess holds her morning assembly, the equivalent of the Rake's *levée*. Silvertongue

OVERLEAF

130 Hogarth,

Marriage à la Mode

(Tête à Tête), detail

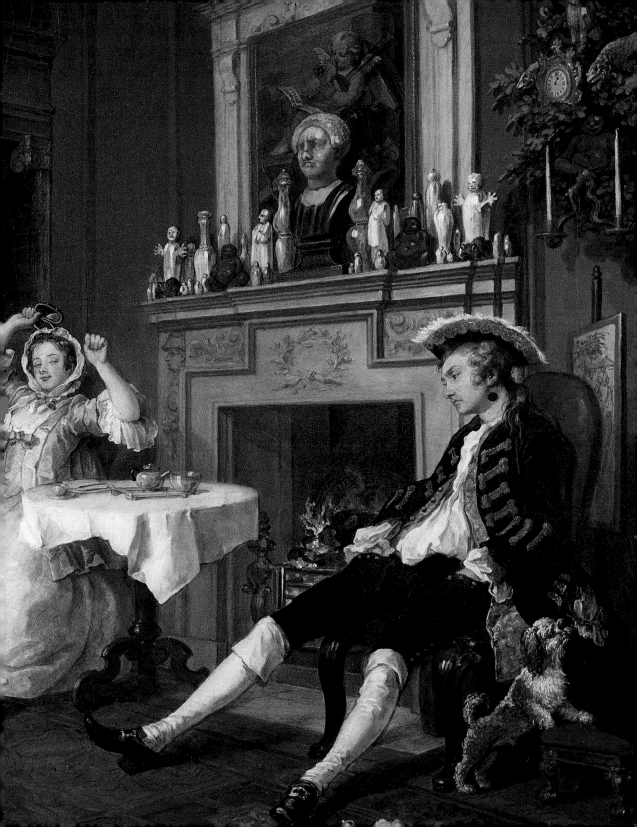

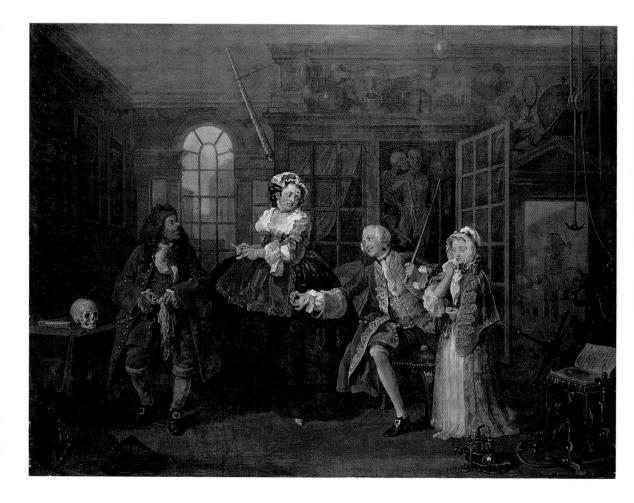

lounges on a sofa. A book lies beside him. Published in France in 1740 and in English translation in 1741, two years before this painting was done, it's the French erotic novel *La Sopha*, in which aristocratic ladies swoon in the arms of passionate Negroes. A servant pouring coffee for the Countess laughs at the ear-ringed Italian castrato across the room, warbling away, while another guest, the wife of a thick-looking country squire, swoons with affected delight.

The moral blindness of Hogarth's main players is pointed up by the presence of sexy old-master paintings that nobody looks at. They're all nudes apart from a formal portrait of a pious clergyman. One is homoerotic – Jupiter carrying off

131 Hogarth, *Marriage à la Mode (III The Quack)*

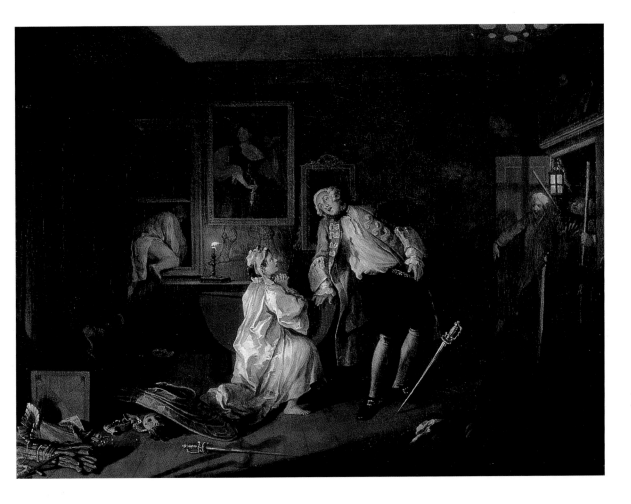

132 Hogarth,
Marriage à la Mode
(V The Bagnio)

the beautiful nude youth, Ganymede – which comments on the likely sexual preferences of the foreigners in the room. Hogarth travesties the culture of high art. He mucks about with the references and the sacred cows, mocking and parodying, in order to attack his audience's empty relationship to tradition. They see the old masters only as a sign of 'good taste'. They see paintings as items of furniture. They don't actually possess any taste themselves and they don't have any curiosity about the stuff they're mindlessly buying all the time.

Hogarth keeps stabbing at this particular target: foreign old masters. Obviously it's obsessive, but it's also about work: he has to compete in a market dominated by foreigners. It also makes a moral point: it's about correcting

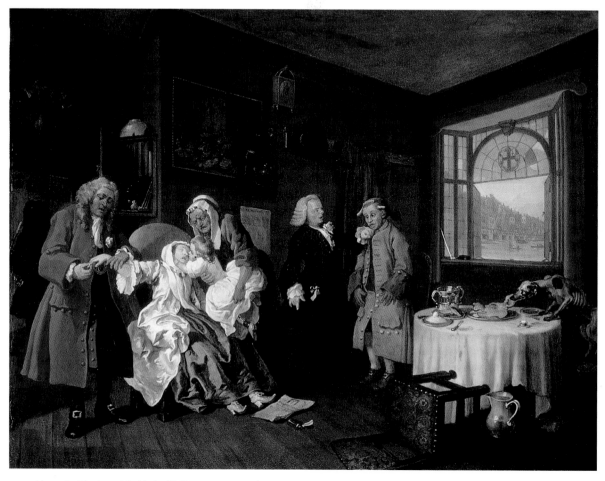

133 Hogarth, *Marriage à la Mode (VI The Lady's Death)*

shallowness. He's not shallow himself. He wants old-master art on his own terms: he doesn't want to be swamped by other peoples' ideas of it. He wants the gold coin of the past. He doesn't want to be choked by the rust on the coin.

In the fifth painting, *The Bagnio*, the Countess and Silvertongue hire a room in a brothel to have sex in **132**. The Count bursts in. A fight starts. Out comes Silvertongue's dagger and down goes the silly Count. Silvertongue flees. The Countess is filled with horror. She's on her knees praying. She's been living a lie and now she sees the truth at last. Too late!

Finally the Countess reads in the papers that Silvertongue's just been hanged, so she OD's on laudanum **133**. She's dying. Instead of attending to her a doctor admonishes the servant who gave her the dope. The Countess is too out of it to kiss her child, who's got a wasted leg and a few little black patches, having inherited the dad's disease. It's all happening in the Countess's father's house. The sins of the parents go round and round. The Countess is unable to surround herself with fashion and ephemera any more. Instead of the old Earl's Palladian mansion outside the window in painting I, we now see old Tower Bridge, with its row of wonky houses: her father's house is plain. There's bog-standard Dutch realism on the wall instead of flamboyant Italianate scenes.

Everything about this painting is enjoyable. A series of lively contours starts under the window with the arch of the dog's back, as he steals a pig's head off the table. It continues up to the shoulder and wig of the idiot servant in his lime-green coat, and then stops at the punctuation point provided by the black hat on the wall. It starts up again on the other side running down through the cluster of faces to the buckle on the Alderman's shoe. This is the unifying pyramid composition that holds all the detail together. In moral terms, the Countess's father slipping his daughter's marriage ring off her finger as she dies – so he can sell it – is a mirror image of the dog stealing the meat.

Hogarth had the engravings of the *Marriage à la Mode* series done in Paris, he travelled there himself to commission the craftsmen. The French style of engraving was much more sophisticated than the English, just as French taste and skill in painting was more advanced. Of course, Hogarth knew French art was better: it was just that he knew English art could never begin to compete unless it was given a chance. He wasn't a philistine. He just pretended to be one.

Life says no to zombies

If you drive out beyond the Hogarth Roundabout today you can visit Hogarth House. This corner of Chiswick is a hideous noisy suburban place but in the eighteenth century it was surrounded by rural pleasantness. Now it's surrounded by industrial estates and by the road to the airport. Hogarth moved into this country villa, as it was then, in 1749, with his wife, sister and servants; and for the rest of his life he spent part of the year here and part back in London. Nothing ever happened here, so it was probably a happy existence. But Hogarth's public life back in London wasn't happy: in fact, he came to think of himself as a failure. The changing times had begun to bring about his decline from top dog to forgotten figure. The things that had been right about his intuitive solutions to the problem of art in England, and effective about his oddly contradictory personality, now became wrong.

Some of his oddness seems jarring to us, too. He painted *The Painter and his Pug* in 1745 **134** when he was forty-eight. The dog, called Trump, is one of a series of pugs he owned, which all looked like Hogarth. How are we supposed to read Hogarth's clothes? Are they the height of fashion, or not fashionable, or what? The fashion point is really a class point: he's not got his wig on, which a gentleman would normally wear for a portrait, so his appearance makes the statement that he's not affected or pompous. He knows what he is. He gets his sense of values from his own head, not from putting on airs. So far so good, we agree with that. He's a free, red-blooded, foreign-hating, beef-eating, pig-headed – hang on! But in fact it's perfectly true that Hogarth really did help to found the Sublime Society of Beefsteaks where only enormous sides of beef were eaten: the idea was that beef, being British, was natural, while French food, with its sauces, was depraved.

Hogarth's *O The Roast Beef of Old England* was painted in 1748 **135**. Beef is lusted after by the French – a fat friar in the painting personifies French greed – because they only have thin gruel. (This is a variation on the food-insult theme: it's either too rich or there's nothing to it at all.) The painting commemorates Hogarth's second trip to France, in 1748, when there was a lull in the wars that were always going on between France and England. While returning to England through Calais he was arrested for spying, when in fact he was only sketching. He

134 Hogarth,

The Painter and his Pug

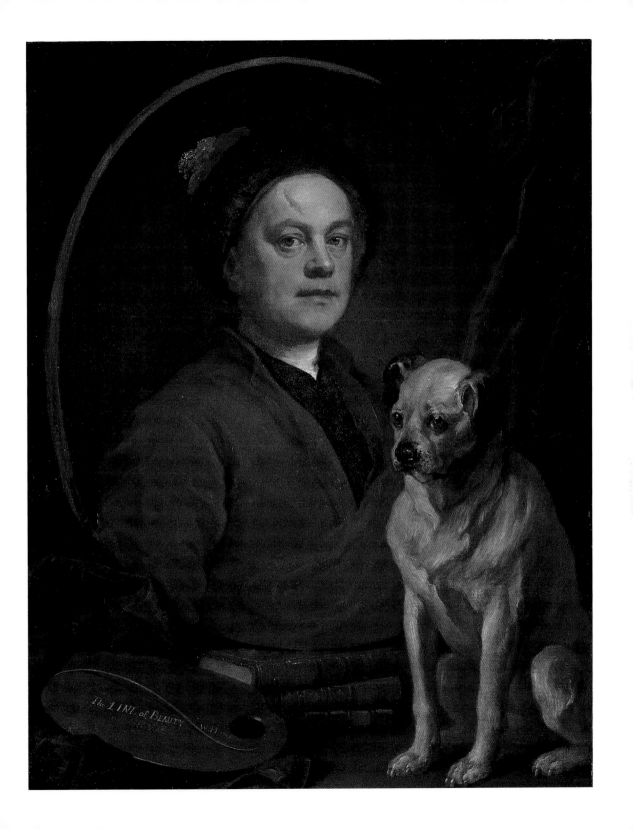

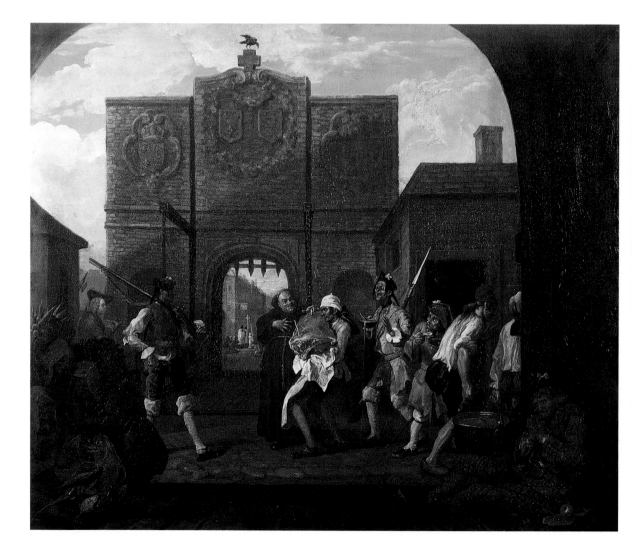

was kept in a cell for a day and then deported. (His profile can be seen on the left of the painting, the pike of the arresting French officer just behind him.) He'd been drunk all the time, shouting at the French, complaining if he didn't like their socks or if he couldn't understand what they were saying. All his impressions of France were contemptuous, as he made clear later when he talked about the 'farcical pomp of war' that went on constantly there, the 'bustle with very little business' combined with 'poverty and slavery' and 'the pompous parade of

135 Hogarth,
O The Roast Beef
of Old England
('The Gate of Calais')

religion'. He said the hateful friars with their 'innate insolence' were all 'dirty, sleek and solemn'. (The combination of 'sleek' with 'dirty' is good.)

If his behaviour in France was out of control, this is nevertheless a very well-controlled painting, with its stage-set structure – the various scenes all going on through a series of framing devices: the arch, the alleyway, the gate – and Hogarth's light fluent touch everywhere. This is the same quality of touch he respected in the old masters, and which he'd seen reaffirmed in modern French painting on his trip to Paris in 1743 to get *Marriage à la Mode* engraved. The still life in the bottom left corner of *O The Roast Beef of Old England* is dominated by a rayfish, which was the subject of Chardin's first great public success as a painter – Chardin's painting was done in the mid-1730s, and Hogarth might well have seen it on his 1743 trip. Another scene, this time in the far background through the arch with its raised portcullis, shows the ceremony of the Eucharist: the transformation of wine into blood. The dove symbolising the Holy Ghost is in fact a painting on a pub sign, suggesting that Catholicism is just a fantasy in the mind of a lot of drunks. The little set-up is so beautifully painted that its delicacy almost defeats its viciousness. This is typical of the subtlety that lies behind Hogarth's rantings. It's often invisible to us, because we're so removed from the original context. But it wasn't all that clear to his contemporaries, either – because they had careerist axes to grind, or else were blinded by the general view of him as an entertainer rather than an artist.

He wants to say the French are slaves and the English are free. Hogarth's nationalistic railing against slavery was connected to something aesthetic. In artistic terms, 'freedom' meant a look of freshness, of spontaneity. The curving line carefully painted on the palette **137** in *The Painter and his Pug* was Hogarth's symbol for the principle of spontaneity. He called it 'the line of beauty'. It stands for a set of visual qualities which he thought art should be based on, and which came from observation of nature: variety, vitality and intricacy. The function of straight lines in art was merely to provide occasional contrast for curviness: nature was the thing and nature was all about curves. Hogarth wrote up these theories in a serious, bluster-free book, called *The Analysis of Beauty*, which he published in 1752. Under the title on the inside front page runs the sentence: 'Written with a view of fixing the fluctuating Ideas of TASTE.' A drawing shows a pyramid on a rectangular plane, representing geometry, while the serpentine

136 Hogarth, *The Analysis of Beauty, Plate I*

137 Hogarth, *The Painter and his Pug*, detail

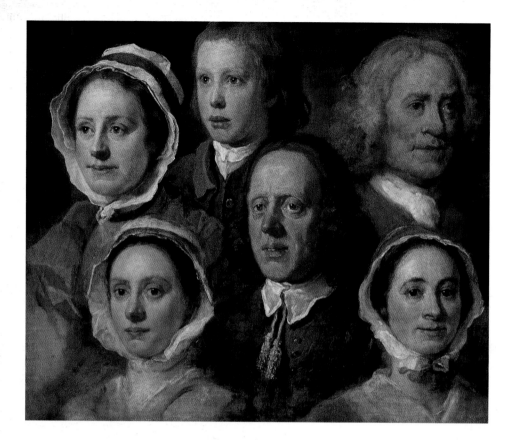

line of beauty runs up the face of the pyramid. Along the outer edge of the solid rectangle the word VARIETY is spelled out.

In the book he says the art of the past speaks in a language understandable by all, but comes from a society ruled by religious belief, which is incompatible with modern commercial life. So it's no good artists going on about Greek gods and goddesses or Jesus all the time: they should look to the modern urban environment for inspiration instead. This is what he meant by observing 'nature'. Hogarth supplied engravings to go with *The Analysis of Beauty* **136**, which elaborate on the theme of curves in nature and art, with unpredictable oppositions of old and new: in one scene a dancing master demonstrates the correct way to stand, while a nearby ancient sculpture of a youth – all effortless attractive *contra posta* posing – shows up the modern man's unnatural stiffness.

Hogarth's painting of his servants **138** (dating from some time in the mid-1750s; the exact date is unknown because he never sold it), their six individual heads painted separately in a kind of swirling portrait-cluster, is a

practical demonstration of his vitality principle. He's a fighter against oppressive notions of hierarchy, so it's good that he does an interesting painting of servants and keeps it in his house where they can look at it. The frankness and looseness of the paint **139** goes with the open vulnerability and kindness of the facial expressions: you can't see one without the other.

He passed on his ideas of freedom in art at the St Martin's Lane academy, which he'd been running since the death in 1734 of Thornhill, its previous head. For twenty years Hogarth ran the place as Thornhill had done, as a 'free' academy, where no one was above anyone and everyone was equal. There were teachers, but no one received a salary. Hogarth believed it was the presence of directors that destroyed the real purpose of the Continental academies and made them into the officious and creatively empty places that, in his opinion, they'd become.

But now all this attitudinising was backfiring. Because there was a new confidence in English art, the modern thing was to say that it was foolish always to attack foreign academies: why not try and be like them instead? New painters were rising, many of them taught by Hogarth: they called for the

140 Joshua Reynolds, *Self-portrait*

formation of a new academy, one that could guarantee professional qualifications – in effect, power. Hogarth thought this type of power was fake, and because he believed that art should be based on observation of life, not merely on following rules, he thought the new academy would only breed conformists. He also suspected it was a platform for the new golden boy of painting: his former student, Joshua Reynolds **140**. Reynolds had made the Grand Tour to Europe, and had trained in Italy. He made six thousand pounds a year from portraits, and had his own swanky house in London – right opposite Hogarth's in Leicester Fields.

A group called the Society of Artists was formed with the aim of starting a new 'royal' academy. As an early member, Hogarth thought his ideas could have an influence, not realising how marginalised he'd become. The Society held an exhibition of paintings in April 1760 in a building off the Strand, the headquarters of the Society for the Encouragement of Arts, Manufacturers and Commerce, of which Hogarth was also a member. This was the first official public exhibition of English art ever held. But Hogarth wasn't in it. He left both Societies in a huff. He'd been hurt by Reynolds' criticisms of him in the press: that he was incapable of rising above the anecdotal, and wasn't grand enough. By leaving the Society of Artists he caused a rift in it: connoisseurs against anti-connoisseurs. But his side didn't stand a chance, because he was on the wrong ranting trip for the time. He'd been shouting for years about English artists' unhealthy obsession with foreign art, and how English art dealers 'smoked' old master canvases with candles to make them look older – and how English connoisseurs could only ever explain the meaning of art by using vague phrases like 'beauty comes from heaven' or affected foreign phrases like *Je ne sais quoi*.

Now these ironies just seemed absurd. 'Stop going on about your ironies, you old fool,' the new generation thought: 'We want to be up there with the powerful foreign guys, not always acting like lager louts towards them!' Where he'd attacked egotism in others, he was now attacked himself in art-world gossip and in the satirical cartoons of Paul Sandby. Sandby believed Hogarth was surrounded by sucker-uppers, who failed to challenge the pretentiousness of *The Analysis of Beauty*. In *Puggs Graces* **141** Sandby shows one of them in the artist's studio: ' ... a Disciple unable to find the Meaning of ye Book ...'. A treatise by the theorist Giampolo Lomazzo pokes out of Hogarth's pocket. It was Lomazzo who coined the phrase 'the line of beauty': he said it could always be found in great art. Hogarth said artists should look for it in nature. Sandby thought that whether it was art or nature Hogarth was merely stealing from Lomazzo, and in another of his satires, *The Analyst Beshit*, he shows Lomazzo rising from the dead to accuse Hogarth of plagiarism.

Hogarth responded by becoming more and more incoherently furious. The writer Horace Walpole reports how Hogarth got in touch with him because he'd heard Walpole was preparing a book about English art. Hogarth had become obsessed with the notion that Walpole might not respect the sacred memory of

141 Paul Sandby,

Puggs Graces

Sir James Thornhill, and he took that as a deliberate slight against himself: he wanted to put him right on the matter. Walpole went round to the Leicester Fields studio, but then had to terminate the interview when he became convinced that Hogarth was going to bite him.

One night Hogarth fell ill and was taken by coach from the Chiswick house to Leicester Fields. Jane Hogarth stayed in Chiswick because he didn't seem that bad – he'd boasted to friends earlier that he'd had a pound of steak for lunch that day. But some time during the night of 25 October 1764, he died from the effects of an aneurysm. He was sixty-seven. His body was brought back to Chiswick, a cast was taken of his painting hand, and he was buried in the cemetery at St Nicholas's church.

The establishment of the Royal Academy in 1768, four years after Hogarth's death, was an ironic trumping of him. The whole idea of it was opposite to what he believed in and yet no one would ever have thought of starting a Royal Academy if it hadn't been for Hogarth getting an English painting scene going, virtually single-handedly. But his principles, that spontaneity and variety were the basis of art, and that observation of nature was more valuable to the artist than following academic ideas, emerged again in the generations that followed him, from Gainsborough to Constable and Turner.

Gainsborough, who was one of Hogarth's students at the St Martin's Lane Academy, is Hogarthian because he's visually witty. In his life-size portrait of Mary Countess Howe **142**, the spontaneity is in the balance of yellow sky and pink dress, and the flash of yellow that makes up the hat, which is all balanced in turn by the free smearing of greens and browns that make up the foliage. It isn't a real bit of the landscape that Gainsborough's interested in, but a general landscape feeling, which is evoked rather than carefully described. That smearing is Gainsborough's way of conveying something fleeting, sensual and visual – which is what he appreciated in Hogarth, whose sayings he was always quoting.

Hogarth had seen what was good about the old painterly tradition when he was young, then he reinvented it by cutting it down to size. He said it wasn't appropriate to paint those 'ridiculous stories' of Greek and Roman

142 Gainsborough,

Portrait of Mary Countess Howe

OVERLEAF

143 Hogarth,

Marriage à la Mode

(II Tête à Tête),

detail

mythology, and the Bible, so he got in new stories about contemporary people: their yawns, despair and boredom, and their inability to distinguish anything from anything else **143**.

Hogarth's not exactly on a level with Titian, Rubens and Velázquez – they're all good in the way the greatest modern painting of the twentieth century is good. They seem to set the standard for that painting. He aspires to be good in that way, but he also puts something else in the mix that's the beginning of the end of painterly painting – and that's his sense of content. That's what makes him a bridge to our time.

Today we've got a kind of art that turns against the visual and sensual side of painting, and against the idea that content can ever really be merely in the look of something. The type of art now celebrated by Tate Modern concerns ideas alone, and a rather twisted notion of what 'ideas' actually are: in this art if a bit of anger or some identity politics are referred to, then the art really is 'angry' or it really does challenge the assumptions of people who haven't read any books about identity politics (however feeble the realisation of the actual art might be). What's said and written about this type of art, its apologia, has become merely a list of the same pretend-important ideas that by now makes one fall asleep just hearing it. In his emphasis on content, Hogarth might seem a bit like this. On the other hand, he's not really, because the vibe of Tate Modern supports and promotes the very thing Hogarth is always attacking, which is empty pretentiousness – even though it also supports the thing he's very interested in, which is modernity.

Hogarth's last print was called *The Bathos* **145**. Issued seven months before his death, and ostensibly a parody of current philosophical ideas about the sublime in art and the impact of vast natural spaces on the artistic imagination, it also seems to be a satirical allegory on his own failure. Instead of the serpentine line of beauty on the artist's palette there's a jagged crack, because the palette's smashed. Everything's in ruins and nothing can stand up. And instead of the sign of the Golden Head there's the sign of the World's End.

His last painted self-portrait was done a few years previously, in 1757, to celebrate his appointment – at last – as 'Painter to the King' **144**. The appointment didn't pay much, and didn't mean much either, because the King hated art. So it was pretty joyless. But this painting has its own integrity. It's not trying

144 Hogarth, *Self-portrait with Comic Muse*

to impress: it just expresses itself, its shapes, atmosphere and dignified loneliness. He's about to paint a classical goddess whose identity is revealed in his title: why is it the 'comic muse'? The idea was to express Hogarth's opposition to the fake solemnity of the academicism by which he felt the new rising British art was dominated. The goddess is meaningless now because we don't value classicism, we don't care about it, so we can make her say anything we like – maybe 'Congratulations on the painterly flair with which you render your own stocky calves, Mr Hogarth!' That would be to return to Hogarth's curving line of beauty, so his purely visual side has got into us after all.

Hogarth's insults against the old masters were really attacks on what he saw as a poseurish cult of the past. The 'ridiculous stories' weren't appropriate for art now: artists had to re-make the old traditions so they fitted with modern times. When you go round Tate Modern today it's obvious the people who run it don't say 'Ridiculous stories out and whatever is good in!' Instead, they're neurotically obsessed with certain types of modern orthodoxy (which are today's equivalent of Greek myths and religious stories). The compulsion to follow this stuff in a zombie-like manner is a way of avoiding the problem of content, not engaging with it. The point of Hogarth's stories was that they provided a way out of emptiness. He could see perfectly well that in the tradition of painting an emptiness had set in, and he wanted to get back to what had been good about the tradition in the first place.

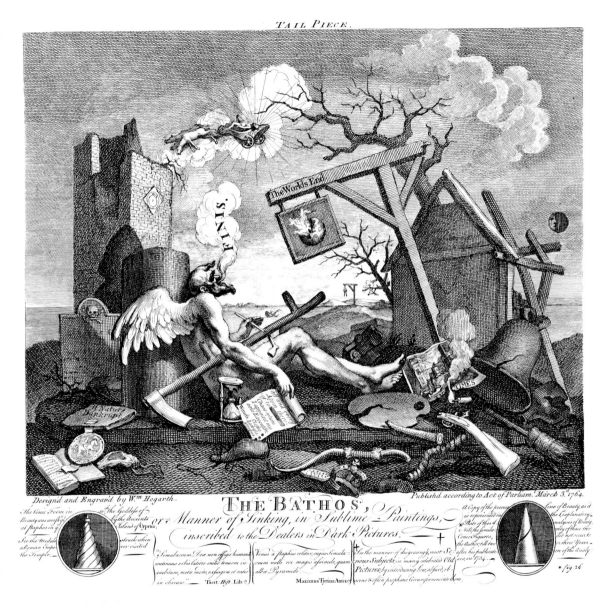

145 Hogarth, *The Bathos*

Picture Credits

1. Titian, *Perseus and Andromeda*, 1554–6. The Wallace Collection, London. Bridgeman Art Library.

2. Giovanni Bellini, *Madonna of the Meadow*, 1503. National Gallery, London.

3. Giorgione, *The Tempest*, 1500–1510. Gallerie dell'Accademia, Venice. Bridgeman Art Library.

4. Titian, *The Holy Family and a Shepherd*, circa 1510. National Gallery, London.

5. Titian, *Ecce Homo*, 1560–70. The Saint Louis Art Museum, St. Louis, Missouri.

6. Michelangelo, *Sistine Chapel Ceiling*, 1510. Vatican Museums and Galleries, Rome. Bridgeman Art Library.

7. Michelangelo, *Sistine Chapel Ceiling: The Fall of Man and the Expulsion from the Garden of Eden*, 1510. Vatican Museum and Galleries, Rome. Bridgeman Art Library.

8. Titian, *The Death of Actaeon*, circa 1576. National Gallery, London.

9. Titian, *The Death of Actaeon*, detail.

10. Titian, *The Entombment*, 1559. Prado, Madrid. Scala.

11. Titian, *Tarquin and Lucretia*, circa 1571. Fitzwilliam Museum, University of Cambridge. Bridgeman Art Library.

12. Titian, *Portrait of a Man*, 1512. National Gallery, London.

13. Veronese, *Ceiling of Doge's Palace, Venice*. Sala del Consiglio dei 10, Palazzo Ducale, Venice. Scala.

14. Veronese, *Juno Showering Venice with Gold*, 1555. Sala dell'Udienza, Palazzo Ducale, Venice. Bridgeman Art Library.

15. Tintoretto, *Crucifixion*, 1565. Scuola Grande di San Rocco, Venice. Bridgeman Art Library.

16. Titian, *Bacchus and Ariadne*, circa 1523. National Gallery, London.

17. Titian, *Bacchus and Ariadne*, detail.

18. Titian, *Venus of Urbino*, 1538. Uffizi, Florence. Scala.

19. Titian, *Venus of Urbino*, detail

20. Edouard Manet, *Olympia*, 1863. Musée d'Orsay, Paris. Bridgeman Art Library.

21. Alexandre Cabanel, *The Birth of Venus*, 1863. Musée d'Orsay, Paris. Bridgeman Art Library.

22. Titian, *Venus of Urbino*, detail.

23. Titian, *Venus of Urbino*, detail.

24. Titian, *Venus of Urbino*, detail.

25. Titian, *Venus of Urbino*, detail.

26. Titian, *Portrait of Charles V, King of Spain*, 1548. Alte Pinakothek, Munich. Bridgeman Art Library.

27. Titian, *The Crowning with Thorns*, 1558. Alte Pinakothek, Munich. Scala.

28. Titian, *Portrait of Jacopo Strada*, circa 1568. Kunsthistorisches Museum, Vienna. Bridgeman Art Library.

29. Titian, *Georges d'Armagnac, Bishop of Rodez, with his Secretary Guillaume Philandrier*, 1536–9. Collection of the Duke of Northumberland.

30. Titian, *Portrait of Pope Paul III with his grandsons*, 1545. Museo e Gallerie Nazionali di Capodimonte, Naples. Bridgeman Art Library.

31. Titian, *Assumption of the Virgin Mary*, 1516–18. Santa Maria Gloriosa dei Frari, Venice. Bridgeman Art Library.

32. Titian, *Self-portrait*, circa 1567. Prado, Madrid. Bridgeman Art Library.

33. Titian, *The Flaying of Marsyas*, 1570–75. Kromeriz, Erzbischoefliches Schloss. AKG-images, London.

34. Giulio Romano, *Apollo Flaying Marsyas*, circa 1527. Louvre, Paris.

35. Titian, *The Flaying of Marsyas*, detail.

36. Titian, *Pietà*, 1576. Gallerie dell'Accademia, Venice. Scala.

37. Titian, *Pietà*, detail.

38. Titian, *Self-portrait*, 1562. Staatliche Museen, Gemäldegalerie, Berlin. AKG-images London.

39. Rubens, *The Medici Cycle: The Disembarkation of Marie de Medici at Marseilles*, circa 1621. Louvre, Paris. Bridgeman Art Library.

40. Rubens, *The Raising of the Cross*, detail.

41. Rubens, *The Descent from the Cross*, detail.

42 Rubens, *The Raising of the Cross*, triptych, 1610–11. Antwerp Cathedral. Bridgeman Art Library.

43. Rubens, *The Descent from the Cross*, triptych, 1614. Antwerp Cathedral. Scala.

44. Rubens, *Self-portrait with his wife, Isabella Brandt*, circa 1609. Alte Pinakothek, Munich. Bridgeman Art Library.

45. Rubens, *The Raising of the Cross*, left-hand panel.

46. *Laocöon*, first century AD (Roman copy of Greek original, rediscovered in 1506). Vatican Museums and Galleries, Rome. Bridgeman Art Library.

47. Rubens, drawing of *Laocöon*, circa 1600–1608. Biblioteca Ambrosiana, Milan.

48. Caravaggio, *Seven Acts of Mercy*, 1607. Pio Monte della Misericordia, Naples. Scala.

49. Rubens, *The Felicity of the Regency of Marie de Medici*, 1622–25. Louvre, Paris. Bridgeman Art Library.

50. Rubens, *The Felicity of the Regency of Marie de Medici*, detail.

51. Rubens, *The Felicity of the Regency of Marie de Medici*, detail.

52. Rubens, *The Disembarkation of Marie de Medici at Marseilles*, detail, 1622–25. Louvre, Paris. Scala.

53. Rubens, *The Meeting of the King and Marie de Medici at Lyons*, 1622. Louvre, Paris. Bridgeman Art Library.

54. Titian, *Adam and Eve*, circa 1550. Prado, Madrid. Bridgeman Art Library.

55. Rubens, *Adam and Eve (after Titian)*, 1628–9. Prado, Madrid. Bridgeman Art Library.

56. Titian, *Europa*, 1559–62. Isabella Stewart Gardner Museum, Boston, Massachusetts. Bridgeman Art Library.

57. Rubens, *Rape of Europa (after Titian)*, 1628–9. Prado, Madrid. Bridgeman Art Library.

58. Rubens, *Allegory of Peace*, 1630. National Gallery, London. Bridgeman Art Library.

59. Rubens, *Ceiling of The Banqueting Hall, Whitehall*, 1632–34. Crown copyright: Historic Royal Palaces Photographic Library.

60. Rubens, *Apotheosis of James I*, The Banqueting Hall ceiling. Crown copyright: Historic Royal Palaces Photographic Library.

61. Rubens, *Portrait of Suzanna Fourment*, 1622–5. National Gallery, London. Bridgeman Art Library.

62. Rubens, *Self-portrait*, 1628. Uffizi, Florence. Scala.

63. Rubens, *Autumn Landscape with View of Het Steen*, circa 1635. National Gallery, London.

64. Rubens, *Autumn Landscape with View of Het Steen*, detail.

65. Rubens, *Trees Reflected in Water*, circa 1635. British Museum, London. Scala.

66. Rubens, *Portrait of Helena Fourment in a Fur Wrap*, 1636–8. Kunsthistorisches Museum, Vienna. Bridgeman Art Library.

67. Rubens, *Rubens and Helena Fourment in the Garden*, circa 1635. Alte Pinakothek, Munich. Bridgeman Art Library.

68. Rubens, oil sketch for *The Lion Hunt*, 1621–25. Alte Pinakothek, Munich. AKG-images, London (Erich Lessing).

69. Rubens, *The Lion Hunt*, 1621. Alte Pinakothek, Munich. Scala.

70. Annibale Carracci, retouched by Rubens, *A Woman with Two Children*, circa 1620–30. Louvre, Paris.

71. Perino del Vaga, retouched by Rubens, *Nessus and Deianeira*, 1621–30. British Museum, London.

72. Rubens, *Drunken Silenus*, circa 1618. Alte Pinakothek, Munich. Bridgeman Art Library.

73. Rubens, *Drunken Silenus*, detail.

74. Rubens, *Self-portrait*, 1638–40. Kunsthistorisches Museum, Vienna. AKG-images.

75. Rubens, *The Three Graces*, 1636–38. Prado, Madrid. Bridgeman Art Library.

76. Velázquez, *Las Meniñas*, circa 1656. Prado, Madrid. Bridgeman Art Library.

77. Velázquez, *Las Meniñas*, detail.

78. Sarah Lucas, *Self-portrait with Fried Eggs*, 1996. © the Artist; courtesy Sadie Coles HQ, London.

79. Andy Warhol, *Self-portrait*, 1967. Private collection. Bridgeman Art Library. © The Andy Warhol Foundation for the Visual Arts, Inc. – ARS New York DACS, London 2003.

80. Frida Kahlo, *The Two Fridas*, 1939. The Art Archive – Museum of Modern Art, Mexico. Photo: Dagli Orti. Copyright Banco de Mexico (Frida Kahlo Museums Trust), Instituto Nacional de Bellas Artes y Literatura, Mexico.

81. Gilbert & George, *Street*, 1983. Royal Academy of Arts, London. Bridgeman Art Library.

82. Poussin, *A Dance to the Music of Time*, 1638–40. Wallace Collection, London. Bridgeman Art Library.

83. Poussin, *A Dance to the Music of Time*, detail. Wallace Collection, London. Photo courtesy National Gallery, London.

84. Velázquez, *Las Meniñas*, detail.

85. Velázquez, *Las Meniñas*, circa 1656. Prado, Madrid. Bridgeman Art Library.

86. Velázquez, *Mariana of Austria*, 1652. Prado, Madrid. Bridgeman Art Library.

87. Velázquez, *Man with Ruff Collar, thought to be Francisco Pacheco*, circa 1620–3. Prado, Madrid. Scala.

88. Francisco Pacheco, *The Immaculate Conception*, 1621. Palacio Arzobispal, Seville. Bridgeman Art Library.

89. Velázquez, *Christ in the House of Martha and Mary*, 1618, detail. National Gallery, London. Bridgeman Art Library.

90. Velázquez, *Old Woman Frying Eggs*, 1618. National Gallery of Scotland, Edinburgh. Bridgeman Art Library.

91. Velázquez, *Waterseller of Seville*, circa 1623. Apsley House, Wellington Museum, London. Bridgeman Art Library.

92. Velázquez, *Count-Duke of Olivares*, circa 1625. Varez-Fisa Collection. Bridgeman Art Library.

93. Velázquez, *Philip IV*, x-ray. Prado, Madrid.

94. Velázquez, *Philip IV*, circa 1623 (repainted 1626). Prado, Madrid. Bridgeman Art Library.

95. Velázquez, *The Triumph of Bacchus*, 1628. Prado, Madrid. Bridgeman Art Library.

96. Velázquez, *Philip IV in Brown and Silver*, circa 1632. National Gallery, London.

97. Velázquez, *Philip IV in Brown and Silver*, detail. National Gallery, London. Bridgeman Art Library.

98. Velázquez, *Las Meniñas*, detail.

99. Rembrandt, *Self-portrait*, 1661–2. Kenwood House, London. Bridgeman Art Library.

100. Velázquez, *Court Jester, El Primo*, circa 1649. Prado, Madrid. Bridgeman Art Library.

101. Velázquez, *The Court Dwarf, Don Francisco Lezcano*, circa 1646. Prado, Madrid. Bridgeman Art Library.

102. Velázquez, *Don Sebastian de Morra*, circa 1646. Prado, Madrid. Bridgeman Art Library.

103. Velázquez, *The Toilet of Venus ('The Rokeby Venus')*, circa 1650. National Gallery, London.

104. Velázquez, *Las Meniñas*, detail.

105. Salvator Rosa, *Self-portrait as a Philosopher*, 1641. National Gallery, London.

106. Velázquez, *Pope Innocent X*, 1650. Galleria Doria Pamphilj, Rome. Bridgeman Art Library.

107. Velázquez, *Las Meniñas*, detail.

108. Velázquez, *Las Meniñas*, detail.

Hogarth chapter opener: *A Rake's Progress (VII The Prison)*, 1733–4. Courtesy of the Trustees of Sir John Soane's Museum, London. Bridgeman Art Library.

109. Hogarth, *Marriage à la Mode (IV The Countess's Levée)*, 1743. National Gallery, London. Bridgeman Art Library.

110. Sir James Thornhill, The Painted Hall, Greenwich, 1707–27. Bridgeman Art Library (photo John Bethell).

111. Sir James Thornhill, The Painted Hall, Greenwich, detail. The Greenwich Foundation (photo © James Brittain).

112. Hogarth, *The Lottery Scheme*, 1724. Weidenfeld Archive.

113. Hogarth, *The Cholmondley Family*, 1732. Private collection. Bridgeman Art Library.

114. Hogarth, *The Wollaston Family*, 1730. On loan to New Walk Museum, Leicester City Museum Service. Bridgeman Art Library.

115. Hogarth, scene from *The Beggar's Opera*, 1728. The Yale Center for British Art, Paul Mellon Collection. Bridgeman Art Library.

116. Sir James Thornhill, *Conversation Piece of the Family*, circa 1730. The Burghley House Collection.

117. Jean-Baptiste-Siméon Chardin, *The House of Cards*, 1736–7. National Gallery, London. Bridgeman Art Library.

118. Hogarth, *Before*, 1730–1. Fitzwilliam Museum, Cambridge. Bridgeman Art Library.

119. Hogarth, *After*, 1730–1. Fitzwilliam Museum, Cambridge. Bridgeman Art Library.

120. Hogarth, *A Harlot's Progress (II Apprehended by a Magistrate)*, 1732. Weidenfeld Archive.

121. Hogarth, *A Harlot's Progress (III Scene in Bridewell)*, 1732. Weidenfeld Archive.

122. Hogarth, *A Rake's Progress*, in position in Sir John Soane's Museum. Arcaid (photo Richard Bryant).

123. Hogarth, *A Rake's Progress (I The Heir)*, 1733–4. Courtesy of the Trustees of Sir John Soane's Museum, London. Bridgeman Art Library.

124. Hogarth, *A Rake's Progress (II The Levée)*, 1733–4. Courtesy of the Trustees of Sir John Soane's Museum, London. Bridgeman Art Library.

125. Hogarth, *A Rake's Progress (III The Orgy)*, 1733–4. Courtesy of the Trustees of Sir John Soane's Museum, London. Bridgeman Art Library.

126. Hogarth, *A Rake's Progress (VIII The Madhouse)*, 1733–4. Courtesy of the Trustees of Sir John Soane's Museum, London. Bridgeman Art Library.

127. Hogarth, *Marriage à la Mode (I The Contract)*, detail.

128. Hogarth, *Marriage à la Mode (I The Contract)*, 1743. National Gallery, London. Bridgeman Art Library.

129. Hogarth, *Marriage à la Mode (II Tête à Tête)*, 1743. National Gallery, London. Bridgeman Art Library.

130. Hogarth, *Marriage à la Mode (II Tête à Tête)*, detail.

131. Hogarth, *Marriage à la Mode (III The Quack)*, 1743. National Gallery, London. Bridgeman Art Library.

132. Hogarth, *Marriage à la Mode (V The Bagnio)*, 1743. National Gallery, London. Bridgeman Art Library.

133. Hogarth, *Marriage à la Mode (VI The Lady's Death)*, 1743. National Gallery, London. Bridgeman Art Library.

134. Hogarth, *The Painter and his Pug*, 1745. Tate Picture Library.

135. Hogarth, *O The Roast Beef of Old England ('The Gate of Calais')*, 1748. Tate Picture Library.

136. Hogarth, *The Analysis of Beauty, Plate I*, 1753. Weidenfeld Archive.

137. Hogarth, *The Painter and his Pug*, detail.

138. Hogarth, *Heads of Six of Hogarth's Servants*, circa 1750–5. Tate Picture Library.

139. Hogarth, *Heads of Six of Hogarth's Servants*, detail.

140. Joshua Reynolds, *Self-portrait*, circa 1780. Royal Academy of Arts, London. Bridgeman Art Library.

141. Paul Sandby, *Puggs Graces*, 1758. Weidenfeld Archive.

142. Gainsborough, *Portrait of Mary Countess Howe*, 1763–4. Kenwood House, London. Bridgeman Art Library.

143. Hogarth, *Marriage à la Mode (II Tête à Tête)*, detail.

144. Hogarth, *Self-portrait with Comic Muse*, 1757. National Portrait Gallery, London.

145. Hogarth, *The Bathos*, 1764. Weidenfeld Archive.

Index

Acknowledgements

Thank you very much to everyone
who helped with this book,
including the designer, Harry Green,
and the Publishing Director
at Weidenfeld, Richard Milner,
but especially my wife, Emma Biggs.